DAVID HUME

An Enquiry concerning Human Understanding

My Own Life

An Abstract of A Treatise of Human Nature

INTRODUCTION, NOTES, AND EDITORIAL ARRANGEMENT BY ANTONY FLEW

Open ***** Court La Salle, Illinois

AG

OPEN COURT and the above logo are registered in the U.S. Patent and Trademark Office.

Introduction, notes, and editorial arrangement © 1988 by Open Court Publishing Company.

First printing 1988 Second printing 1990 Third printing 1991 Fourth printing 1992 Fifth printing 1993

All rights reserved. No part of this publication may be reproduced, stored in a retrieval system, or transmitted, in any form or by any means, electronic, mechanical, photocopying, recording, or otherwise, without the prior written permission of the publisher, Open Court Publishing Company, POB 599, Peru, Illinois 61354.

Printed and bound in the United States of America.

Library of Congress Cataloging-in-Publication Data

Hume, David, 1711-1776.

An enquiry concerning human understanding / David Hume: introduction, notes, and editorial arrangment by Antony Flew.

p. cm. Bibliography: p. Includes index. ISBN 0-8126-9054-0

1. Knowledge, Theory of—Early works to 1800. I. Flew, Antony, 1923— . II. Title.

B1493.E57 1988

88-22480

121-dc19

CIP

CONTENTS

Publisher's Preface	ν
Introduction v	i
My Own Life	1
Three Letters from David Hume 13	
LETTER 1	To Gilbert Eliot of Minto 14
LETTER 2	To Benjamin Franklin 15
LETTER 3	To the Reverend George Campbell 17
	A Treatise of Human Nature 27
Why a cause is always necessary 45 An Enquiry concerning Human Understanding 51	
Advertisement	52
SECTION	. Of the different Species of Philosophy 53
SECTION	ll. Of the Origin of Ideas 63
SECTION	II. Of the Association of Ideas 69
SECTION	V. Sceptical Doubts concerning the Operations of the Understanding 71

iv CONTENTS

SECTION V. Sceptical Solution of these Doubts 84 SECTION VI. Of Probability 98 SECTION VII. Of the Idea of necessary Connexion 101 SECTION VIII. Of Liberty and Necessity 119 SECTION IX. Of the Reason of Animals 139 SECTION X. Of Miracles 143 SECTION XI. Of a particular Providence and of a future State 167 SECTION XII. Of the academical or sceptical Philosophy 181 **Bibliography** 197

Index

201

PUBLISHER'S PREFACE

This book is the first in a new series of classroom materials, the Paul Carus Student Editions, named in memory of Paul Carus (1852–1919). Carus was editor of Open Court Publishing Company from 1887 until his death. He was the first editor of *The Monist*, one of the world's leading philosophy journals, and he wrote over 1,000 works, more than 50 of them books. Under his direction, Open Court was a pioneer in the development of paperback and other scholarly materials.

Open Court published an edition of Hume's *Enquiry* concerning *Human Understanding* in 1907, and a second edition, prepared by Eugene Freeman, in 1966. The present edition is a completely new treatment, with every line checked and rechecked, and with notes and ancillary material superior to any other edition on the market.

INTRODUCTION

In giving this book, first published in 1748, the title *An Enquiry concerning Human Understanding*, David Hume (1711–76) was putting it into a succession which began in 1690 with *An Essay concerning Human Understanding* by John Locke (1632–1704), and which was to continue through the three great *Critiques* of Immanuel Kant (1724–1804). Locke's *Essay*, as he tells us in a prefatory epistle, took its start from an occasion when

five or six friends meeting at my chamber, and discoursing on a subject very remote from this, found themselves quickly at a stand, by the difficulties that arose on every side. After we had a while puzzled ourselves, without coming any nearer a resolution of those doubts which perplexed us, it came into my thoughts that we took a wrong course; and that, before we set ourselves upon enquiries of that nature, it was necessary to examine our own abilities and see what objects our understandings were or were not fitted to deal with.

In conducting this examination—and taking hints from, above all, Descartes (1596–1650)—Locke developed what he called "the new way of ideas". In Book I 'Of innate notions' he argued that there are none, but that all have to be derived in some way from post-natal, waking experience. Book II 'Of ideas' distinguishes the different sorts which we can and do have. In Book III Locke found himself, rather to his own surprise, treating 'Of words'. Finally, Book IV 'Of knowledge and opinion' gives his conclusions.

Hume's first *Enquiry*, so called because he later published *An Enquiry concerning the Principles of Morals* (1751), was not his first major publication. That position is held by *A Treatise of Human Nature* (1739–40), by common consent the greatest work of philosophy to have appeared first in the English language. However, as Hume was, in an autobiographical fragment writ-

 $^{^1}$ The standard edition is by L.A. Selby-Bigge, revised by Peter Nidditch (Oxford: Clarendon, 1978).

viii INTRODUCTION

ten during the last year of his life (reprinted below), so famously to complain, "It fell *deadborn from the press*, without reaching such distinction as even to excite a murmur among the zealots."

Nevertheless. Hume immediately continues, "being naturally of a cheerful and sanguine temper, I very soon recovered the blow and prosecuted with great ardour my studies in the country." Eventually, encouraged by the success of his Essays, Moral and Political, and having "always entertained a notion that my want of success in publishing the Treatise of Human Nature had proceeded more from the manner than the matter", he "cast the first part of that work anew in the Enquiry concerning Human Understanding, which was published while I was at Turin:" where, one may now add, the author of Section X 'Of Miracles' might have been shown the famous, or notorious. Shroud of Turin.³ To what turned out to be the first posthumous edition of his Essays and Treatises on Several Subjects (1777), Hume added an 'Advertisement', categorically disowning "that juvenile work" the Treatise and insisting that "the following pieces," beginning with the two Enquiries, "may alone be regarded as containing his philosophical sentiments and principles."

In order fully to appreciate these "sentiments and principles" we have to recognize that and in what ways Hume's starting point in philosophy—like those both of Locke and of Berkeley (1685–1753) before him, and of so many others later—was fundamentally, and some would add preposterously, Cartesian. In Parts I–III of his *Discourse on the Method* Descartes warms up gently. Then, suddenly, in the first two paragraphs of Part IV he unmasks an almost total scepticism:

And since all the same thoughts and conceptions which we have while awake may also come to us in sleep, without any of them being at that time true, I resolved to assume that everything that ever entered into my mind was no more true than the illusions of my dreams.

 $^{^2}$ The most recent complete edition of all Hume's essays is from the Liberty Press of Indianapolis, 1985.

³ At the time of writing the only full-length critically constructive study of this *Enquiry* is Antony Flew, *Hume's Philosophy of Belief* (London and New York: Routledge and Kegan Paul, and Humanities Press, 1961).

INTRODUCTION

The thesis which Descartes is thus at this stage resolved to maintain—a thesis nowadays nicknamed the Doctrine of the Veil of Appearance—is that all any of us are ever immediately aware of are our own mental images, sense-data, bodily sensations and so on; or, in Locke's terminology, our own ideas. We find the same thing in the very first sentence of Berkeley's *Principles of Human Knowledge* (1710):

It is evident to anyone who takes a survey of the *objects of human knowledge*, that they are either *ideas* actually imprinted on the senses; or else such as are perceived by attending to the passions and operations of the mind; or, lastly, *ideas* formed by help of memory and imagination—either compounding, dividing, or barely representing those originally perceived in the aforesaid ways (emphasis in original).

Hume too in Section XII (i) of this *Enquiry* takes the same fundamental absolutely for granted:

These are the obvious dictates of reason; and no man, who reflects, ever doubted, that the existences which we consider, when we say, this house and that tree, are nothing but perceptions in the mind, and fleeting copies or representations of other existences, which remain uniform and independent.

In Section I Hume offers no more than a restatement of Locke's programme, though there are sharp hints that Hume will be finding that "a considerable part of metaphysics" arises "from the fruitless efforts of human vanity, which would penetrate into subjects utterly inaccessible to the understanding, or from the craft of popular superstitions", threatening to overwhelm the naturally secular mind "with religious fears and prejudices". It is in Section II that Hume begins to innovate, by dividing what his predecessors had confounded together as ideas into two sub-categories, ideas and impressions. Locke's empiricist denial of innate notions is now transposed into the contention that, in order to legitimate ideas we have, as it were. to show their proper parentage in antecedent impressions. Presented as Hume does present it, as a psychological thesis about origins, this is at best unproven and at worst decisively falsified by the counter-example of the missing shade.

But now consider how you would test the psychological hypothesis that people blind from birth neither enjoy nor suffer any visual imagery. You could not even explain to your blindX INTRODUCTION

from-birth experimental subjects what is meant by such colour words as 'red' or 'blue'; until and unless, that is, the surgeons had succeeded in putting their blind eyes into working order. So there is some excuse for Hume's rather disreputable dismissal of that counter-example: "this instance is so singular, that it is scarcely worth our observing, and does not merit that for it alone we should alter our general maxim"! He was, presumably, groping towards a different though in a way analogous, a truly philosophical, and a vastly important conclusion. This is a conclusion the truth of which becomes manifest as we consider why our blind-from-birth subjects cannot, until and unless they become sighted, answer our questions. It is that two people cannot share, and know that they share, a common vocabulary save in so far as its terms are explicable by reference to their own shared experience.

Section III ended much shorter than it started, because Hume had eventually to abandon some of the high hopes of the *Treatise*. Part of the Cartesian inheritance was a deep dichotomy between consciousness and stuff. So, with classical mechanics accepted as the fundamental science of stuff, it had seemed to Hume, and to many others, that there must be room for a psychological para-mechanics of consciousness. In this ideas (or ideas and impressions) replaced the hard, massy and impenetrable atoms; while principles of association were recruited to do duty as the natural laws of this new science. But even by the time when this first *Enquiry* was first printed Hume had largely abandoned his hopes of becoming the Newton of a new psychological para-mechanics.

In Section IV (i) we find what, from its aggressive employments, has come to be called Hume's Fork. This instrument is at once put to work: not only to distinguish pure from applied or "mixed" mathematics; but also to establish his great negative insight, that it is only from experience that we can learn what things or sorts of things either cannot be or must be the causes of other things or sorts of things. This insight is important: both "as destroying that implicit faith and security, which is the bane of all reasoning and free enquiry"—especially perhaps in the fields of social science and social policy;⁴ and as discrediting

⁴ Compare, for instance, Antony Flew, *Thinking about Social Thinking* (Oxford: Blackwell, 1985).

INTRODUCTION

several supposedly self-evident truths frequently serving as premisses in arguments for the existence of God.

Hume's Fork forces a choice: between propositions stating, or purporting to state, matters of fact and real existence; and propositions stating, or purporting to state, only the purely logical, not to say tautological, relations between ideas or concepts. Like Hume's Law—the insistence that you cannot validly deduce what ought to be from premisses stating only and neutrally what supposedly is—Hume's Fork is a tool for analysis, not a claim (obviously false) that all utterances already fall into one or other of the categories thus distinguished. This needs to be said often and with emphasis. For there are those, nowadays including many paid to know better, who would have it that some favourite guru has 'transcended', when the truth is that he has either failed to make or wantonly collapsed, these elementary distinctions.

In Section IV (ii) Hume applies his Fork more generally to all kinds of argument from experience. In this application, as on other occasions in the present Enquiry, he writes more as the logician and less as the would be psychologist than he did in the Treatise. Argument from experience is now represented as involving an irreparably fallacious move: from a first premiss of the form 'All known X's are or have been \emptyset '; by way of an always missing second premiss; to a conclusion of the form 'All X's have been, are and will be \emptyset '. This representation has traditionally been labelled The Problem of Induction. But Hume himself never introduces the word 'induction'. He is also, in his characteristically ironic way, clearly, and quite rightly, confident that no one will ever succeed in supplying a known second premiss satisfactorily completing the syllogism.

The one proposition which would perfectly fill this particular bill is: 'For all values of X, the classes of all X's known anywhere, at any time, to anyone, always constitute, in all respects, ideally representative samples of the class of all X's'. But this, as a moment's thought will reveal, is neither known to be true, nor even known but knowable only by reliance upon precisely the very form of argument which is here in question. It is instead and by everyone, without any such reliance, known to be false. Recall, for instance, in a spirit of philosophical piety, the case of Abel Tasman and his crew, who met their first non-white

XII

swans while exploring the mouth of Western Australia's Swan River. 5

The conclusion which Hume himself draws, and which he develops in Sections V and VI, is that argument from experience—argument which by its very nature goes beyond what is contained in, and is thus deducible form, its premisses—is not a matter of reason or reasoning, but of custom or habit. About these perceived implications he is complacent. The outcome of the previous Section IV is

that, in all reasonings from experience, there is a step taken by the mind which is not supported by any argument or process of the understanding . . . [However,] If the mind be not engaged by argument to make this step, it must be induced by some other principle of equal weight and authority; and that principle will preserve its influence as long as human nature remains the same.

This might be all very well had Hume not so vividly represented argument from experience as being always and necessarily fallacious. So long as this form of representation is accepted the implication, surely, is that the whole business is: not just, innocuously, nonrational; but instead, unacceptably, irrational? But perhaps the nerve of such argument is more faithfully represented as the following of a paradigmatically rational and studiously corrigible rule of procedure: 'If all X's known have been \emptyset ', and if there is no particular reason to suspect that these may not constitute a fair sample of the class of all X's, then assume that all X's are in fact \emptyset ; but in no dogmatic, bigotted or inflexible spirit'?

It is in the context of his treatment of argument from experience that in Section V (i) Hume begins to expound and advocate "the Academic or Sceptical philosophy", which is the intended outcome of this whole Enquiry. In his own day all readers will have recognized, as few of our contemporaries will, references to the philosophical writings of Cicero (106–43 $_{\rm BCE}$). For us the most relevant emphasis here is upon "confining to very narrow bounds the enquiries of the understanding, and . . . renouncing all speculations which lie not within the limits of common life and practice."

⁵ Abundant particular reason was in fact available to those Europeans seeing their first black swans: they knew that the earth was far from fully explored; and they knew that many species differ from others mainly or only in pigmentation.

INTRODUCTION xiii

At the end of Part I and throughout Part II of this section Hume has something to say about the psychology of belief. He also offers a philosophical analysis proposing, in accordance with a Cartesian concept of mind as including all and only kinds of consciousness, to distinguish the belief that the proposition p is true from any more non-committal entertainment of p, by reference to differences between (private) consciousness rather than (public) dispositions to behave: "belief", Hume insists, "is something felt by the mind, which distinguishes the ideas of the judgement from the fictions of the imagination."

We should also notice, both here and in Section IX and elsewhere, Hume's concern to maintain that man is a part of Nature. Certainly man is the highest of the animals, while human reason is vastly superior to "the reason of animals". But there is no suggestion in Hume of any absolute and unbridgable divide. One thing which he has not accepted from Descartes is the notion of a rational soul as something the presence of which is what alone, yet utterly and decisively, distinguishes human beings from the supposedly insensible and wholly machinelike brutes. Hume indeed writes often as if he were waiting impatiently for Darwin: there is, Hume remarks, "a kind of preestablished harmony between the course of nature and the succession of our ideas". So those, "who delight in the discovery and contemplation of final causes, have here ample subject to employ their wonder and admiration."

In order adequately to appreciate what is going on, and going wrong, in Sections VII and VIII we need to go back to the *Discourse on the Method*. For, immediately after propounding the Doctrine of the Veil of Appearance, Descartes proceeded to epitomize his sole remaining, rock-solid certainty in the oft-quoted words 'I think, therefore I am' (or, since he was writing neither in English nor in Latin but in French, "Je pense, donc je suis"). Elsewhere he explains that 'I think' is to be construed here as meaning 'I am a subject of consciousness'; rather than as making a narrower claim to be engaged in the austerely ratiocinative activities of Rodin's *The Thinker*. Descartes asked next 'What is this "I"?", and answered that he "was a substance the whole essence or nature of which is to think"; that is, to be conscious.

Accepting all this as quite undeniably obvious, Hume in the *Treatise* found himself committed to what has been mischievously described as "a paralytic's eye view of causation". All that

xiv INTRODUCTION

a bodiless Cartesian point of view could possibly observe would be either successions of singular events, or perhaps the succession of events of one sort by events of another sort. The events in themselves could only seem to be "loose and separate", apparently conjoined yet never connected. So what does, what can, all the familiar talk of causal connections amount to? If there really is a legitimate idea of connection or of necessary connection involved here, then that idea must, on Humean principles, be preceded and legitimated by some antecedent impression. The challenge is put at the end of Section II of this *Enquiry* thus:

When we entertain, therefore, any suspicion that a philosophical term is employed without any meaning or idea (as is but too frequent) we need but enquire, from what impression is that supposed idea derived?

To this Hume discovers a response very congenial to the scientific ambitions of the *Treatise*. We observe, he insists, only constant conjunctions and regular successions. But, being the creatures of custom that we are, this leads us to form habits of association and expectation. The impression sought is the felt force of those habits, while we project the idea derived therefrom out onto ongoings in the universe around us. To Hume all this, like his later account of evaluative characteristics, presented itself as a trophy of that introduction of "the experimental method of reasoning into moral subjects" proclaimed in the subtitle of the *Treatise*. For had not the great Sir Isaac Newton himself, in the *Opticks*, offered as one of the findings of the natural sciences that such supposedly secondary qualities as colour are similarly projected?

For as sound in a bell, or musical string, or other sounding body, is nothing but a trembling motion, and in the air nothing but that motion propagated from the object, and in the sensorium it is a sense of that motion under the form of sound; so colours in the object are nothing but a disposition to reflect this or that sort of rays more copiously than the rest.⁶

In that perspective it should become obvious that what are offered in Section VII (ii) as two alternative, yet manifestly not equivalent, definitions of 'cause' are intended: not as definitions, such as might be submitted as contributions to a twentieth

⁶ I (ii) Definition to the second Theorem under the second Proposition.

INTRODUCTION

century philosophical journal; but rather as summaries of what Hume believed was what, and all that, is actually going on when people assert, truly, that this is the cause of that. Those who actually do seek a definition should seize on Hume's incongruous addition to his own first offering: "Or, in other words, where, if the first object had not been, the second never had existed." For while in truth this is neither equivalent to nor deducible from that first Humean 'definition', no candidate can hope to qualify unless it does carry such a contrary-to-fact implication.

Hume's investigations 'Of the Idea of Necessary Connexion' in Section VII go badly wrong for two reasons. First, because he is—and very rightly—concerned not to lose his negative insight about causality: there is nothing which logically must or logically cannot be the cause of anything. Second, because he is unable to admit that as agents we might, and in fact do, have experience of physical necessity and physical impossibility. He thus in effect denies that causing is making things happen: that is, that the occurrence of whatever is in fact a sufficient cause makes it physically necessary that whatever is in fact is its effect will happen and physically impossible that it will not.

So long as Hume remembers that denial, the "reconciling project" of Section VIII (i) will seem to go through at the trot. For if once we accept what in his own *Abstract* of the *Treatise* Hume called his new definition of 'necessity', and which in fact simply substitutes the idea of regular succession for that of physical necessity, then there is no major difficulty in effecting a reconciliation 'Of Liberty and Necessity'.

However the habits of verbal usage and of the association of ideas were too strong even for Hume. So both at the start of Part I of Section VIII, and throughout Part II, he himself is certainly still thinking of causing as making things happen. It is, after all, only upon this assumption that we can reasonably hold the Deity, or indeed anyone else, to be "the author of sin".

Sections X and XI form a complementary pair. There is no anticipation of either, or of Section VIII (ii), in the *Treatise* as published. But we know from a letter that, while Hume was "castrating my work, that is, cutting off its nobler parts; that is, endeavouring it shall give as little offence as possible", he excised some *Reasonings concerning Miracles*. The comple-

⁷ To Henry Home, dated December 2nd, 1737.

xvi INTRODUCTION

mentarity of those two sections arises from the fact that together they respond to what was in Hume's day, and thereafter long remained, the standard rational apologetic for the Christian religion. Both are, therefore, centrally relevant to the whole project of this *Enquiry*. For Hume's contention is that the subject matter of that or any other putative illumination of the transcendent is beyond the range of human knowledge.

The first stage of that traditional systematic apologetic consisted in arguments of natural theology, supposed to establish the existence and certain minimum characteristics of the theist God; plus, sometimes, even the immortality of the human soul. (The word 'natural' is here opposed to 'revealed'.) The second stage appealed to supposedly sufficient historical evidence showing that miracles had been wrought by God in order to vindicate the claims of some particular candidate revelation. (Such a revelation is thought necessary in order more richly to supplement the somewhat sketchy religion of nature.) What we must now call the First Vatican Council defined as dogmas of the Roman Catholic faith that both these two exercises can be accomplished.⁸

In Section X Hume took no pains to avoid giving offence: quite the reverse. But in Section XI he was careful to wrap up his message in such a way that, while it is not missed by readers really wishing to learn, it could, if need be, have been disowned as not truly the opinion of the author himself. Presumably the reason for this discrimination was what, with some exaggeration, he once called his "abundant caution". For, while Deists had by Hume's time long been challenging the credentials of revelation, everyone—both Deists and Christians alike—still accepted natural theology, and in particular the Argument to Design, as luminously sound. Notice too that, as is required by the project of which they constitute essential elements, both Sections X and XI deal with evidence rather than with fact. Hume can, therefore, treat himself to sardonic and disingenuous pieties about the insufficiencies of reason, opening the way to faith.

Had he felt freer, Section XI might have been entitled most aptly 'The Religious Hypothesis'. What he is attacking is the only argument for which he has any respect, and it might well be

⁸ See H. Denzinger (Ed.) *Enchiridion Symbolorum* (Freiburg i-Breisgau: Herder, Twenty-ninth Revised Edition 1953), Sections 1806 and 1813.

INTRODUCTION xvii

so described. All the others—which are, as attempts to prove existence without appealing to experience, inept—he is going to dismiss in very short order in Section XII (iii). But the Argument to Design is an hypothesis offered to explain the existence and character of the Universe. So Hume points out first that such an argument cannot properly be employed to yield conclusions about the infinite: "If the cause be known only by the effect, we never ought to ascribe to it any qualities, beyond what we premisely requisite to produce the effect..." He then confronts the sixty-four thousand guinea question:

If you saw upon the sea-shore the print of one human foot, you would conclude that a man had passed that way, and that he had also left the traces of the other foot . . . [Defoe had published *Robinson Crusoe* first in 1719] Why then do you refuse to admit the same method of reasoning with regard to the order of nature?

Hume's move to break this putative parity of reasoning is as elegant as it is decisive. He reminds us that both the hypothesized Cause and its alleged Effect are, in the second of the two cases, unique by definition. There therefore neither are nor could be other relevantly and sufficiently similar cases providing the basis of experience from which it would be rationally legitimate to argue.

For, although there is a wayward sense in which the Andromeda Nebula may be said to be one of innumerable other island universes (lower case), in the primary sense (upper case) the Universe—with the sole exception of its Creator, if such in fact exists—is stipulated to be all there is. Again, the hypothesized designing Cause, "The Deity, is known to us only by his productions, and is a single being . . . not comprehended under any species or genus, from whose experienced attributes or qualities we can, by analogy, infer any attribute or quality in him."

At the very end of Section XI Hume in his own person tosses off the crucial point. It is one which later helped to awaken Kant from his "dogmatic slumbers". Hume pretends to be musing:

... there occurs to me... a difficulty, which I shall just propose to you without insisting upon it... It is only when two species of objects are found to be constantly conjoined, that we can infer the one from the other... If experienced observation and analogy be, indeed, the only guides which we can reasonably

xviii INTRODUCTION

follow in inferences of this nature, both the effect and the cause must bear a similarity . . . to other effects and causes, which we know, and which we have found, in many instances, to be conjoined with each other.

At the beginning of Section X (i) Hume promises to propound an argument "which, if just, will, with the wise and learned, be an everlasting check to all kinds of superstitious delusion." He then proceeds to discuss the evidence of witnesses. noticing that this must become suspect when "the fact which the testimony endeavours to establish partakes of the extraordinary or the marvellous." But now, he continues, "suppose that the fact which they affirm, instead of being only marvellous, is really miraculous; and suppose that the testimony considered apart and in itself, amounts to an entire proof . . . "Then our reasons for saving that the event in question—"the fact which they affirm"-would be miraculous are by the same token our sufficient reasons for saving that it was impossible for such an event to have occurred. So "in that case there is proof against proof, of which the strongest must prevail, but still with a diminution of its force, in proportion to that of its antagonist."

Here again, as in Section XI, Hume's argument is extremely elegant, although he is himself restrained from making as much of this as he might by his previous denial of the crucial notions of physical necessity and physical impossibility. Hume, along with all those whom he was arguing against, accepted that the word 'miracle' would be "accurately defined" as "a transgression of a law of nature by a particular volition of the Deity . . . " But now —pace Hume—a true law of nature states more than some mere regularity of constant conjunction. For it also affirms that whatever accords with its own truth is physically necessary, while whatever would be incompatible with that truth must be physically impossible. It is precisely and only in so far as miracles are conceived in this way that the occurrence of miracles could serve as a divine endorsement of "a system of religion". For it is precisely and only in so far as a miracle is naturally impossible that we should, if such an event did occur, have to infer that it could have been brought about only by an exercise of Supernatural power. But now, with his elegantly devastating objection, enter Hume:

A miracle is a violation of the laws of nature; and, as a firm and unalterable experience has established these laws, the proof

INTRODUCTION

against a miracle, from the very nature of the fact, is as entire as any argument from experience can possibly be imagined.

In Section X (ii) Hume moves from the completely general to the rather more particular. We have to notice here that Hume the future historian is making a contribution to the philosophy of history as well as to the philosophy of religion. The critical historian cannot but proceed assuming all that he knows, or believes that he knows, about what is probable or improbable, possible or impossible. Back in the *Treatise* (II (iii) 1, pp. 404–05) Hume had argued that it is only on the basis of such assumptions that inkmarks on old pieces of paper can be identified as historical evidence. The critical historian has to argue, therefore, as the celebrated physician De Sylva argued in the case of Mademoiselle Thibaut. In a long note about the alleged miracles around the tomb of the Abbé Paris, Hume reports thus:

The physician declares that it was impossible that she could have been so ill as was proved by witnesses, because it was impossible she could, in so short a time, have recovered so perfectly as he found her. He reasoned, like a man of sense, from natural causes...

It is, of course, always possible that even "a man of sense" may turn out to have been methodologically right yet substantively wrong. Indeed this possibility appears to have been realized several times in Section X (ii). For instance: the two 'miracles' allegedly wrought in Egypt by the Roman soldier Emperor Vespasian would, in the light of advances in medical knowledge since Hume's day, appear to have been well within the range of psychosomatic possibility. But our good new reasons for allowing that these cures were in fact effected constitute at the same time more than sufficient warrant for denying that they were genuinely miraculous.

In Section XII Hume returns to the presentation and discussion of the general philosophical position which he outlined earlier, in Section V (i). Throughout the final Section XII he is trying to steer a moderate and practical course between the extremes of unlearning bigotry and all-destroying scepticism. Admirable though this middle course is, both in its

⁹ His *History of England* became a best-seller, and was, until Macaulay, standard. The catalogue of the British Museum library still describes him as "Hume, David, the historian."

XX INTRODUCTION

intentions and in its results, it must remain for the reader to decide how far Hume succeeds in undermining the actual arguments of the Pyrrhonian sceptics (followers of Pyrrho of Elis, c. 365–c. 275 BCE). For even a critic as sympathetic as the present writer would have to concede that Hume's victory here is psychological rather than logical.

There is, however, no question but that the final paragraphs of Section XII (iii) provide the most splendid, swinging summary of the outcome of this whole *Enquiry concerning Human Understanding*. Nevertheless, in what his despiser Wittgenstein would have rated "the darkness of these times", Hume would surely have wanted to warn us against taking his own last words too literally:

When we run over libraries, persuaded of these principles, what havoc must we make? If we take in our hand any volume—of divinity or school metaphysics, for instance—let us ask, Does it contain any abstract reasoning concerning quantity or number? No. Does it contain any experimental reasoning concerning matter of fact and existence? No. Commit it then to the flames, for it can contain nothing but sophistry and illusion.

My Own Life

The Life of David Hume, Esq.

Written by Himself My Own Life

Mr. Hume, a few months before his death, wrote the following short account of his own life; and, in a codicil to his will, desired that it might be prefixed to the next edition of his Works. That edition cannot be published for a considerable time. The Editor, in the mean while, in order to serve the purchasers of the former editions; and, at the same time, to gratify the impatience of the public curiosity; has thought proper to publish it separately, without altering even the title or superscription, which was written in Mr. Hume's own hand on the cover of the manuscript.¹

It is difficult for a man to speak long of himself without vanity; therefore, I shall be short. It may be thought an instance of vanity that I pretend at all to write my life, but this Narrative shall contain little more than the History of my Writings; as, indeed, almost all my life has been spent in literary pursuits and occupations. The first success of most of my writings was not such as to be an object of vanity.

I was born the 26th of April 1711, old style, at Edinburgh. I was of a good family, both by father and mother: my father's family is a branch of the Earl of Home's, or Hume's;² and my ancestors had been proprietors of the estate, which my brother possesses, for several generations. My mother was daughter of Sir David Falconer, President of the College of Justice:³ the title of Lord Halkerton came by succession to her brother.

¹ This note appeared opposite the first page of text when Hume's brief autobiography was first published.

 $^{^2}$ A later Earl served in two administrations as Foreign Secretary and, for some months in 1963–4, as Prime Minister. But the claims in the nineteenth century of the supposed wonder-worker D. D. Home to have been a member of the same extended family were, it seems, like almost everything else about Home, false.

³ The Scottish position equivalent to Lord Chief Justice of England.

My family, however, was not rich, and being myself a younger brother, my patrimony, according to the mode of my country, was of course very slender. My father, who passed for a man of parts. died when I was an infant, leaving me, with an elder brother and a sister, under the care of our mother, a woman of singular merit. who, though young and handsome, devoted herself entirely to the rearing and educating of her children. I passed through the ordinary course of education with success, and was seized very early with a passion for literature, which has been the ruling passion of my life, and the great source of my enjoyments. My studious disposition, my sobriety, and my industry, gave my family a notion that the law was a proper profession for me; but I found an unsurmountable aversion to everything but the pursuits of philosophy and general learning; and while they fancied I was poring upon Voet and Vinnius, Cicero and Virgil were the authors which I was secretly devouring.4

My very slender fortune, however, being unsuitable to this plan of life, and my health being a little broken by my ardent application, I was tempted, or rather forced, to make a very feeble trial for entering into a more active scene of life. In 1734, I went to Bristol, with some recommendations to eminent merchants, but in a few months found that scene totally unsuitable to me. I went over to France, with a view of prosecuting my studies in a country retreat; and I there laid that plan of life, which I have steadily and successfully pursued. I resolved to make a very rigid frugality supply my deficiency of fortune, to maintain unimpaired my independency, and to regard every object as contemptible, except the improvement of my talents in literature.

During my retreat in France, first at Reims, but chiefly at La Fleche, in Anjou, I composed my *Treatise of Human Nature*. After passing three years very agreeably in that country, I came over to London in 1737. In the end of 1738, I published my Treatise, and immediately went down to my mother and my brother, who lived at his country-house, and was employing himself very judiciously and successfully in the improvement of his fortune.

Never literary attempt was more unfortunate than my Treatise of Human Nature. It fell dead-born from the press

⁴ The first two were, of course, lawyers. Virgil was a Latin poet of the Augustan Age, author of *The Aeneid* and *The Georgics*.

without reaching such distinction, as even to excite a murmur among the zealots. But being naturally of a cheerful and sanguine temper, I very soon recovered the blow, and prosecuted with great ardour my studies in the country. In 1742, I printed at Edinburgh the first part of my Essays: the work was favourably received, and soon made me entirely forget my former disappointment. I continued with my mother and brother in the country, and in that time recovered the knowledge of the Greek language, which I had too much neglected in my early youth.

In 1745, I received a letter from the Marquis of Annandale, inviting me to come and live with him in England; I found also, that the friends and family of that young nobleman were desirous of putting him under my care and direction, for the state of his mind and health required it. I lived with him a twelvemonth. My appointments during that time made a considerable accession to my small fortune. I then received an invitation from General St. Clair to attend him as a secretary to his expedition, which was at first meant against Canada, but ended in an incursion on the coast of France. Next year, to wit. 1747, I received an invitation from the General to attend him in the same station in his military embassy to the courts of Vienna and Turin. I then wore the uniform of an officer, and was introduced at these courts as aid-de-camp to the general, along with Sir Harry Erskine and Captain Grant, now General Grant. These two years were almost the only interruptions which my studies have received during the course of my life: I passed them agreeably, and in good company; and my appointments, with my frugality, had made me reach a fortune, which I called independent, though most of my friends were inclined to smile when I said so; in short, I was now master of near a thousand pounds.

I had always entertained a notion, that my want of success in publishing the Treatise of Human Nature, had proceeded more from the manner than the matter, and that I had been guilty of a very usual indiscretion, in going to the press too early. I, therefore, cast the first part of that work anew in the Enquiry concerning Human Understanding, which was published while I was at Turin.⁵ But this piece was at first little more successful

⁵ In view both of Hume's own early and continuing interest in questions about possible evidence for the miraculous and of the claims recently made for The Shroud of Turin it is remarkable that there is no reference, either here or elsewhere in the surviving Hume papers, to that now famous relic.

than the Treatise of Human Nature. On my return from Italy, I had the mortification to find all England in a ferment, on account of Dr. Middleton's Free Enquiry, while my performance was entirely overlooked and neglected.⁶ A new edition, which had been published at London of my Essays, moral and political, met not with a much better reception.

Such is the force of natural temper, that these disappointments made little or no impression on me. I went down in 1749. and lived two years with my brother at his country-house, for my mother was now dead. I there composed the second part of my Essays, which I called Political Discourses, and also my Enquiry concerning the Principles of Morals, which is another part of my treatise that I cast anew. Meanwhile, my bookseller, A. Millar. informed me, that my former publications (all but the unfortunate Treatise) were beginning to be the subject of conversation: that the sale of them was gradually increasing, and that new editions were demanded. Answers by Reverends, and Right Reverends, came out two or three in a year; and I found, by Dr. Warburton's railing, that the books were beginning to be esteemed in good company.7 However, I had fixed a resolution, which I inflexibly maintained, never to reply to any body; and not being very irascible in my temper, I have easily kept myself clear of all literary squabbles. These symptoms of a rising reputation gave me encouragement, as I was ever more disposed to see the favourable than unfavourable side of things; a turn of mind which it is more happy to possess, than to be born to an estate of ten thousand a year.

In 1751, I removed from the country to the town, the true scene for a man of letters. In 1752, were published at Edinburgh, where I then lived, my Political Discourses, the only work of mine that was successful on the first publication. It was well received abroad and at home. In the same year was published at

⁶ A Free Inquiry into the Miraculous Powers was written by Conyers Middleton. It was reprinted by Sherwood of London in 1825. It contains much more detailed discussion of particular cases than Hume provides in his primarily methodological treatment.

⁷ Dr. Warburton protested to Hume's publisher, Andrew Millar, not without reason, that Hume's *Natural History of Religion* was designed "to establish *naturalism*, a species of atheism, instead of religion..." Warburton himself had a theory, which he elaborately developed, according to which the legends and mythologies of all peoples could be interpreted in a uniform symbolic way consistent with the truth of Christianity.

London, my Enquiry concerning the Principles of Morals; which, in my own opinion (who ought not to judge on that subject), is of all my writings, historical, philosophical, or literary, incomparably the best. It came unnoticed and unobserved into the world.

In 1752, the Faculty of Advocates chose me their Librarian. an office from which I received little or no emolument, but which gave me the command of a large library. I then formed the plan of writing the History of England; but being frightened with the notion of continuing a narrative through a period of 1700 years. I commenced with the accession of the House of Stuart, an epoch when, I thought, the misrepresentations of faction began chiefly to take place. I was, I own, sanguine in my expectations of the success of this work. I thought that I was the only historian, that had at once neglected present power, interest, and authority, and the cry of popular prejudices; and as the subject was suited to every capacity, I expected proportional applause. But miserable was my disappointment: I was assailed by one cry of reproach. disapprobation, and even detestation; English, Scotch, and Irish, Whig and Tory, churchman and sectary, freethinker and religionist, patriot and courtier, united in their rage against the man, who had presumed to shed a generous tear for the fate of Charles I. and the Earl of Strafford; and after the first ebullitions of their fury were over, what was still more mortifying, the book seemed to sink into oblivion. Mr. Millar told me, that in a twelve-month he sold only forty-five copies of it. I scarcely, indeed, heard of one man in the three kingdoms, considerable for rank or letters, that could endure the book. I must only except the primate of England, Dr. Herring, and the primate of Ireland, Dr. Stone, which seem two odd exceptions. These dignified prelates separately sent me messages not to be discouraged.

I was, however, I confess, discouraged; and had not the war been at that time breaking out between France and England, I had certainly retired to some provincial town of the former kingdom, have changed my name, and never more have returned to my native country. But as this scheme was not now practicable, and the subsequent volume was considerably advanced, I resolved to pick up courage and to persevere.

In this interval, I published at London my Natural History of

 $^{^8\,\}mbox{The Nine Years' War, in which England and Prussia were allied against France and Austria.$

Religion, along with some other small pieces: its public entry was rather obscure, except only that Dr. Hurd wrote a pamphlet against it, with all the illiberal petulance, arrogance, and scurrility, which distinguish the Warburtonian school. This pamphlet gave me some consolation for the otherwise indifferent reception of my performance.

In 1756, two years after the fall of the first volume, was published the second volume of my History, containing the period from the death of Charles I. till the Revolution. This performance happened to give less displeasure to the Whigs, and was better received. It not only rose itself, but helped to buoy up its unfortunate brother.

But though I had been taught by experience, that the Whig party were in possession of bestowing all places, both in the state and in literature, I was so little inclined to yield to their senseless clamour, that in above a hundred alterations, which farther study, reading, or reflection engaged me to make in the reigns of the two first Stuarts, I have made all of them invariably to the Tory side. It is ridiculous to consider the English constitution before that period as a regular plan of liberty.

In 1759, I published my History of the House of Tudor. The clamour against this performance was almost equal to that against the History of the two first Stuarts. The reign of Elizabeth was particularly obnoxious. But I was now callous against the impressions of public folly, and continued very peaceably and contentedly in my retreat at Edinburgh, to finish, in two volumes, the more early part of the English History, which I gave to the public in 1761, with tolerable, and but tolerable success.

But, notwithstanding this variety of winds and seasons, to which my writings had been exposed, they had still been making such advances, that the copy-money given me by the booksellers, much exceeded anything formerly known in England;¹⁰ I was

⁹ Hume was emphatically not a Tory in the sense of an opponent of the national aspirations of the American colonists. Nor would it be correct to construe his rejection of historico-contractarian Whig apologetics as involving opposition either to the constitutional settlement consequent upon the Glorious Revolution of 1688 or to classical liberal principles of political economy. On the contrary: Hume was able on his deathbed to study and with few reservations to approve that first and greatest masterpiece of development economics, Smith's *An Inquiry into the Nature and Causes of the Wealth of Nations*.

become not only independent, but opulent. I retired to my native country of Scotland, determined never more to set my foot out of it: and retaining the satisfaction of never having preferred a request to one great man, or even making advances of friendship to any of them. As I was now turned of fifty, I thought of passing all the rest of my life in this philosophical manner, when I received in 1763, an invitation from the Earl of Hertford. with whom I was not in the least acquainted, to attend him on his embassy to Paris, with a near prospect of being appointed secretary to the embassy; and, in the meanwhile, of performing the functions of that office. This offer, however inviting, I at first declined, both because I was reluctant to begin connexions with the great, and because I was afraid that the civilities and gay company of Paris would prove disagreeable to a person of my age and humour: but on his lordship's repeating the invitation, I accepted of it. I have every reason, both of pleasure and interest. to think myself happy in my connexion with that nobleman, as well as afterwards with his brother, General Conway.

Those who have not seen the strange effects of modes, will never imagine the reception I met with at Paris, from men and women of all ranks and stations. The more I resiled¹¹ from their excessive civilities, the more I was loaded with them. There is, however, a real satisfaction in living at Paris, from the great number of sensible, knowing, and polite company with which that city abounds above all places in the universe. I thought once of settling there for life.

I was appointed secretary to the embassy; and, in summer 1765, Lord Hertford left me, being appointed Lord Lieutenant of Ireland. I was *chargé d'affaires* till the arrival of the Duke of Richmond, towards the end of the year. In the beginning of 1766, I left Paris, and next summer went to Edinburgh, with the same view as formerly, of burying myself in a philosophical retreat. I returned to that place, not richer, but with much more money, and a much larger income, by means of Lord Hertford's friendship, than I left it; and I was desirous of trying what superfluity could produce, as I had formerly made an experiment of a competency. But, in 1767, I received from Mr. Conway an invitation to be under-secretary; and this invitation, both the

¹⁰ It has been plausibly claimed that Hume was the first author in history to have made a comfortable living from the sales of his books.

^{11 &}quot;Resiled" = 'recoiled'.

character of the person, and my connexions with Lord Hertford, prevented me from declining. I returned to Edinburgh in 1768, very opulent (for I possessed a revenue of £1000 a year), healthy, and though somewhat stricken in years, with the prospect of enjoying long my ease, and of seeing the increase of my reputation.

In spring 1775, I was struck with a disorder in my bowels, which at first gave me no alarm, but has since, as I apprehend it, become mortal and incurable. I now reckon upon a speedy dissolution. I have suffered very little pain from my disorder; and what is more strange, have, notwithstanding the great decline of my person, never suffered a moment's abatement of my spirits; insomuch, that were I to name the period of my life, which I should most choose to pass over again, I might be tempted to point to this later period. I possess the same ardour as ever in study, and the same gaiety in company. I consider, besides, that a man of sixty-five, by dying, cuts off only a few years of infirmities; and though I see many symptoms of my literary reputation's breaking out at last with additional lustre, I knew that I could have but a few years to enjoy it. It is difficult to be more detached from life than I am at present.

To conclude historically with my own character. I am, or rather was (for that is the style I must now use in speaking of myself, which emboldens me the more to speak my sentiments); I was, I say, a man of mild dispositions, of command of temper, of an open, social, and cheerful humour, capable of attachment, but little susceptible of enmity, and of great moderation in all my passions. Even my love of literary fame, my ruling passion, never soured my temper, notwithstanding my frequent disappointments. My company was not unacceptable to the young and careless, as well as to the studious and literary; and as I took a particular pleasure in the company of modest women. I had no reason to be displeased with the reception I met with from them. In a word, though most men any wise eminent, have found reason to complain of calumny. I never was touched, or even attacked by her baleful tooth: and though I wantonly exposed myself to the rage of both civil and religious factions, they seemed to be disarmed in my behalf of their wonted fury. My friends never had occasion to vindicate any one circumstance of my character and conduct: not but that the zealots, we may well suppose, would have been glad to invent and propagate any story to my disadvantage, but they could never find any which

they thought would wear the face of probability. I cannot say there is no vanity in making this funeral oration of myself, but I hope it is not a misplaced one; and this is a matter of fact which is easily cleared and ascertained.

April 18, 1776.

Three Letters from David Hume

To Gilbert Elliot of Minto

[March or April 1751]

Dear Sir

I am sorry your keeping these Papers¹ has proceeded from Business & Avocations, & not from your Endeavours to clear up so difficult an Argument. I despair not, however, of getting some Assistance from you; the Subject is surely of the greatest Importance; and the Views of it so new as to challenge some Attention.

I believe the philosophical Essays² contain every thing of Consequence relating to the Understanding, which you woud meet with in the Treatise; & I give you my Advice against reading the latter. By shortening & simplifying the Questions, I really render them much more complete. Addo dum minuo.³ The philosophical Principles are the same in both: But I was carry'd away by the Heat of Youth & Invention to publish too precipitately. So vast an Undertaking, plan'd before I was one and twenty, & compos'd before twenty five, must necessarily be very defective. I have repented my Haste a hundred, & a hundred times.

I return Strabo,⁴ whom I have found very judicious & useful. I give you a great many Thanks for your Trouble.

I am Dear Sir Yours Da. HUME.

¹ They constituted the manuscript of a first draft of what were published only posthumously, Hume's *Dialogues concerning Natural Religion*.

² The reference to "the philosophical Essays" is to what we now call Hume's first *Enquiry*. Originally published as *Philosophical Essays concerning Human Understanding* Hume later retitled it *An Enquiry concerning Human Understanding*.

³ A Latin proverb which means "I add [to the substance] while shortening [the size]".

⁴ Strabo was a Roman writer on geography.

To Benjamin Franklin

Edinburgh, 10 May, 1762.

Dear Sir,

I have a great many thanks to give you for your goodness in remembering my request, and for the exact description, which you sent me of your method of preserving houses from thunder. I communicated it to our Philosophical Society, as you gave me permission; and they desire me to tell you, that they claim it as their own, and intend to enrich with it the first collection which they may publish. The established rule of our Society is, that after a paper is read to them, it is delivered by them to some member, who is obliged, in a subsequent meeting, to read some paper of remarks upon it.

It was communicated to our friend, Mr Russell; who is not very expeditious in finishing any undertaking; and he did not read his remarks, till the last week, which is the reason, why I have been so late in acknowledging your favour. Mr Russell's remarks, besides the just praises of your invention, contained only two proposals for improving it. One was, that in houses, where the rain water is carried off the roof by a lead pipe, this metallic body might be employed as a conductor to the electric fire, and save the expense of a new apparatus. Another was, that the wire might be carried down to the foundations of the house, and be thence conveyed below ground to the requisite distance, which would better secure it against accidents. I thought it proper to convey to you these two ideas of so ingenious a man, that you might adopt them, if they appear to you well founded.

I am very sorry, that you intend soon to leave our hemisphere. America has sent us many good things, gold, silver, sugar, tobacco, indigo, etc.; but you are the first philosopher, and indeed the first great man of letters, for whom we are beholden to her. It is our own fault, that we have not kept him; whence it appears, that we do not agree with Solomon, that wisdom is above gold; for we take care never to send back an ounce of the latter, which we once lay our fingers upon.

I saw yesterday our friend Sir Alexander Dick, who desired

me to present his compliments to you. We are all very unwilling to think of your settling in America, and that there is some chance for our never seeing you again; but no one regrets it more than does,

 $\begin{array}{c} \textbf{Dear Sir, Your most affectionate humble Servant,} \\ \textbf{David Hume.} \end{array}$

To the Reverend George Campbell¹

7 June, 1762.

Dear Sir,

It has so seldom happened that controversies in philosophy, much more in theology, have been carried on without producing a personal quarrel between the parties, that I must regard my present situation as somewhat extraordinary, who have reason to give you thanks for the civil and obliging manner in which you have conducted the dispute against me, on so interesting a subject as that of miracles. Any little symptoms of vehemence, of which I formerly used the freedom to complain, when you favoured me with a sight of the manuscript, are either removed or explained away, or atoned for by civilities, which are far beyond what I have any title to pretend to. It will be natural for you to imagine, that I will fall upon some shift to evade the force of your arguments, and to retain my former opinion in the point controverted between us; but it is impossible for me not to see the ingenuity of your performance, and the great learning which you have displayed against me.

I consider myself as very much honoured in being thought worthy of an answer by a person of so much merit; and as I find that the public does you justice with regard to the ingenuity and good composition of your piece, I hope you will have no reason to repent engaging with an antagonist, whom, perhaps in strictness, you might have ventured to neglect. I own to you, that I never felt so violent an inclination to defend myself as at present, when I am thus fairly challenged by you, and I think I could find something specious at least to urge in my defence; but as I had fixed a resolution, in the beginning of my life, always to leave the public to judge between my adversaries and me, without making

 $^{^1}$ George Campbell (1719–96), Principal of Marischal College, Aberdeen and later a Professor of Divinity therein had earlier in 1762 published a *Dissertation on Miracles*.

any reply. I must adhere inviolably to this resolution, otherways my silence on any future occasion would be construed an inability to answer, and would be matter of triumph against me.

It may perhaps amuse you to learn the first hint, which suggested to me that argument which you have so strenuously attacked. I was walking in the cloisters of the Jesuits' College of La Flèche, a town in which I passed two years of my youth, and engaged in a conversation with a Jesuit of some parts and learning, who was relating to me, and urging some nonsensical miracle performed in their convent, when I was tempted to dispute against him; and as my head was full of the topics of my Treatise of Human Nature, which I was at that time composing. this argument immediately occurred to me, and I thought it very much gravelled² my companion; but at last he observed to me, that it was impossible for that argument to have any solidity, because it operated equally against the Gospel as the Catholic miracles:—which observation I thought proper to admit as a sufficient answer. I believe you will allow, that the freedom at least of this reasoning makes it somewhat extraordinary to have been the produce of a convent of Jesuits, the perhaps you may think the sophistry of it savours plainly of the place of its birth.

Yours sincerely
DAVID HUME.

² "Gravelled" = 'perplexed'.

Letter from Adam Smith, LL.D. to William Strahan, Esq.

Letter from Adam Smith, LL.D. to William Strahan, Esq.

Kirkcaldy, Fifeshire, Nov. 9, 1776.

Dear Sir,

It is with a real, though a very melancholy pleasure, that I sit down to give you some account of the behaviour of our late excellent friend, Mr. Hume, during his last illness.

Though, in his own judgment, his disease was mortal and incurable, yet he allowed himself to be prevailed upon, by the entreaty of his friends, to try what might be the effects of a long journey. A few days before he set out, he wrote that account of his own life, which, together with his other papers, he has left to your care. My account, therefore, shall begin where his ends.

He set out for London towards the end of April, and at Morpeth met with Mr. John Home and myself, who had both come down from London on purpose to see him, expecting to have found him at Edinburgh. Mr. Home returned with him, and attended him during the whole of his stay in England, with that care and attention which might be expected from a temper so perfectly friendly and affectionate. As I had written to my mother that she might expect me in Scotland, I was under the necessity of continuing my journey. His disease seemed to yield to exercise and change of air, and when he arrived in London, he was apparently in much better health than when he left Edinburgh. He was advised to go to Bath to drink the waters, which appeared for some time to have so good an effect upon him. that even he himself began to entertain, what he was not apt to do, a better opinion of his own health. His symptoms, however, soon returned with their usual violence, and from that moment he gave up all thoughts of recovery, but submitted with the utmost cheerfulness, and the most perfect complacency and resignation. Upon his return to Edinburgh, though he found himself much weaker, yet his cheerfulness never abated, and he continued to divert himself, as usual, with correcting his own works for a new edition, with reading books of amusement, with

the conversation of his friends; and, sometimes in the evening. with a party at his favourite game of whist. His cheerfulness was so great, and his conversation and amusements run so much in their usual strain, that, notwithstanding all bad symptoms. many people could not believe he was dving. "I shall tell your friend, Colonel Edmondstone," said Doctor Dundas to him one day, "that I left you much better, and in a fair way of recovery." "Doctor," said he, "as I believe you would not chuse to tell any thing but the truth, you had better tell him, that I am dving as fast as my enemies, if I have any, could wish, and as easily and cheerfully as my best friends could desire." Colonel Edmondstone soon afterwards came to see him, and take leave of him: and on his way home, he could not forbear writing him a letter bidding him once more an eternal adieu, and applying to him, as to a dving man, the beautiful French verses in which the Abbé Chaulieu, in expectation of his own death, laments his approaching separation from his friend, the Marquis de la Fare, Mr. Hume's magnanimity and firmness were such, that his most affectionate friends knew, that they hazarded nothing in talking or writing to him as to a dving man, and that so far from being hurt by this frankness, he was rather pleased and flattered by it. I happened to come into his room while he was reading this letter, which he had just received, and which he immediately showed me. I told him, that though I was sensible how very much he was weakened, and that appearances were in many respects very bad, yet his cheerfulness was still so great, the spirit of life seemed still to be so very strong in him, that I could not help entertaining some faint hopes. He answered, "Your hopes are groundless. An habitual diarrhoea of more than a year's standing, would be a very bad disease at any age: at my age it is a mortal one. When I lie down in the evening, I feel myself weaker than when I rose in the morning; and when I rise in the morning. weaker than when I lav down in the evening. I am sensible. besides, that some of my vital parts are affected, so that I must soon die." "Well." said I, "if it must be so, you have at least the satisfaction of leaving all your friends, your brother's family in particular, in great prosperity." He said that he felt that satisfaction so sensibly, that when he was reading a few days before, Lucian's Dialogues of the Dead, among all the excuses which are alleged to Charon for not entering readily into his boat, he could not find one that fitted him; he had no house to finish, he had no daughter to provide for, he had no enemies

upon whom he wished to revenge himself. "I could not well imagine," said he, "what excuse I could make to Charon in order to obtain a little delay. I have done every thing of consequence which I ever meant to do, and I could at no time expect to leave my relations and friends in a better situation than that in which I am now likely to leave them: I, therefore, have all reason to die contented." He then diverted himself with inventing several jocular excuses, which he supposed he might make to Charon. and with imagining the very surly answers which it might suit the character of Charon to return to them. "Upon further consideration," said he, "I thought I might say to him, 'Good Charon, I have been correcting my works for a new edition. Allow me a little time, that I may see how the Public receives the alterations.' But Charon would answer, 'When you have seen the effect of these, you will be for making other alterations. There will be no end of such excuses; so, honest friend, please step into the boat.' But I might still urge, 'Have a little patience, good Charon, I have been endeavouring to open the eyes of the Public. If I live a few years longer, I may have the satisfaction of seeing the downfall of some of the prevailing systems of superstition.' But Charon would then lose all temper and decency. You loitering rogue, that will not happen these many hundred years. Do you fancy I will grant you a lease for so long a term? Get into the boat this instant, you lazy loitering rogue."

But, though Mr. Hume always talked of his approaching dissolution with great cheerfulness, he never affected to make any parade of his magnanimity. He never mentioned the subject but when the conversation naturally led to it, and never dwelt longer upon it than the course of the conversation happened to require: it was a subject indeed which occurred pretty frequently, in consequence of the inquiries which his friends, who came to see him, naturally made concerning the state of his health. The conversation which I mentioned above, and which passed on Thursday the 8th of August, was the last, except one. that I ever had with him. He had now become so very weak, that the company of his most intimate friends fatigued him; for his cheerfulness was still so great, his complaisance and social disposition were still so entire, that when any friend was with him, he could not help talking more, and with greater exertion. than suited the weakness of his body. At his own desire, therefore, I agreed to leave Edinburgh, where I was staying partly upon his account, and returned to my mother's house

here, at Kirkaldy, upon condition that he would send for me whenever he wished to see me; the physician who saw him most frequently, Doctor Black, undertaking, in the mean time, to write me occasionally an account of the state of his health.

On the 22nd of August, the Doctor wrote me the following letter:

"Since my last, Mr. Hume has passed his time pretty easily, but is much weaker. He sits up, goes down stairs once a day, and amuses himself with reading, but seldom sees any body. He finds that even the conversation of his most intimate friends fatigues and oppresses him; and it is happy that he does not need it, for he is quite free from anxiety, impatience, or low spirits, and passes his time very well with the assistance of amusing books."

I received the day after a letter from Mr. Hume himself, of which the following is an extract.

Edinburgh, 23rd August, 1776.

"My Dearest Friend,

"I am obliged to make use of my nephew's hand in writing to you, as I do not rise to-day. . . .

"I go very fast to decline, and last night had a small fever, which I hoped might put a quicker period to this tedious illness, but unluckily it has, in a great measure, gone off. I cannot submit to your coming over here on my account, as it is possible for me to see you so small a part of the day, but Doctor Black can better inform you concerning the degree of strength which may from time to time remain with me.

Adieu, &c."

Three days after I received the following letter from Doctor Black.

Edinburgh, Monday, 26th August, 1776.

"Dear Sir,

"Yesterday about four o'clock afternoon, Mr. Hume expired. The near approach of his death became evident in the night between Thursday and Friday, when his disease became excessive, and soon weakened him so much, that he could no longer rise out of his bed. He continued to the last perfectly sensible, and free from much pain or feelings of distress. He never dropped the smallest expression of impatience; but when he had

occasion to speak to the people about him, always did it with affection and tenderness. I thought it improper to write to bring you over, especially as I heard that he had dictated a letter to you desiring you not to come. When he became very weak, it cost him an effort to speak, and he died in such a happy composure of mind, that nothing could exceed it."

Thus died our most excellent, and never to be forgotten friend: concerning whose philosophical opinions men will, no doubt, judge variously, every one approving, or condemning them, according as they happen to coincide or disagree with his own: but concerning whose character and conduct there can scarce be a difference of opinion. His temper, indeed, seemed to be more happily balanced, if I may be allowed such an expression, than that perhaps of any other man I have ever known. Even in the lowest state of his fortune, his great and necessary frugality never hindered him from exercising, upon proper occasions, acts both of charity and generosity. It was a frugality founded, not upon avarice, but upon the love of independency. The extreme gentleness of his nature never weakened either the firmness of his mind, or the steadiness of his resolutions. His constant pleasantry was the genuine effusion of good-nature and good-humour, tempered with delicacy and modesty, and without even the slightest tincture of malignity, so frequently the disagreeable source of what is called wit in other men. It never was the meaning of his raillery to mortify; and therefore, far from offending, it seldom failed to please and delight, even those who were the objects of it. To his friends, who were frequently the objects of it, there was not perhaps any one of all his great and amiable qualities, which contributed more to endear his conversation. And that gaiety of temper, so agreeable in society, but which is so often accompanied with frivolous and superficial qualities, was in him certainly attended with the most severe application, the most extensive learning, the greatest depth of thought, and a capacity in every respect the most comprehensive. Upon the whole, I have always considered him, both in his lifetime and since his death, as approaching as nearly to the idea of a perfectly wise and virtuous man, as perhaps the nature of human frailty will permit.

> I ever am, dear Sir, Most affectionately your's, ADAM SMITH.

An Abstract of A Treatise of Human Nature

An Abstract of A Treatise of Human Nature

This book seems to be written upon the same plan with several other works that have had a great vogue of late years in England. The philosophical spirit, which has been so much improved all over Europe within these last fourscore years, has been carried to as great a length in this kingdom as in any other. Our writers seem even to have started a new kind of philosophy, which promises more, both to the entertainment and advantage of mankind, than any other with which the world has been yet acquainted. Most of the philosophers of antiquity who treated of human nature have shown more of a delicacy of sentiment, a just sense of morals, or a greatness of soul, than a depth of reasoning and reflection. They content themselves with representing the common sense of mankind in the strongest lights, and with the best turn of thought and expression, without following out steadily a chain of propositions, or forming the several truths into a regular science. But it is at least worth while to try if the science of man will not admit of the same accuracy, which several parts of natural philosophy are found susceptible of. There seems to be all the reason in the world to imagine that it may be carried to the greatest degree of exactness. If, in examining several phenomena, we find that they resolve themselves into one common principle, and can trace this principle into another. we shall at last arrive at those few simple principles on which all the rest depend. And though we can never arrive at the ultimate principles, it is a satisfaction to go as far as our faculties will allow us.

This seems to have been the aim of our late philosophers, and, among the rest, of this author. He proposes to anatomize human nature in a regular manner, and promises to draw no conclusions but where he is authorized by experience. He talks

¹ A Treatise of Human Nature was published anonymously in 1739. It was at first greeted with incomprehension and derision, but mostly silence. In an attempt to stimulate more interest in the work, Hume wrote the Abstract, also anonymous, which appeared in 1740.

with contempt of hypotheses; and insinuates that such of our countrymen as have banished them from moral philosophy, have done a more signal service to the world than my Lord Bacon, whom he considers as the father of experimental physics. He mentions, on this occasion, Mr. Locke, my Lord Shaftesbury, Dr. Mandeville, Mr. Hutcheson, Dr. Butler, who, though they differ in many points among themselves, seem all to agree in founding their accurate disquisitions of human nature entirely upon experience.²

Beside the satisfaction of being acquainted with what most nearly concerns us, it may be safely affirmed that almost all the sciences are comprehended in the science of human nature, and are dependent on it. The sole end of logic is to explain the principles and operations of our reasoning faculty, and the nature of our ideas; morals and criticism regard our tastes and sentiments; and politics consider men as united in society, and dependent on each other. This treatise, therefore, of human nature seems intended for a system of the sciences. The author has finished what regards logic, and has laid the foundation of the other parts in his account of the passions.

The celebrated Monsieur Leibnitz³ has observed it to be a defect in the common systems of logic that they are very copious

² Lord Bacon was Francis Bacon, first Lord Verulam (1561–1626), author of Essays, The Advancement of Learning, Novum Organum, and New Atlantis. John Locke (1632–1704) is best known for An (not 'The') Essay (not 'on' but) concerning Human Understanding and Two Treatises of Civil Government. The second of these is one of the key documents of classical liberalism, becoming a major influence upon the founding fathers of the American republic. Locke also tutored the future third Earl of Shaftesbury (1671-1713), whose main work was Characteristics of Men, Manners, Opinions, Times. Bernard de Mandeville (1670–1733) wrote a mischievous, notorious, but also serious work, The Fable of the Bees, a landmark in the development of the conception of the social sciences as primarily the study of the unintended consequences of intended action. The main work of Francis Hutcheson (1694-1746), a personal friend of Hume, was An Inquiry into the original of Our Ideas of Beauty and Virtue. Joseph Butler (1692–1752), who died as Bishop of Durham, is famous for Fifteen Sermons, on topics of moral philosophy, and for An Analogy of Religion. Hume had planned to solicit Butler's opinion of the Treatise, but abandoned this project on hearing of Butler's first elevation to the bench of bishops.

³ Gottfried Wilhelm Leibniz (1646–1716)—this spelling is now standard—was one of the great philosophical rationalists. During his lifetime he published only two books: *Theodicy*; and *New Essays on the Human Understanding*, a critique of Locke's *Essay*.

when they explain the operations of the understanding in the forming of demonstrations, but are too concise when they treat of probabilities, and those other measures of evidence on which life and action entirely depend, and which are our guides even in most of our philosophical speculations. In this censure he comprehends *The Essay on Human Understanding, Le Recherche de la Verité*, and *L'Art de Penser*. The author of the *Treatise of Human Nature* seems to have been sensible of this defect in these philosophers, and has endeavoured, as much as he can, to supply it. As his book contains a great number of speculations very new and remarkable, it will be impossible to give the reader a just notion of the whole. We shall, therefore, chiefly confine ourselves to his explication of our reasonings from cause and effect. If we can make this intelligible to the reader, it may serve as a specimen of the whole.

Our author begins with some definitions. He calls a perception whatever can be present to the mind, whether we employ our senses, or are actuated with passion, or exercise our thought and reflection. He divides our perceptions into two kinds, viz. impressions and ideas. When we feel a passion or emotion of any kind, or have the images of external objects conveyed by our senses, the perception of the mind is what he calls an impression, which is a word that he employs in a new sense. When we reflect on a passion or an object which is not present, this perception is an idea. Impressions, therefore, are our lively and strong perceptions; ideas are the fainter and weaker. This distinction is evident; as evident as that betwixt feeling and thinking.

The first proposition he advances is that all our ideas, or weak perceptions, are derived from our impressions, or strong perceptions, and that we can never think of anything which we have not seen without us, or felt in our own minds. This

⁴ De la Recherche de la Vérité [On The Search for Truth] is by the Oratorian Father Nicolas Malebranche (1638–1715). It develops what came to be called the Occasionalist view of the relations between mind and body, conceived as, respectively, consciousness and stuff. Occasionalists held that conscious events could not be caused by material events, but that the occurrence of certain of the latter was sometimes the occasion for God to cause certain of the former. La logique, ou l'art de penser, more usually known nowadays as the Port-Royal Logic, is credited to Antoine Arnauld (1612–94) and Pierre Nicole (1625–95), although Blaise Pascal (1623–62) also appears to have had some hand in the composition.

proposition seems to be equivalent to that which Mr. Locke has taken such pains to establish, viz. that no ideas are innate. Only it may be observed, as an inaccuracy of that famous philosopher. that he comprehends all our perceptions under the term of idea. in which sense it is false that we have no innate ideas. For it is evident our stronger perceptions or impressions are innate, and that natural affection, love of virtue, resentment, and all the other passions, arise immediately from nature. I am persuaded whoever would take the question in this light, would be easily able to reconcile all parties. Father Malebranche would find himself at a loss to point out any thought of the mind which did not represent something antecedently felt by it, either internally, or by means of the external senses, and must allow that however we may compound, and mix, and augment, and diminish our ideas, they are all derived from these sources. Mr. Locke. on the other hand, would readily acknowledge that all our passions are a kind of natural instincts, derived from nothing but the original constitution of the human mind.

Our author thinks, 'that no discovery could have been made more happily for deciding all controversies concerning ideas than this, that impressions always take the precedency of them, and that every idea with which the imagination is furnished first makes its appearance in a correspondent impression. These latter perceptions are all so clear and evident that they admit of no controversy; though many of our ideas are so obscure that it is almost impossible, even for the mind which forms them, to tell exactly their nature and composition.' Accordingly, wherever any idea is ambiguous, he has always recourse to the impression, which must render it clear and precise. And when he suspects that any philosophical term has no idea annexed to it (as is too common) he always asks from what impression that idea is derived? And if no impression can be produced, he concludes that the term is altogether insignificant. It is after this manner he examines our idea of substance and essence; and it were to be wished that this rigorous method were more practised in all philosophical debates.

It is evident that all reasonings concerning *matter of fact* are founded on the relation of cause and effect, and that we can never infer the existence of one object from another, unless they be connected together, either mediately or immediately. In order, therefore, to understand these reasonings, we must be perfectly

acquainted with the idea of a cause; and in order to that, must look about us to find something that is the cause of another.

Here is a billiard ball lying on the table, and another ball moving towards it with rapidity. They strike; and the ball which was formerly at rest now acquires a motion. This is as perfect an instance of the relation of cause and effect as any which we know. either by sensation or reflection. Let us therefore examine it. It is evident that the two balls touched one another before the motion was communicated, and that there was no interval betwixt the shock and the motion. Contiguity in time and place is therefore a requisite circumstance to the operation of all causes. It is evident, likewise, that the motion which was the cause is prior to the motion which was the effect. Priority in time is therefore another requisite circumstance in every cause. But this is not all. Let us try any other balls of the same kind in a like situation, and we shall always find that the impulse of the one produces motion in the other. Here, therefore, is a third circumstance, viz. that of a constant conjunction betwixt the cause and effect. Every object like the cause produces always some object like the effect. Beyond these three circumstances of contiguity, priority, and constant conjunction, I can discover nothing in this cause. The first ball is in motion; touches the second; immediately the second is in motion: and when I try the experiment with the same or like balls, in the same or like circumstances. I find that upon the motion and touch of the one ball, motion always follows in the other. In whatever shape I turn this matter, and however I examine it, I can find nothing farther.

This is the case when both the cause and effect are present to the senses. Let us now see upon what our inference is founded, when we conclude from the one that the other has existed or will exist. Suppose I see a ball moving in a straight line towards another, I immediately conclude that they will shock and that the second will be in motion. This is the inference from cause to effect, and of this nature are all our reasonings in the conduct of life: on this is founded all our belief in history; and from hence is derived all philosophy, excepting only geometry and arithmetic. If we can explain the inference from the shock of two balls, we shall be able to account for this operation of the mind in all instances.

Were a man, such as Adam, created in the full vigour of understanding, without experience, he would never be able to infer motion in the second ball from the motion and impulse of the first. It is not anything that reason sees in the cause which makes us *infer* the effect. Such an inference, were it possible, would amount to a demonstration, as being founded merely on the comparison of ideas. But no inference from cause to effect amounts to a demonstration, of which there is this evident proof. The mind can always *conceive* any effect to follow from any cause, and indeed any event to follow upon another: whatever we *conceive* is possible, at least in a metaphysical sense; but wherever a demonstration takes place, the contrary is impossible, and implies a contradiction. There is no demonstration, therefore, for any conjunction of cause and effect. And this is a principle which is generally allowed by philosophers.

It would have been necessary, therefore, for Adam (if he was not inspired) to have had *experience* of the effect which followed upon the impulse of these two balls. He must have seen, in several instances, that when the one ball struck upon the other, the second always acquired motion. If he had seen a sufficient number of instances of this kind, whenever he saw the one ball moving towards the other, he would always conclude without hesitation that the second would acquire motion. His understanding would anticipate his sight and form a conclusion suitable to his past experience.

It follows, then, that all reasonings concerning cause and effect are founded on experience, and that all reasonings from experience are founded on the supposition that the course of nature will continue uniformly the same. We conclude that like causes, in like circumstances, will always produce like effects. It may now be worth while to consider what determines us to form a conclusion of such infinite consequence.

It is evident that Adam, with all his science, would never have been able to *demonstrate* that the course of nature must continue uniformly the same, and that the future must be conformable to the past. What is possible can never be demonstrated to be false; and it is possible the course of nature may change, since we can conceive such a change. Nay, I will go farther, and assert that he could not so much as prove by any *probable* arguments that the future must be conformable to the past. All probable arguments are built on the supposition that there is this conformity betwixt the future and the past, and therefore can never prove it. This conformity is a *matter of fact*, and, if it must be proved, will admit of no proof but from experience. But our experience in the past can be a proof of nothing for the future, but upon a supposition that there is a

resemblance betwixt them. This, therefore, is a point which can admit of no proof at all, and which we take for granted without any proof.

We are determined by *custom* alone to suppose the future conformable to the past. When I see a billiard ball moving towards another, my mind is immediately carried by habit to the usual effect, and anticipates my sight by conceiving the second ball in motion. There is nothing in these objects, abstractly considered, and independent of experience, which leads me to form any such conclusion; and even after I have had experience of many repeated effects of this kind, there is no argument which determines me to suppose that the effect will be conformable to past experience. The powers by which bodies operate are entirely unknown. We perceive only their sensible qualities: and what *reason* have we to think that the same powers will always be conjoined with the same sensible qualities?

It is not, therefore, reason which is the guide of life, but custom. That alone determines the mind, in all instances, to suppose the future conformable to the past. However easy this step may seem, reason would never, to all eternity, be able to make it.

This is a very curious discovery, but leads us to others that are still more curious. When I see a billard ball moving towards another, my mind is immediately carried by habit to the usual effect, and anticipates my sight by conceiving the second ball in motion. But is this all? Do I nothing but conceive the motion of the second ball? No, surely. I also believe that it will move. What then is this belief? And how does it differ from the simple conception of anything? Here is a new question unthought of by philosophers.

When a demonstration convinces me of any proposition, it not only makes me conceive the proposition, but also makes me sensible that it is impossible to conceive anything contrary. What is demonstratively false implies a contradiction; and what implies a contradiction cannot be conceived. But with regard to any matter of fact, however strong the proof may be from experience, I can always conceive the contrary, though I cannot always believe it.⁵ The belief, therefore, makes some difference

⁵ In a Section of the *Treatise* which had no successor in either the first *Enquiry* or in any of Hume's other later writings he applies these principles to "a general maxim in philosophy, that *whatever begins to exist must have a cause of existence.*" This section is reprinted below.

betwixt the conception to which we assent, and that to which we do not assent.

To account for this, there are only two hypotheses. It may be said that belief joins some new idea to those which we may conceive without assenting to them. But this hypothesis is false. For *first*, no such idea can be produced. When we simply conceive an object, we conceive it in all its parts. We conceive it as it might exist, though we do not believe it to exist. Our belief of it would discover no new qualities. We may paint out the entire object in imagination without believing it. We may set it, in a manner, before our eyes, with every circumstance of time and place. It is the very object conceived as it might exist; and when we believe it, we can do no more.

Secondly, the mind has a faculty of joining all ideas together, which involve not a contradiction; and therefore, if belief consisted in some idea, which we add to the simple conception, it would be in a man's power, by adding this idea to it, to believe anything which he can conceive.

Since, therefore, belief implies a conception, and yet is something more; and since it adds no new idea to the conception; it follows that it is a different manner of conceiving an object something that is distinguishable to the feeling, and depends not upon our will, as all our ideas do. My mind runs by habit from the visible object of one ball moving towards another, to the usual effect of motion in the second ball. It not only conceives that motion, but feels something different in the conception of it from a mere reverie of the imagination. The presence of this visible object, and the constant conjunction of that particular effect, render the idea different to the feeling from those loose ideas which come into the mind without any introduction. This conclusion seems a little surprising; but we are led into it by a chain of propositions which admit of no doubt. To ease the reader's memory I shall briefly resume them. No matter of fact can be proved but from its cause or its effect. Nothing can be known to be the cause of another but by experience. We can give no reason for extending to the future our experience in the past. but are entirely determined by custom when we conceive an effect to follow from its usual cause. But we also believe an effect to follow, as well as conceive it. This belief joins no new idea to the conception. It only varies the manner of conceiving, and makes a difference to the feeling or sentiment. Belief, therefore, in all matters of fact arises only from custom, and is an idea conceived in a peculiar manner.

Our author proceeds to explain the manner or feeling, which renders belief different from a loose conception. He seems sensible that it is impossible by words to describe this feeling, which everyone must be conscious of in his own breast. He calls it sometimes a *stronger* conception, sometimes a more *lively*, a more *vivid*, a *firmer*, or a more *intense* conception. And, indeed, whatever name we may give to this feeling which constitutes belief, our author thinks it evident that it has a more forcible effect on the mind than fiction and mere conception. This he proves by its influence on the passions and on the imagination, which are only moved by truth, or what is taken for such. Poetry, with all its art, can never cause a passion like one in real life. It fails in the original conception of its objects, which never *feel* in the same manner as those which command our belief and opinion.

Our author, presuming that he had sufficiently proved that the ideas we assent to are different to the feeling from the other ideas, and that this feeling is more firm and lively than our common conception, endeavours in the next place to explain the cause of this lively feeling by an analogy with other acts of the mind. His reasoning seems to be curious; but could scarce be rendered intelligible, or at least probable to the reader, without a long detail, which would exceed the compass I have prescribed to myself.

I have likewise omitted many arguments which he adduces to prove that belief consists merely in a peculiar feeling or sentiment. I shall only mention one; our past experience is not always uniform. Sometimes one effect follows from a cause, sometimes another: in which case we always believe that that will exist which is most common. I see a billiard ball moving towards another. I cannot distinguish whether it moves upon its axis, or was struck so as to skim along the table. In the first case, I know it will not stop after the shock. In the second it may stop. The first is most common, and therefore I lay my account with that effect. But I also conceive the other effect, and conceive it as possible, and as connected with the cause. Were not the one conception different in the feeling or sentiment from the other, there would be no difference betwixt them.

We have confined ourselves in this whole reasoning to the relation of cause and effect, as discovered in the motions and operations of matter. But the same reasoning extends to the operations of the mind. Whether we consider the influence of the will in moving our body, or in governing our thought, it may

safely be affirmed that we could never foretell the effect, merely from the consideration of the cause, without experience. And even after we have experience of these effects, it is custom alone, not reason, which determines us to make it the standard of our future judgments. When the cause is presented, the mind, from habit, immediately passes to the conception and belief of the usual effect. This belief is something different from the conception. It does not, however, join any new idea to it. It only makes it be felt differently, and renders it stronger and more lively.

Having dispatched this material point concerning the nature of the inference from cause and effect, our author returns upon his footsteps, and examines anew the idea of that relation. In the considering of motion communicated from one ball to another, we could find nothing but contiguity, priority in the cause, and constant conjunction. But, beside these circumstances, it is commonly supposed that there is a necessary connexion betwixt the cause and effect, and that the cause possesses something, which we call a *power*, or *force*, or *energy*. The question is, what idea is annexed to these terms? If all our ideas or thoughts be derived from our impressions, this power must either discover itself to our senses, or to our internal feeling. But so little does any power discover itself to the senses in the operations of matter, that the Cartesians⁶ have made no scruple to assert that matter is utterly deprived of energy, and that all its operations are performed merely by the energy of the supreme Being. But the question still recurs, what idea have we of energy or power even in the supreme Being? All our idea of a Deity (according to those who deny innate ideas) is nothing but a composition of those ideas which we acquire from reflecting on the operations of our minds. Now our own minds afford us no more notion of energy than matter does. When we consider our will or volition a priori, abstracting from experience, we should never be able to infer any effect from it. And when we take the assistance of experience, it only shows us objects contiguous, successive, and constantly conjoined. Upon the whole, then, either we have no idea at all of force and energy, and these words are altogether insignificant, or they can mean nothing but that determination of the thought, acquired by habit, to pass from the cause to its usual effect. But whoever would thoroughly

⁶ Cartesians are followers of René Descartes (1591–1650).

 $^{^7}$ Hume takes a seemingly stronger position in the *Abstract* than in the *Enquiry*. He here denies that the idea of a force or power in objects has mean-

understand this must consult the author himself. It is sufficient if I can make the learned world apprehend that there is some difficulty in the case, and that whoever solves the difficulty must say something very new and extraordinary—as new as the difficulty itself.

By all that has been said the reader will easily perceive that the philosophy contained in this book is very sceptical, and tends to give us a notion of the imperfections and narrow limits of human understanding. Almost all reasoning is there reduced to experience; and the belief, which attends experience, is explained to be nothing but a peculiar sentiment, or lively conception produced by habit. Nor is this all; when we believe anything of *external* existence, or suppose an object to exist a moment after it is no longer perceived, this belief is nothing but a sentiment of the same kind. Our author insists upon several other sceptical topics; and upon the whole concludes that we assent to our faculties, and employ our reason, only because we cannot help it. Philosophy would render us entirely Pyrrhonian, were not nature too strong for it.⁸

I shall conclude the logics of this author with an account of two opinions, which seem to be peculiar to himself, as indeed are most of his opinions. He asserts that the soul, as far as we can conceive it, is nothing but a system or train of different perceptions, those of heat and cold, love and anger, thoughts and sensations, all united together, but without any perfect simplicity or identity. Descartes maintained that thought was the essence of the mind; not this thought or that thought, but thought in general. This seems to be absolutely unintelligible, since everything that exists is particular; and, therefore, it must be our several particular perceptions that compose the mind. I say, compose the mind, not belong to it. The mind is not a substance, in which the perceptions inhere. That notion is as unintelligible as the Cartesian, that thought or perception in general is the essence of the mind. We have no idea of substance

ing: in the Enquiry he denies only that we have any idea of what such force of

power consists of.

CONTINUED FROM PAGE 38

⁸ Pyrrho of Elis (c. 365–c. 275 BCE), generally regarded as the first systematic Sceptic, wrote nothing. In his own day his views were propagated by his younger disciple Timon of Phlius (c. 320–230 BCE). But the very considerable influence of Pyrrhonism in modern times dates from the publication in 1569, in a Latin translation, of the complete works of Sextus Empiricus (second century CE).

of any kind, since we have no idea but what is derived from some impression, and we have no impression of any substance either material or spiritual. We know nothing but particular qualities and perceptions. As our idea of any body, a peach, for instance, is only that of a particular taste, colour, figure, size, consistence, etc.; so our idea of any mind is only that of particular perceptions, without the notion of anything we call substance, either simple or compound.

The second principle, which I proposed to take notice of, is with regard to geometry. Having denied the infinite divisibility of extension, our author finds himself obliged to refute those mathematical arguments which have been adduced for it: and these indeed are the only ones of any weight. This he does by denying geometry to be a science exact enough to admit of conclusions so subtle as those which regard infinite divisibility. His arguments may be thus explained. All geometry is founded on the notions of equality and inequality, and, therefore, according as we have or have not an exact standard of that relation, the science itself will or will not admit of great exactness. Now there is an exact standard of equality, if we suppose that quantity is composed of indivisible points. Two lines are equal when the numbers of the points that compose them are equal, and when there is a point in one corresponding to a point in the other. But though this standard be exact, it is useless; since we can never compute the number of points in any line. It is besides founded on the supposition of finite divisibility, and therefore can never afford any conclusion against it. If we reject this standard of equality, we have none that has any pretensions to exactness. I find two that are commonly made use of. Two lines above a yard, for instance, are said to be equal when they contain any inferior quantity, as an inch, an equal number of times. But this runs in a circle. For the quantity we call an inch in the one is supposed to be *equal* to what we call an inch in the other: and the question still is, by what standard we proceed when we judge them to be equal; or, in other words, what we mean when we say they are equal. If we take still inferior quantities, we go on in infinitum. This therefore is no standard of equality. The greatest part of philosophers, when asked what they mean by equality, say that the word admits of no definition.

⁹ Hume's argument is that there is no exact measure of equality for two instances of what would now be called a non-denumerable infinite. His sug-

and that it is sufficient to place before us two equal bodies, such as two diameters of a circle, to make us understand that term. Now this is taking the *general appearance* of the objects for the standard of that proportion, and renders our imagination and senses the ultimate judges of it. But such a standard admits of no exactness, and can never afford any conclusion contrary to the imagination and senses. Whether this question be just or not must be left to the learned world to judge. It were certainly to be wished that some expedient were fallen upon to reconcile philosophy and common sense, which, with regard to the question of infinite divisibility, have waged most cruel wars with each other.

We must now proceed to give some account of the second volume of this work, which treats of the passions. It is of more easy comprehension than the first, but contains opinions that are together as new and extraordinary. The author begins with pride and humility. He observes that the objects which excite these passions are very numerous, and seemingly very different from each other. Pride or self-esteem may arise from the qualities of the mind-wit, good-sense, learning, courage, integrity; from those of the body—beauty, strength, agility, good mien, address in dancing, riding, fencing; from external advantages-country, family, children, relations, riches, houses, gardens, horses, dogs, clothes. He afterwards proceeds to find out that common circumstance in which all these objects agree, and which causes them to operate on the passions. His theory likewise extends to love and hatred, and other affections. As these questions, though curious, could not be rendered intelligible without a long discourse, we shall here omit them.

It may perhaps be more acceptable to the reader to be informed of what our author says concerning *free-will*. He has laid the foundation of his doctrine in what he said concerning cause and effect, as above explained. It is universally acknowledged, that the operations of external bodies are necessary, and that in the communication of their motion, in their attraction and mutual cohesion, there are not the least traces of indifference or liberty. . . Whatever, therefore, is in this respect on

CONTINUED FROM PAGE 40

gestion of matching indivisible points one to one anticipates the one-to-one correspondence method for classifying denumerable infinite sets developed by Georg Cantor.

the same footing with matter, must be acknowledged to be necessary. That we may know whether this be the case with the actions of the mind, we may examine matter, and consider on what the idea of a necessity in its operations are founded, and why we conclude one body or action to be the infallible cause of another.

'It has been observed already, that in no single instance the ultimate connexion of any object is discoverable either by our senses or reason, and that we can never penetrate so far into the essence and construction of bodies, as to perceive the principle on which their mutual influence is founded. It is their constant union alone with which we are acquainted; and it is from the constant union the necessity arises, when the mind is determined to pass from one object to its usual attendant, and infer the existence of one from that of the other. Here then are two particulars, which we are to regard as essential to *necessity*, viz. the constant union and the inference of the mind, and wherever we discover these we must acknowledge a necessity.' Now nothing is more evident than the constant union of particular actions with particular motives. If all actions be not constantly united with their proper motives, this uncertainty is no more than what may be observed every day in the actions of matter. where, by reason of the mixture and uncertainty of causes, the effect is often variable and uncertain. Thirty grains of opium will kill any man that is not accustomed to it, though thirty grains of rhubarb will not always purge him. In like manner, the fear of death will always make a man go twenty paces out of his road, though it will not always make him do a bad action.

And as there is often a constant conjunction of the actions of the will with their motives, so the inference from the one to the other is often as certain as any reasoning concerning bodies; and there is always an inference proportioned to the constancy of the conjunction. On this is founded our belief in witnesses, our credit in history, and indeed all kinds of moral evidence, and almost the whole conduct of life.

Our author pretends that this reasoning puts the whole controversy in a new light, by giving a new definition of necessity. And indeed the most zealous advocates for free will must allow this union and inference with regard to human actions. They will only deny that this makes the whole of necessity. But then they must show that we have an idea of something else in the actions of matter; which, according to the foregoing reasoning, is impossible.

Through this whole book there are great pretensions to new discoveries in philosophy; but if anything can entitle the author to so glorious a name as that of an inventor, it is the use he makes of the principle of the association of ideas, which enters into most of his philosophy. 10 Our imagination has a great authority over our ideas; and there are no ideas that are different from each other which it cannot separate, and join, and compose into all the varieties of fiction. But notwithstanding the empire of the imagination, there is a secret tie or union among particular ideas, which causes the mind to conjoin them more frequently together, and makes the one, upon its appearance, introduce the other. Hence arises what we call the apropos of discourse; hence the connexion of writing; and hence that thread, or chain of thought, which a man naturally supports even in the loosest reverie. These principles of association are reduced to three, viz. resemblance—a picture naturally makes us think of the man it was drawn for: contiguity—when St. Denis is mentioned, the idea of Paris naturally occurs: causation— when we think of the son, we are apt to carry our attention to the father. It will be easy to conceive of what vast consequence these principles must be in the science of human nature, if we consider that, so far as regards the mind, these are the only links that bind the parts of the universe together, or connect us with any person or object exterior to ourselves. For as it is by means of thought only that anything operates upon our passions, and as these are the only ties of our thoughts, they are really to us the cement of the universe, and all the operations of the mind must, in a great measure, depend on them.

FINIS

¹⁰ Hume became progressively disenchanted with this project for an associationist psychology. Since our text of the first *Enquiry* is based on that of the last edition to have been revised by Hume himself, Section III is the merest fragment of what it once was. In 1749 David Hartley (1705–57) had published *Observations on Man, His Frame, His Duty and His Expectations*, containing an attempt at an associationist psychology far superior to anything achieved on these lines by Hume.

Why a cause is always necessary

Why a cause is always necessary¹

To begin with the first question concerning the necessity of a cause: 'Tis a general maxim in philosophy, that whatever begins to exist, must have a cause of existence. This is commonly taken for granted in all reasonings, without any proof given or demanded. 'Tis suppos'd to be founded on intuition, and to be one of those maxims, which tho' they may be deny'd with the lips, 'tis impossible for men in their hearts really to doubt of. But if we examine this maxim by the idea of knowledge above-explain'd, we shall discover in it no mark of any such intuitive certainty; but on the contrary shall find, that 'tis of a nature quite foreign to that species of conviction.

All certainty arises from the comparison of ideas, and from the discovery of such relations as are unalterable, so long as the ideas continue the same. These relations are resemblance, proportions in quantity and number, degrees of any quality, and contrariety; none of which are imply'd in this proposition, Whatever has a beginning has also a cause of existence. That proposition therefore is not intuitively certain. At least any one, who wou'd assert it to be intuitively certain, must deny these to be the only infallible relations, and must find some other relation of that kind to be imply'd in it; which it will then be time enough to examine.

But here is an argument, which proves at once, that the foregoing proposition is neither intuitively nor demonstrably certain. We can never demonstrate the necessity of a cause to every new existence, or new modification of existence, without

 $^{^1}$ This is Section 3 of Book I, Part III, of A Treatise of Human Nature. It is included here because neither the Abstract nor the first Enquiry develops a direct application to the maxim 'Every event must have a cause' of Hume's radical contention that we cannot know a priori that any particular thing or sort of thing either must or cannot cause any other particular thing or sort of thing.

What appear here as parenthetical references to Mr. Hobbes, Dr. Clarke and others, and Mr. Locke were originally made by Hume in footnotes.

shewing at the same time the impossibility there is, that any thing can ever begin to exist without some productive principle; and where the latter proposition cannot be prov'd, we must despair of ever being able to prove the former. Now that the latter proposition is utterly incapable of a demonstrative proof we may satisfy ourselves by considering, that as all distinct ideas are separable from each other, and as the ideas of cause and effect are evidently distinct, 'twill be easy for us to conceive any object to be non-existent this moment, and existent the next, without conjoining to it the distinct idea of a cause or productive principle. The separation, therefore, of the idea of a cause from that of a beginning of existence, is plainly possible for the imagination; and consequently the actual separation of these objects is so far possible, that it implies no contradiction nor absurdity; and is therefore incapable of being refuted by any reasoning from mere ideas; without which 'tis impossible to demonstrate the necessity of a cause.

Accordingly we shall find upon examination, that every demonstration, which has been produc'd for the necessity of a cause, is fallacious and sophistical. All the points of time and place, say some philosophers (e.g., Mr. Hobbes), in which we can suppose any object to begin to exist, are in themselves equal; and unless there be some cause, which is peculiar to one time and to one place, and which by that means determines and fixes the existence, it must remain in eternal suspence; and the object can never begin to be, for want of something to fix its beginning. But I ask; Is there any more difficulty in supposing the time and place to be fix'd without a cause, than to suppose the existence to be determin'd in that manner? The first question that occurs on this subject is always, whether the object shall exist or not: The next, when and where it shall begin to exist. If the removal of a cause be intuitively absurd in the one case, it must be so in the other: And if that absurdity be not clear without a proof in the one case, it will equally require one in the other. The absurdity. then, of the one supposition can never be a proof of that of the other; since they are both upon the same footing, and must stand or fall by the same reasoning.

The second argument (urged by Dr. Clarke and others), which I find us'd on this head, labours under an equal difficulty. Every thing, 'tis said, must have a cause; for if any thing wanted a cause, *it* wou'd produce *itself*; that is, exist before it existed; which is impossible. But this reasoning is plainly unconclusive;

because it supposes, that in our denial of a cause we still grant what we expressly deny, *viz*. that there must be a cause; which therefore is taken to be the object itself; and *that*, no doubt, is an evident contradiction. But to say that any thing is produc'd, or to express myself more properly, comes into existence, without a cause, is not to affirm, that 'tis itself its own cause; but on the contrary in excluding all external causes, excludes *a fortiori* the thing itself which is created. An object, that exists absolutely without any cause, certainly is not its own cause; and when you assert, that the one follows from the other, you suppose the very point in question, and take it for granted, that 'tis utterly impossible any thing can ever begin to exist without a cause, but that upon the exclusion of one productive principle, we must still have recourse to another.

'Tis exactly the same case with the third argument (found in Mr. Locke), which has been employ'd to demonstrate the necessity of a cause. Whatever is produc'd without any cause, is produc'd by *nothing*; or in other words, has nothing for its cause. But nothing can never be a cause, no more than it can be something, or equal to two right angles. By the same intuition, that we perceive nothing not to be equal to two right angles, or not to be something, we perceive, that it can never be a cause; and consequently must perceive, that every object has a real cause of its existence.

I believe it will not be necessary to employ many words in shewing the weakness of this argument, after what I have said of the foregoing. They are all of them founded on the same fallacy, and are deriv'd from the same turn of thought. 'Tis sufficient only to observe, that when we exclude all causes we really do exclude them, and neither suppose nothing nor the object itself to be the causes of the existence; and consequently can draw no argument for the absurdity of these suppositions to prove the absurdity of that exclusion. If every thing must have a cause, it follows, that upon the exclusion of other causes we must accept of the object itself or of nothing as causes. But 'tis the very point in question, whether every thing must have a cause or not; and therefore, according to all just reasoning, it ought never to be taken for granted.

They are still more frivolous, who say, that every effect must have a cause, because 'tis imply'd in the very idea of effect. Every effect necessarily pre-supposes a cause; effect being a relative term, of which cause is the correlative. But this does not prove, that every being must be preceded by a cause; no more than it follows, because every husband must have a wife, that therefore every man must be marry'd. The true state of the question is, whether every object, which begins to exist, must owe its existence to a cause; and this I assert neither to be intuitively nor demonstratively certain, and hope to have prov'd it sufficiently by the foregoing arguments.

Since it is not from knowledge or any scientific reasoning, that we derive the opinion of the necessity of a cause to every new production, that opinion must necessarily arise from observation and experience. The next question, then, shou'd naturally be, how experience gives rise to such a principle? But as I find it will be more convenient to sink this question in the following, Why we conclude, that such particular causes must necessarily have such particular effects, and why we form an inference from one to another? we shall make that the subject of our future enquiry. 'Twill, perhaps, be found in the end, that the same answer will serve for both questions.

An Enquiry concerning Human Understanding

ADVERTISEMENT¹

Most of the principles, and reasonings, contained in this volume, were published in a work in three volumes, called A Treatise of Human Nature: A work which the Author had projected before he left College, and which he wrote and published not long after. But not finding it successful, he was sensible of his error in going to the press too early, and he cast the whole anew in the following pieces, where some negligences in his former reasoning and more in the expression, are, he hopes, corrected. Yet several writers, who have honoured the Author's Philosophy with answers, have taken care to direct all their batteries against that juvenile work, which the Author never acknowledged, and have affected to triumph in any advantages, which, they imagined, they had obtained over it: A practice very contrary to all rules of candour and fair-dealing, and a strong instance of those polemical artifices, which a bigotted zeal thinks itself authorized to employ. Henceforth, the Author desires, that the following Pieces² may alone be regarded as containing his philosophical sentiments and principles.

¹ "Advertisement" = 'announcement' in present-day usage. Hume wrote this advertisement around October 1775, to be included in remaining copies of the 1772 edition. Well-known Scottish philosophers such as Thomas Reid and James Beattie kept on attacking the early *Treatise of Human Nature*, even 20 years after the appearance of the first *Enquiry*.

 $^{^2}$ Originally "the following Pieces" were four: the first Enquiry and the second; A Dissertation on the Passions; and The Natural History of Religion.

Of the Different Species of Philosophy

MORAL philosophy.3 or the science of human nature, may be treated after two different manners; each of which has its peculiar merit, and may contribute to the entertainment, instruction, and reformation of mankind. The one considers man chiefly as born for action; and as influenced in his measures by taste and sentiment; pursuing one object, and avoiding another, according to the value which these objects seem to possess, and according to the light in which they present themselves. As virtue, of all objects, is allowed to be the most valuable, this species of philosophers paint her in the most amiable colours; borrowing all helps from poetry and eloquence. and treating their subject in an easy and obvious manner, and such as is best fitted to please the imagination, and engage the affections. They select the most striking observations and instances from common life; place opposite characters in a proper contrast; and alluring us into the paths of virtue by the views of glory and happiness, direct our steps in these paths by the soundest precepts and most illustrious examples. They make us feel the difference between vice and virtue; they excite and regulate our sentiments; and so they can but bend our hearts to the love of probity and true honour, they think, that they have fully attained the end of all their labours.

The other species of philosophers consider man in the light of a reasonable rather than an active being, and endeavour to form his understanding more than cultivate his manners. They regard human nature as a subject of speculation; and with a narrow scrutiny examine it, in order to find those principles, which regulate our understanding, excite our sentiments, and make us approve or blame any particular object, action, or behaviour. They think it a reproach to all literature, that

³ "Moral philosophy" is the study of human nature as opposed to 'natural philosophy' (physical science). 'Moral' in Hume's usage sometimes refers to knowledge that is not perfectly certain.

philosophy should not yet have fixed, beyond controversy, the foundation of morals, reasoning, and criticism; and should for ever talk of truth and falsehood, vice and virtue, beauty and deformity, without being able to determine the source of these distinctions. While they attempt this arduous task, they are deterred by no difficulties; but proceeding from particular instances to general principles, they still push on their enquiries to principles more general, and rest not satisfied till they arrive at those original principles, by which, in every science, all human curiosity must be bounded. Though their speculations seem abstract, and even unintelligible to common readers, they aim at the approbation of the learned and the wise; and think themselves sufficiently compensated for the labour of their whole lives, if they can discover some hidden truths, which may contribute to the instruction of posterity.

It is certain that the easy and obvious philosophy will always, with the generality of mankind, have the preference above the accurate and abstruse; and by many will be recommended, not only as more agreeable, but more useful than the other. It enters more into common life; moulds the heart and affections; and, by touching those principles which actuate men, reforms their conduct, and brings them nearer to that model of perfection which it describes. On the contrary, the abstruse philosophy, being founded on a turn of mind, which cannot enter into business and action, vanishes when the philosopher leaves the shade, and comes into open day; nor can its principles easily retain any influence over our conduct and behaviour. The feelings of our heart, the agitation of our passions, the vehemence of our affections, dissipate all its conclusions, and reduce the profound philosopher to a mere plebeian.

This also must be confessed, that the most durable, as well as justest fame, has been acquired by the easy philosophy, and that abstract reasoners seem hitherto to have enjoyed only a momentary reputation, from the caprice or ignorance of their own age, but have not been able to support their renown with more equitable posterity. It is easy for a profound philosopher to commit a mistake in his subtile reasonings; and one mistake is

⁴ Compare with this the passage in the *Treatise of Human Nature* in which Hume denies that sceptical doubts affect his behavior when he is not engaged in philosophy (*A Treatise of Human Nature*, Book I, Part IV, section vii).

the necessary parent of another, while he pushes on his consequences, and is not deterred from embracing any conclusion, by its unusual appearance, or its contradiction to popular opinion. But a philosopher, who purposes only to represent the common sense of mankind in more beautiful and more engaging colours, if by accident he falls into error, goes no farther; but renewing his appeal to common sense, and the natural sentiments of the mind, returns into the right path, and secures himself from any dangerous illusions. The fame of Cicero flourishes at present; but that of Aristotle is utterly decayed. La Bruyère passes the seas, and still maintains his reputation: But the glory of Malebranche is confined to his own nation, and to his own age. And Addison, perhaps, will be read with pleasure, when Locke shall be entirely forgotten.

The mere philosopher is a character, which is commonly but little acceptable in the world, as being supposed to contribute nothing either to the advantage or pleasure of society; while he lives remote from communication with mankind, and is wrapped up in principles and notions equally remote from their comprehension. On the other hand, the mere ignorant is still more despised; nor is any thing deemed a surer sign of an illiberal genius in an age and nation where the sciences flourish. than to be entirely destitute of all relish for those noble entertainments. The most perfect character is supposed to lie between those extremes; retaining an equal ability and taste for books, company, and business; preserving in conversation that discernment and delicacy which arise from polite letters; and in business, that probity and accuracy which are the natural result of a just philosophy. In order to diffuse and cultivate so accomplished a character, nothing can be more useful than compositions of the easy style and manner, which drawn not too

⁵ Marcus Tullius Cicero (106–43 BCE) was a Roman politician, orator, and writer. In Hume's day most educated persons would have been familiar both with Cicero's speeches and with his hasty and wholly derivative philosophical writings. Aristotle (384–322 BCE) is, of course, a figure whose historic influence can be compared only with that of his own first teacher Plato (c. 428–c. 348 BCE). La Bruyère was a Frenchman who wrote Fables, whereas his compatriot Father Nicolas Malebranche (1638–1715) developed in his De la Recherche de la Vérité [On the Search for Truth] some of the ideas of René Descartes (1591–1650). Addison was an English occasional essayist, whereas his compatriot John Locke (1632–1704) wrote the philosophical classic An Essay concerning Human Understanding.

much from life, require no deep application or retreat to be comprehended, and send back the student among mankind full of noble sentiments and wise precepts, applicable to every exigence of human life. By means of such compositions, virtue becomes amiable, science agreeable, company instructive, and retirement entertaining.

Man is a reasonable being; and as such, receives from science his proper food and nourishment: But so narrow are the bounds of human understanding, that little satisfaction can be hoped for in this particular, either from the extent or security of his acquisitions. Man is a sociable, no less than a reasonable being: But neither can he always enjoy company agreeable and amusing, or preserve the proper relish for them. Man is also an active being; and from that disposition, as well as from the various necessities of human life, must submit to business and occupation: But the mind requires some relaxation, and cannot always support its bent to care and industry. It seems, then. that nature has pointed out a mixed kind of life as most suitable to human race, and secretly admonished them to allow none of these biasses to draw too much, so as to incapacitate them for other occupations and entertainments. Indulge your passion for science, says she, but let your science be human, and such as may have a direct reference to action and society. Abstruse thought and profound researches I prohibit, and will severely punish, by the pensive melancholy which they introduce, by the endless uncertainty in which they involve you, and by the cold reception which your pretended discoveries shall meet with. when communicated. Be a philosopher; but, amidst all your philosophy, be still a man.

Were the generality of mankind contented to prefer the easy philosophy to the abstract and profound, without throwing any blame or contempt on the latter, it might not be improper, perhaps, to comply with this general opinion, and allow every man to enjoy, without opposition, his own taste and sentiment. But as the matter is often carried farther, even to the absolute rejecting of all profound reasonings, or what is commonly called *metaphysics*, we shall now proceed to consider what can reasonably be pleaded in their behalf.

We may begin with observing, that one considerable advantage, which results from the accurate and abstract philosophy, is, its subserviency to the easy and humane; which, without the former, can never attain a sufficient degree of exactness in its

sentiments, precepts, or reasonings. All polite letters are nothing but pictures of human life in various attitudes and situations; and inspire us with different sentiments, of praise or blame, admiration or ridicule, according to the qualities of the object, which they set before us. An artist must be better qualified to succeed in this undertaking, who, besides a delicate taste and a quick apprehension, possesses an accurate knowledge of the internal fabric, the operations of the understanding. the workings of the passions, and the various species of sentiment which discriminate vice and virtue. How painful soever this inward search or enquiry may appear, it becomes, in some measure, requisite to those, who would describe with success the obvious and outward appearances of life and manners. The anatomist presents to the eye the most hideous and disagreeable objects; but his science is useful to the painter in delineating even a Venus or an Helen.⁶ While the latter employs all the richest colours of his art, and gives his figures the most graceful and engaging airs; he must still carry his attention to the inward structure of the human body, the position of the muscles, the fabric of the bones, and the use and figure of every part or organ. Accuracy is, in every case, advantageous to beauty, and just reasoning to delicate sentiment. In vain would we exalt the one by depreciating the other.

Besides, we may observe, in every art or profession, even those which most concern life or action, that a spirit of accuracy, however acquired, carries all of them nearer their perfection, and renders them more subservient to the interests of society. And though a philosopher may live remote from business, the genius of philosophy, if carefully cultivated by several, must gradually diffuse itself throughout the whole society, and bestow a similar correctness on every art and calling. The politician will acquire greater foresight and subtility, in the subdividing and balancing of power; the lawyer more method and finer principles in his reasonings; and the general more regularity in his discipline, and more caution in his plans and operations. The stability of modern governments above the ancient, and the accuracy of modern philosophy, have improved,

⁶ Venus was the Roman god of love, identified with the Greek Aphrodite: hence the modern English expression 'venereal disease'. Helen was a legendary beauty. In the *Iliad* and the *Odyssey* she was the wife of Menelaus, king of Sparta, and her abduction by Paris to Troy was the cause of the Trojan War.

and probably will still improve, by similar gradations.

Were there no advantage to be reaped from these studies, beyond the gratification of an innocent curiosity, yet ought not even this to be despised; as being one accession to those few safe and harmless pleasures, which are bestowed on human race. The sweetest and most inoffensive path of life leads through the avenues of science and learning; and whoever can either remove any obstructions in this way, or open up any new prospect, ought so far to be esteemed a benefactor to mankind. And though these researches may appear painful and fatiguing, it is with some minds as with some bodies, which being endowed with vigorous and florid health, require severe exercise, and reap a pleasure from what, to the generality of mankind, may seem burdensome and laborious. Obscurity, indeed, is painful to the mind as well as to the eye; but to bring light from obscurity, by whatever labour, must needs be delightful and rejoicing.

But this obscurity in the profound and abstract philosophy. is objected to, not only as painful and fatiguing, but as the inevitable source of uncertainty and error. Here indeed lies the justest and most plausible objection against a considerable part of metaphysics, that they are not properly a science; but arise either from the fruitless efforts of human vanity, which would penetrate into subjects utterly inaccessible to the understanding, or from the craft of popular superstitions, which, being unable to defend themselves on fair ground, raise these intangling brambles to cover and protect their weakness. Chaced from the open country, these robbers fly into into the forest, and lie in wait to break in upon every unguarded avenue of the mind. and overwhelm it with religious fears and prejudices. The stoutest antagonist, if he remit his watch a moment, is oppressed. And many, through cowardice and folly, open the gates to the enemies, and willingly receive them with reverence and submission, as their legal sovereigns.

But is this a sufficient reason, why philosophers should desist from such researches, and leave superstition still in possession of her retreat? Is it not proper to draw an opposite conclusion, and perceive the necessity of carrying the war into the most secret recesses of the enemy? In vain do we hope, that

⁷ Hume's attitude contrasts with Augustine's warning against "vain and perishing curiosity". "In consideratione creaturarum non est vana et peritura curiositas exercenda." Augustine, *De Vera Religione*.

men, from frequent disappointment, will at last abandon such airy sciences, and discover the proper province of human reason. For, besides, that many persons find too sensible an interest in perpetually recalling such topics; besides this, I say, the motive of blind despair can never reasonably have place in the sciences: since, however unsuccessful former attempts may have proved. there is still room to hope, that the industry, good fortune, or improved sagacity of succeeding generations may reach discoveries unknown to former ages. Each adventurous genius will still leap at the arduous prize, and find himself stimulated, rather than discouraged, by the failures of his predecessors: while he hopes that the glory of achieving so hard an adventure is reserved for him alone. The only method of freeing learning, at once, from these abstruse questions, is to enquire seriously into the nature of human understanding, and show, from an exact analysis of its powers and capacity, that it is by no means fitted for such remote and abstruse subjects. We must submit to this fatigue, in order to live at ease ever after: And must cultivate true metaphysics with some care, in order to destroy the false and adulterate. Indolence, which, to some persons, affords a safeguard against this deceitful philosophy, is, with others, overbalanced by curiosity; and despair, which, at some moments, prevails, may give place afterwards to sanguine hopes and expectations. Accurate and just reasoning is the only catholic remedy, fitted for all persons and all dispositions; and is alone able to subvert that abstruse philosophy and metaphysical jargon, which, being mixed up with popular superstition. renders it in a manner impenetrable to careless reasoners, and gives it the air of science and wisdom.

Besides this advantage of rejecting, after deliberate enquiry, the most uncertain and disagreeable part of learning, there are many positive advantages, which result from an accurate scrutiny into the powers and faculties of human nature. It is remarkable concerning the operations of the mind, that, though most intimately present to us, yet, whenever they become the object of reflexion, they seem involved in obscurity; nor can the eye readily find those lines and boundaries, which discriminate and distinguish them. The objects are too fine to remain long in the same aspect or situation; and must be apprehended in an instant, by a superior penetration, derived from nature, and improved by habit and reflexion. It becomes, therefore, no inconsiderable part of science barely to know the different

operations of the mind, to separate them from each other, to class them under their proper heads, and to correct all that seeming disorder, in which they lie involved, when made the object of reflexion and enquiry. This talk of ordering and distinguishing, which has no merit, when performed with regard to external bodies, the objects of our senses, rises in its value, when directed towards the operations of the mind, in proportion to the difficulty and labour, which we meet with in performing it.⁸ And if we can go no farther than this mental geography, or delineation of the distinct parts and powers of the mind, it is at least a satisfaction to go so far; and the more obvious this science may appear (and it is by no means obvious) the more contemptible still must the ignorance of it be esteemed, in all pretenders to learning and philosophy.

Nor can there remain any suspicion, that this science is uncertain and chimerical: unless we should entertain such a scepticism as is entirely subversive of all speculation, and even action. It cannot be doubted, that the mind is endowed with several powers and faculties, that these powers are distinct from each other, that what is really distinct to the immediate perception may be distinguished by reflexion; and consequently that there is a truth and falsehood in all propositions on this subject, and a truth and falsehood, which lie not beyond the compass of human understanding. There are many obvious distinctions of this kind, such as those between the will and understanding, the imagination and passions, which fall within the comprehension of every human creature; and the finer and more philosophical distinctions are no less real and certain, though more difficult to be comprehended. Some instances, especially late ones, of success in these enquiries, may give us a juster notion of the certainty and solidity of this branch of learning. And shall we esteem it worthy the labour of a philosopher to give us a true system of the planets, and adjust the position and order of those remote bodies; while we affect to overlook those, who, with so much success, delineate the parts of the mind, in which we are so intimately concerned?9

⁸ The ordering and distinguishing of external bodies "has no merit" when it is very easy to do. Hume claims that distinguishing the power and faculties of the mind involves greater difficulties than classifying external objects and so earns more merit.

⁹ Earlier editions added here a tribute to Francis Hutcheson, for having shown—to put it in modern terms—that value characteristics are not intrin-

But may we not hope, that philosophy, if cultivated with care, and encouraged by the attention of the public, may carry its researches still farther, and discover, at least in some degree. the secret springs and principles, by which the human mind is actuated in its operations? Astronomers had long contented themselves with proving, from the phaenomena, the true motions, order, and magnitude of the heavenly bodies: Till a philosopher, at last rose, who seems, from the happiest reasoning, to have also determined the laws and forces, by which the revolutions of the planets are governed and directed. 10 The like has been performed with regard to other parts of nature. And there is no reason to despair of equal success in our enquiries concerning the mental powers and economy, if prosecuted with equal capacity and caution. It is probable, that one operation and principle of the mind depends on another; which, again, may be resolved into one more general and universal: And how far these researches may possibly be carried, it will be difficult for us, before, or even after, a careful trial, exactly to determine. This is certain, that attempts of this kind are every day made even by those who philosophize the most negligently: And nothing can be more requisite than to enter upon the enterprize with thorough care and attention; that, if it lie within the compass of human understanding, it may at last be happily achieved; if not, it may, however, be rejected with some confidence and security. This last conclusion, surely, is not desirable; nor ought it to be embraced too rashly. For how much must we diminish from the beauty and value of this species of philosophy. upon such a supposition? Moralists have hitherto been accustomed, when they considered the vast multitude and diversity of those actions that excite our approbation or dislike, to search for some common principle, on which this variety of sentiments might depend. And though they have sometimes carried the matter too far, by their passion for some one general principle; it must, however, be confessed, that they are excusable in expecting to find some general principles, into which all the vices and virtues were justly to be resolved. The like has been the

CONTINUED FROM PAGE 60

 $[\]operatorname{sic}$ to the objects valued but are, rather, somehow projections of purely human desires and preferences.

 $^{^{10}}$ Hume here has in mind Sir Isaac Newton (1642–1727) whose $Philosophiae\ Naturalis\ Principia\ Mathematica\ (1687)$ explained planetary motion through gravitation.

endeavour of critics, logicians, and even politicians: Nor have their attempts been wholly unsuccessful; though perhaps longer time, greater accuracy, and more ardent application may bring these sciences still nearer their perfection. To throw up at once all pretensions of this kind may justly be deemed more rash, precipitate, and dogmatical, than even the boldest and most affirmative philosophy, that has ever attempted to impose its crude dictates and principles on mankind.

What though these reasonings concerning human nature seem abstract, and of difficult comprehension? This affords no presumption of their falsehood. On the contrary, it seems impossible, that what has hitherto escaped so many wise and profound philosophers can be very obvious and easy. And whatever pains these researches may cost us, we may think ourselves sufficiently rewarded, not only in point of profit but of pleasure, if, by that means, we can make any addition to our stock of knowledge, in subjects of such unspeakable importance.

But as, after all, the abstractedness of these speculations is no recommendation, but rather a disadvantage to them, and as this difficulty may perhaps be surmountd by care and art, and the avoiding of all unnecessary detail, we have, in the following enquiry, attempted to throw some light upon subjects, from which uncertainty has hitherto deterred the wise, and obscurity the ignorant. Happy, if we can unite the boundaries of the different species of philosophy, by reconciling profound enquiry with clearness, and truth with novelty! And still more happy, if, reasoning in this easy manner, we can undermine the foundations of an abstruse philosophy, which seems to have hitherto served only as a shelter to superstition, and a cover to absurdity and error!

¹¹ Hume here refers to Scholastic philosophy, used to defend Roman Catholicism, which, writing for a mainly Protestant readership, he can safely label "superstition".

Of the Origin of Ideas

HEVERY one will readily allow, that there is a considerable difference between the perceptions of the mind, when a man feels the pain of excessive heat, or the pleasure of moderate warmth, and when he afterwards recalls to his memory this sensation, or anticipates it by his imagination. These faculties may mimic or copy the perceptions of the senses; but they never can entirely reach the force and vivacity of the original sentiment. The utmost we say of them, even when they operate with greatest vigour, is, that they represent their object in so lively a manner, that we could almost say we feel or see it: But, except the mind be disordered by disease or madness, they never can arrive at such a pitch of vivacity, as to render these perceptions altogether undistinguishable. All the colours of poetry, however splendid, can never paint natural objects in such a manner as to make the description be taken for a real landskip. The most lively thought is still inferior to the dullest sensation. 12

We may observe a like distinction to run through all the other perceptions of the mind. A man in a fit of anger, is actuated in a very different manner from one who only thinks of that emotion. If you tell me, that any person is in love, I easily understand your meaning, and form a just conception of his situation; but never can mistake that conception for the real disorders and agitations of the passion. When we reflect on our past sentiments and affections, our thought is a faithful mirror, and copies its objects truly; but the colours which it employs are faint and dull, in comparison of those in which our original perceptions were clothed. It requires no nice discernment or metaphysical head to mark the distinction between them.

Here therefore we may divide all the perceptions of the mind into two classes or species, which are distinguished by their different degrees of force and vivacity. The less forcible and lively

12

¹² Notice the ambiguity here: Hume could be saying a) that any thought is inferior in force to any corresponding sensation; or b) that every thought is inferior in force to any sensation whatsoever.

13

are commonly denominated *Thoughts* or *Ideas*. The other species want a name in our language, and in most others; I suppose, because it was not requisite for any, but philosophical purposes, to rank them under a general term or appellation. Let us, therefore, use a little freedom, and call them *Impressions*; employing that word in a sense somewhat different from the usual. By the term *impression*, then, I mean all our more lively perceptions, when we hear, or see, or feel, or love, or hate, or desire, or will.¹³ And impressions are distinguished from ideas, which are the less lively perceptions, of which we are conscious, when we reflect on any of those sensations or movements above mentioned.

Nothing, at first view, may seem more unbounded than the thought of man, which not only escapes all human power and authority, but is not even restrained within the limits of nature and reality. To form monsters, and join incongruous shapes and appearances, costs the imagination no more trouble than to conceive the most natural and familiar objects. And while the body is confined to one planet, along which it creeps with pain and difficulty; the thought can in an instant transport us into the most distant regions of the universe; or even beyond the universe, into the unbounded chaos, where nature is supposed to lie in total confusion. What never was seen, or heard of, may yet be conceived; nor is any thing beyond the power of thought, except what implies an absolute contradiction. ¹⁴

But though our thought seems to possess this unbounded liberty, we shall find, upon a nearer examination, that it is really confined within very narrow limits, and that all this creative power of the mind amounts to no more than the faculty of compounding, transposing, augmenting, or diminishing the materials afforded us by the senses and experience. When we think of a golden mountain, we only join two consistent ideas, gold, and mountain, with which we were formerly acquainted. A virtuous horse we can conceive; because, from our own feeling, we can conceive virtue; and this we may unite to the figure and

¹³ Hume does not confine "impressions" to the exercise of the sensory faculties. He also includes emotions and acts of will.

¹⁴ Hume will later claim that whatever can be imagined together is logically possible, a view that has aroused controversy. On the other hand, his claim appears restricted in that if something implies a contradiction, it cannot in his view be imagined.

to it.

shape of a horse, which is an animal familiar to us. In short, all the materials of thinking are derived either from our outward or inward sentiment: the mixture and composition of these belongs alone to the mind and will. Or, to express myself in philosophical language, all our ideas or more feeble perceptions are copies of our impressions or more lively ones.

To prove this, the two following arguments will. I hope, be 14 sufficient. First, when we analyze our thoughts or ideas. however compounded or sublime, we always find that they resolve themselves into such simple ideas as were copied from a precedent feeling or sentiment. Even those ideas, which, at first view, seem the most wide of this origin, are found, upon a nearer scrutiny, to be derived from it. The idea of God, as meaning an infinitely intelligent, wise, and good Being, arises from reflecting on the operations of our own mind, and augmenting, without limit, those qualities of goodness and wisdom. 15 We may prosecute this enquiry to what length we please; where we shall always find, that every idea which we examine is copied from a similar impression. Those who would assert that this position is not universally true nor without exception, have only one, and that an easy method of refuting it; by producing that idea,

Secondly. If it happen, from a defect of the organ, that a man is not susceptible of any species of sensation, we always find that he is as little susceptible of the correspondent ideas. A blind man can form no notion of colours; a deaf man of sounds. Restore either of them that sense in which he is deficient; by opening this new inlet for his sensations, you also open an inlet for the ideas; and he finds no difficulty in conceiving these objects. The case is the same, if the object, proper for exciting any sensation, has never been applied to the organ. A Laplander or Negro has no notion of the relish of wine. And though there are few or no instances of a like deficiency in the mind, where a person has never felt or is wholly incapable of a sentiment or passion that

which, in their opinion, is not derived from this source. It will then be incumbent on us, if we would maintain our doctrine, to produce the impression, or lively perception, which corresponds

¹⁵ Hume differs here from Descartes, who held that the idea of God could not be arrived at through combination of ideas derived from the senses, but is innate. It is, as it were, and this comparison is provided by Descartes himself, the trademark which God puts on the souls which he creates.

belongs to his species; yet we find the same observation to take place in a less degree. A man of mild manners can form no idea of inveterate revenge or cruelty; nor can a selfish heart easily conceive the heights of friendship and generosity. It is readily allowed, that other beings may possess many senses of which we can have no conception; because the ideas of them have never been introduced to us in the only manner by which an idea can have access to the mind, to wit, by the actual feeling and sensation.

There is, however, one contradictory phenomenon, which 16 may prove that it is not absolutely impossible for ideas to arise. independent of their correspondent impressions. I believe it will readily be allowed, that the several distinct ideas of colour. which enter by the eye, or those of sound, which are conveyed by the ear, are really different from each other; though, at the same time, resembling. Now if this be true of different colours, it must be no less so of the different shades of the same colour; and each shade produces a distinct idea, independent of the rest. For if this should be denied, it is possible, by the continual gradation of shades, to run a colour insensibly into what is most remote from it; and if you will not allow any of the means to be different, you cannot, without absurdity, deny the extremes to be the same. Suppose, therefore, a person to have enjoyed his sight for thirty years, and to have become perfectly acquainted with colours of all kinds except one particular shade of blue, for instance, which it never has been his fortune to meet with. Let all the different shades of that colour, except that single one, be placed before him, descending gradually from the deepest to the lightest; it is plain that he will perceive a blank, where that shade is wanting, and will be sensible that there is a greater distance in that place between the contiguous colours than in any other. Now I ask. whether it be possible for him, from his own imagination, to supply this deficiency, and raise up to himself the idea of that particular shade, though it had never been conveyed to him by his senses? I believe there are few but will be of opinion that he can; and this may serve as a proof that the simple ideas are not always in every instance, derived from the correspondent impressions; though this instance is so singular, that it is scarcely worth our observing, and does not merit that for it alone we should alter our general maxim.

Here, therefore, is a proposition, which not only seems, in itself, simple and intelligible; but, if a proper use were made of it,

might render every dispute equally intelligible, and banish all that jargon, which has so long taken possession of metaphysical reasonings, and drawn disgrace upon them. All ideas, especially abstract ones, are naturally faint and obscure: the mind has but a slender hold of them: they are apt to be confounded with other resembling ideas; and when we have often employed any term. though without a distinct meaning, we are apt to imagine it has a determinate idea annexed to it. On the contrary, all impressions, that is, all sensations, either outward or inward, are strong and vivid: the limits between them are more exactly determined: nor is it easy to fall into any error or mistake with regard to them. When we entertain, therefore, any suspicion that a philosophical term is employed without any meaning or idea (as is but too frequent), we need but enquire, from what impression is that supposed idea derived? And if it be impossible to assign any, this will serve to confirm our suspicion. 16 By bringing ideas into so clear a light we may reasonably hope to remove all dispute, which may arise, concerning their nature and reality.17

It is probable that no more was meant by those, who denied innate ideas, than that all ideas were copies of our impressions: though it must be confessed, that the terms, which they employed, were not chosen with such caution, nor so exactly defined, as to prevent all mistakes about their doctrine. For what is meant by *innate?* If innate be equivalent to natural, then all the perceptions and ideas of the mind must be allowed to be innate or natural, in whatever sense we take the latter word, whether in opposition to what is uncommon, artificial, or miraculous. If by innate be meant, contemporary to our birth. the dispute seems to be frivolous; nor is it worth while to enquire at what time thinking begins, whether before, at, or after our birth. Again, the word idea, seems to be commonly taken in a very loose sense, by Locke and others; as standing for any of our perceptions, our sensations and passions, as well as thoughts. Now in this sense, I should desire to know, what can be meant by asserting, that self-love, or resentment of injuries, or the passion between the sexes is not innate?

¹⁶ Hume here is *not* presenting an early vision of the principle of verification, favored by the logical positivists. Hume's claim concerns the *origins* of concepts. 'God is an all-powerful being', for instance, passes Hume's test, if Hume is right about the origins of the idea of God.

¹⁷ The next three paragraphs were originally printed as a footnote.

But admitting these terms, *impressions* and *ideas*, in the sense above explained, and understanding by *innate*, what is original or copied from no precedent perception, then may we assert that all our impressions are innate, and our ideas not innate.

To be ingenuous, I must own it to be my opinion, that LOCKE was betrayed into this question by the schoolmen, who, making use of undefined terms, draw out their disputes to a tedious length, without ever touching the point in question. A like ambiguity and circumlocution seem to run through that philosopher's reasonings on this as well as most other subjects.

¹⁸ The schoolmen were the Scholastic philosopher-theologians of the high Middle Ages. Among the most famous names were those of Thomas Aquinas (c. 1225–76), John Duns Scotus (c. 1266–1308) and William of Ockham (c. 1285–1349). Connoisseurs of the unfairness of life may delight to reflect: both that our word 'dunce' supposedly derives from the second name; and that two out of three apparently came from the British Isles.

Of the Association of Ideas

IT is evident that there is a principle of connexion between the different thoughts or ideas of the mind, and that, in their appearance to the memory or imagination, they introduce each other with a certain degree of method and regularity. In our more serious thinking or discourse this is so observable, that any particular thought, which breaks in upon the regular tract or chain of ideas, is immediately remarked and rejected. And even in our wildest and most wandering reveries, nay in our very dreams, we shall find, if we reflect, that the imagination ran not altogether at adventures, but that there was still a connexion upheld among the different ideas, which succeeded each other. Were the loosest and freest conversation to be transcribed, there would immediately be observed something which connected it in all its transitions. Or where this is wanting, the person who broke the thread of discourse might still inform you, that there had secretly revolved in his mind a succession of thought, which had gradually led him from the subject of conversation. Among different languages, even where we cannot suspect the least connexion or communication, it is found, that the words. expressive of ideas, the most compounded, do yet nearly correspond to each other: a certain proof that the simple ideas, comprehended in the compound ones, were bound together by some universal principle, which had an equal influence on all mankind.19

Though it be too obvious to escape observation, that different ideas are connected together; I do not find that any philosopher has attempted to enumerate or class all the principles of association; a subject, however, that seems worthy of curiosity. To me, there appear to be only three principles of connexion among ideas, namely, *Resemblance*, *Contiguity* in time or place, and *Cause* or *Effect*.

¹⁹ Hume's argument is that in unrelated foreign languages, there tend to be words corresponding to the same ideas. It is not that these words resemble each other phonetically or in some other way not related to the idea.

That these principles serve to connect ideas will not, I believe, be much doubted. A picture naturally leads our thoughts to the original (Resemblance): the mention of one apartment in a building naturally introduces an enquiry or discourse concerning the others (Contiguity): and if we think of a wound, we can scarcely forbear reflecting on the pain which follows it (Cause and effect). But that this enumeration is complete, and that there are no other principles of association except these, may be difficult to prove to the satisfaction of the reader, or even to a man's own satisfaction. All we can do, in such cases, is to run over several instances, and examine carefully the principle which binds the different thoughts to each other, never stopping till we render the principle as general as possible. (For instance, Contrast or Contrariety is also a connexion among Ideas: but it may, perhaps, be considered as a mixture of Causation and Resemblance. Where two objects are contrary, the one destroys the other; that is, the cause of its annihilation, and the idea of the annihilation of an object, implies the idea of its former existence.) The more instances we examine, and the more care we employ, the more assurance shall we acquire, that the enumeration, which we form from the whole, is complete and entire.20

 $^{^{20}\,\}rm The$ words and the passage in parentheses in this paragraph originally appeared as four successive footnotes.

Sceptical Doubts concerning the Operations of the Understanding

PARTI

ALL the objects of human reason or enquiry may naturally be divided into two kinds, to wit, *Relations of Ideas*, and *Matters of Fact*. Of the first kind are the sciences of Geometry, Algebra, and Arithmetic; and in short, every affirmation which is either intuitively or demonstratively certain. *That the square of the hypothenuse is equal to the square of the two sides*, is a proposition which expresses a relation between these figures. *That three times five is equal to the half of thirty*, expresses a relation between these numbers. Propositions of this kind are discoverable by the mere operation of thought, without dependence on what is anywhere existent in the universe. Though there never were a circle or triangle in nature, the truths demonstrated by Euclid would for ever retain their certainty and evidence.²¹

Matters of fact, which are the second objects of human reason, are not ascertained in the same manner; nor is our evidence of their truth, however great, of a like nature with the foregoing. The contrary of every matter of fact is still possible; because it can never imply a contradiction, and is conceived by the mind with the same facility and distinctness, as if ever so conformable to reality. That the sun will not rise to-morrow is no less intelligible a proposition, and implies no more contradiction, than the affirmation, that it will rise. We should in vain,

²¹ Euclid, who flourished around 300 BCE, founded a school of mathematics in Alexandria, Egypt. His systematic treatise *The Elements of Geometry* was for over 2,000 years the pre-eminent textbook. As recently as World War I geometry in British schools was called, simply, 'Euclid.' Hume here is using as his example the conclusion of the Theorem of Pythagoras. Pythagoras of Samos was a philosopher, mystic, and mathematician who died before the end of the sixth century BCE. When Plato was young, a century later, Pythagoras was already a figure of legend and mystery.

therefore, attempt to demonstrate its falsehood. Were it demonstratively false, it would imply a contradiction, and could never be distinctly conceived by the mind.

It may, therefore, be a subject worthy of curiosity, to enquire what is the nature of that evidence which assures us of any real existence and matter of fact, beyond the present testimony of our senses, or the records of our memory. This part of philosophy, it is observable, has been little cultivated, either by the ancients or moderns; and therefore our doubts and errors, in the prosecution of so important an enquiry, may be the more excusable; while we march through such difficult paths without any guide or direction. They may even prove useful, by exciting curiosity, and destroying that implicit faith and security, which is the bane of all reasoning and free enquiry. The discovery of defects in the common philosophy, if any such there be, will not, I presume, be a discouragement, but rather an incitement, as is usual, to attempt something more full and satisfactory than has yet been proposed to the public.

All reasonings concerning matter of fact seem to be founded on the relation of Cause and Effect. By means of that relation alone we can go beyond the evidence of our memory and senses. If you were to ask a man, why he believes any matter of fact, which is absent; for instance, that his friend is in the country, or in France: he would give you a reason; and this reason would be some other fact; as a letter received from him, or the knowledge of his former resolutions and promises. A man finding a watch or any other machine in a desert island, would conclude that there had once been men in that island.²² All our reasonings concerning fact are of the same nature. And here it is constantly supposed that there is a connexion between the present fact and that which is inferred from it. Were there nothing to bind them together, the inference would be entirely precarious. The hearing of an articulate voice and rational discourse in the dark assures us of the presence of some person: Why? because these are the effects of the human make and fabric, and closely connected with it. If we anatomize all the other reasonings of

²² Daniel Defoe's famous novel Robinson Crusoe was first published in 1719, and Hume presumably read it when he was a boy. Finding a watch was an example used later by Archdeacon William Paley in his version of the design argument (Natural Theology. Or Evidences of the Existence and Attributes of the Deity Collected from the Appearances of Nature, 1802).

this nature, we shall find that they are founded on the relation of cause and effect, and that this relation is either near or remote, direct or collateral. Heat and light are collateral effects of fire, and the one effect may justly be inferred from the other.

If we would satisfy ourselves, therefore, concerning the nature of that evidence, which assures us of matters of fact, we must enquire how we arrive at the knowledge of cause and effect.

I shall venture to affirm, as a general proposition, which admits of no exception, that the knowledge of this relation is not. in any instance, attained by reasonings a priori; but arises entirely from experience, when we find that any particular objects are constantly conjoined with each other. Let an object be presented to a man of ever so strong natural reason and abilities; if that object be entirely new to him, he will not be able, by the most accurate examination of its sensible qualities, to discover any of its causes or effects. Adam, though his rational faculties be supposed, at the very first, entirely perfect, could not have inferred from the fluidity and transparency of water that it would suffocate him, or from the light and warmth of fire that it would consume him. No object ever discovers, by the qualities which appear to the senses, either the causes which produced it. or the effects which will arise from it; nor can our reason, unassisted by experience, ever draw any inference concerning real existence and matter of fact.

This proposition, that causes and effects are discoverable, not by reason but by experience, will readily be admitted with regard to such objects, as we remember to have once been altogether unknown to us; since we must be conscious of the utter inability, which we then lay under, of foretelling what would arise from them. Present two smooth pieces of marble to a man who has no tincture of natural philosophy; he will never discover that they will adhere together in such a manner as to require great force to separate them in a direct line, while they make so small a resistance to a lateral pressure. Such events, as bear little analogy to the common course of nature, are also readily confessed to be known only by experience; nor does any man imagine that the explosion of gunpowder, or the attraction of a loadstone, could ever be discovered by arguments a priori. In like manner, when an effect is supposed to depend upon an intricate machinery or secret structure of parts, we make no difficulty in attributing all our knowledge of it to experience. Who will assert that he can give the ultimate reason, why milk or bread is proper nourishment for a man, not for a lion or a tiger?

But the same truth may not appear, at first sight, to have the same evidence with regard to events, which have become familiar to us from our first appearance in the world, which bear a close analogy to the whole course of nature, and which are supposed to depend on the simple qualities of objects, without any secret structure of parts. We are apt to imagine that we could discover these effects by the mere operation of our reason, without experience. We fancy, that were we brought on a sudden into this world, we could at first have inferred that one Billiard-ball would communicate motion to another upon impulse; and that we needed not to have waited for the event, in order to pronounce with certainty concerning it. Such is the influence of custom, that, where it is strongest, it not only covers our natural ignorance, but even conceals itself, and seems not to take place, merely because it is found in the highest degree.

But to convince us that all the laws of nature, and all the operations of bodies without exception, are known only by experience, the following reflections may, perhaps, suffice. Were any object presented to us, and were we required to pronounce concerning the effect, which will result from it, without consulting past observation; after what manner, I beseech you, must the mind proceed in this operation? It must invent or imagine some event, which it ascribes to the object as its effect; and it is plain that this invention must be entirely arbitrary. The mind can never possibly find the effect in the supposed cause, by the most accurate scrutiny and examination. For the effect is totally different from the cause, and consequently can never be discovered in it. Motion in the second Billiard-ball is a quite distinct event from motion in the first; nor is there anything in the one to suggest the smallest hint of the other. A stone or piece of metal raised into the air, and left without any support, immediately falls: but to consider the matter a priori, is there anything we discover in this situation which can beget the idea of a downward, rather than an upward, or any other motion, in the stone or metal?

And as the first imagination or invention of a particular effect, in all natural operations, is arbitrary, where we consult not experience; so must we also esteem the supposed tie or connexion between the cause and effect, which binds them together, and renders it impossible that any other effect could

result from the operation of that cause. When I see, for instance, a Billiard-ball moving in a straight line towards another; even suppose motion in the second ball should by accident be suggested to me, as the result of their contact or impulse; may I not conceive, that a hundred different events might as well follow from that cause? May not both these balls remain at absolute rest? May not the first ball return in a straight line, or leap off from the second in any line or direction? All these suppositions are consistent and conceivable. Why then should we give the preference to one, which is no more consistent or conceivable than the rest? All our reasonings a priori will never be able to show us any foundation for this preference.

In a word, then, every effect is a distinct event from its cause. It could not, therefore, be discovered in the cause, and the first invention or conception of it, *a priori*, must be entirely arbitrary. And even after it is suggested, the conjunction of it with the cause must appear equally arbitrary; since there are always many other effects, which, to reason, must seem fully as consistent and natural. In vain, therefore, should we pretend to determine any single event, or infer any cause or effect, without the assistance of observation and experience.

Hence we may discover the reason why no philosopher, who is rational and modest, has ever pretended to assign the ultimate cause of any natural operation, or to show distinctly the action of that power, which produces any single effect in the universe. It is confessed, that the utmost effort of human reason is to reduce the principles, productive of natural phenomena, to a greater simplicity, and to resolve the many particular effects into a few general causes, by means of reasonings from analogy. experience, and observation. But as to the causes of these general causes, we should in vain attempt their discovery; nor shall we ever be able to satisfy ourselves, by any particular explication of them. 23 These ultimate springs and principles are totally shut up from human curiosity and enquiry. Elasticity. gravity, cohesion of parts, communication of motion by impulse: these are probably the ultimate causes and principles which we shall ever discover in nature; and we may esteem ourselves sufficiently happy, if, by accurate enquiry and reasoning, we can

²³ This is parallel with Newton's statement, "hypotheses non fingo", in the *Principia*. By this he means that he does not make judgements about causes apart from experiences.

trace up the particular phenomena to, or near to, these general principles. The most perfect philosophy of the natural kind only staves off our ignorance a little longer: as perhaps the most perfect philosophy of the moral or metaphysical kind serves only to discover larger portions of it. Thus the observation of human blindness and weakness is the result of all philosophy, and meets us at every turn, in spite of our endeavours to elude or avoid it.

Nor is geometry, when taken into the assistance of natural philosophy, ever able to remedy this defect, or lead us into the knowledge of ultimate causes, by all that accuracy of reasoning for which it is so justly celebrated. Every part of mixed mathematics²⁴ proceeds upon the supposition that certain laws are established by nature in her operations; and abstract reasonings are employed, either to assist experience in the discovery of these laws, or to determine their influence in particular instances, where it depends upon any precise degree of distance and quantity. Thus, it is a law of motion, discovered by experience, that the moment or force of any body in motion is in the compound ratio or proportion of its solid contents and its velocity; and consequently, that a small force may remove the greatest obstacle or raise the greatest weight, if, by any contrivance or machinery, we can increase the velocity of that force, so as to make it an overmatch for its antagonist. Geometry assists us in the application of this law, by giving us the just dimensions of all the parts and figures which can enter into any species of machine; but still the discovery of the law itself is owing merely to experience, and all the abstract reasonings in the world could never lead us one step towards the knowledge of it. When we reason a priori, and consider merely any object or cause, as it appears to the mind, independent of all observation, it never could suggest to us the notion of any distinct object, such as its effect; much less, show us the inseparable and inviolable connexion between them. A man must be very sagacious who could discover by reasoning that crystal is the effect of heat, and ice of cold, without being previously acquainted with the operation of these qualities.

²⁴ By "mixed mathematics" Hume means applied mathematics, that is to say mathematical reasoning applied to the physical world, as in engineering, navigation, or physical science.

PART II

But we have not yet attained any tolerable satisfaction with regard to the question first proposed. Each solution still gives rise to a new question as difficult as the foregoing, and leads us on to farther enquiries. When it is asked, What is the nature of all our reasonings concerning matter of fact? the proper answer seems to be, that they are founded on the relation of cause and effect. When again it is asked, What is the foundation of all our reasonings and conclusions concerning that relation? it may be replied in one word, Experience. But if we still carry on our sifting humour, and ask, What is the foundation of all conclusions from experience? this implies a new question, which may be of more difficult solution and explication. Philosophers, that give themselves airs of superior wisdom and sufficiency, have a hard task when they encounter persons of inquisitive dispositions, who push them from every corner to which they retreat, and who are sure at last to bring them to some dangerous dilemma. The best expedient to prevent this confusion, is to be modest in our pretensions; and even to discover the difficulty ourselves before it is objected to us. By this means, we may make a kind of merit of our very ignorance.

I shall content myself, in this section, with an easy task, and shall pretend²⁵ only to give a negative answer to the question here proposed. I say then, that, even after we have experience of the operations of cause and effect, our conclusions from that experience are *not* founded on reasoning, or any process of the understanding. This answer we must endeavour both to explain and to defend.

It must certainly be allowed, that nature has kept us at a great distance from all her secrets, and has afforded us only the knowledge of a few superficial qualities of objects; while she conceals from us those powers and principles on which the influence of these objects entirely depends. Our senses inform us of the colour, weight, and consistence of bread; but neither sense nor reason can ever inform us of those qualities which fit it for the nourishment and support of a human body. Sight or feeling conveys an idea of the actual motion of bodies; but as to that wonderful force or power, which would carry on a moving

²⁵ In Hume's time 'pretend' could mean 'claim', 'put forward', or 'attempt'.

body for ever in a continued change of place, and which bodies never lose but by communicating it to others; of this we cannot form the most distant conception.²⁶ But notwithstanding this ignorance of natural powers and principles, we always presume. when we see like sensible qualities, that they have like secret powers, and expect that effects, similar to those which we have experienced, will follow from them. (The word Power, is here used in a loose and popular sense. The more accurate explication of it would give additional evidence to this argument. See Section VII.)27 If a body of like colour and consistence with that bread, which we have formerly eat, be presented to us, we make no scruple of repeating the experiment, and foresee, with certainty, like nourishment and support. Now this is a process of the mind or thought, of which I would willingly know the foundation. It is allowed on all hands that there is no known connexion between the sensible qualities and the secret powers: and consequently, that the mind is not led to form such a conclusion concerning their constant and regular conjunction, by anything which it knows of their nature. As to past Experience, it can be allowed to give direct and certain information of those precise objects only, and that precise period of time, which fell under its cognizance: but why this experience should be extended to future times, and to other objects, which for aught we know, may be only in appearance similar; this is the main question on which I would insist. The bread, which I formerly eat, nourished me; that is, a body of such sensible qualities was, at that time, endued with such secret powers; but does it follow. that other bread must also nourish me at another time, and that like sensible qualities must always be attended with like secret powers? The consequence seems nowise necessary. At least, it must be acknowledged that there is here a consequence drawn by the mind: that there is a certain step taken; a process of thought, and an inference, which wants to be explained. These two propositions are far from being the same, I have found that such an object has always been attended with such an effect, and I foresee, that other objects, which are, in appearance, similar, will be attended with similar effects. I shall allow, if you please,

 $^{^{26}}$ A reference to Newton's first law of motion. This contradicted the Scholastic axiom, 'Whatever is moved is moved by another.'

 $^{^{\}rm 27}\,\rm The\; three\; sentences\; in\; parentheses\; were originally printed as a footnote.$

that the one proposition may justly be inferred from the other: I know, in fact, that it always is inferred. But if you insist that the inference is made by a chain of reasoning, I desire you to produce that reasoning. The connexion between these propositions is not intuitive. There is required a medium, which may enable the mind to draw such an inference, if indeed it be drawn by reasoning and argument. What that medium is, I must confess, passes my comprehension; and it is incumbent on those to produce it, who assert that it really exists, and is the origin of all our conclusions concerning matter of fact.

This negative argument must certainly, in process of time, become altogether convincing, if many penetrating and able philosophers shall turn their enquiries this way and no one be ever able to discover any connecting proposition or intermediate step, which supports the understanding in this conclusion. But as the question is yet new, every reader may not trust so far to his own penetration, as to conclude, because an argument escapes his enquiry, that therefore it does not really exist. For this reason it may be requisite to venture upon a more difficult task; and enumerating all the branches of human knowledge, endeavour to show that none of them can afford such an argument.

All reasonings may be divided into two kinds, namely, demonstrative reasoning, or that concerning relations of ideas. and moral reasoning, or that concerning matter of fact and existence. That there are no demonstrative arguments in the case seems evident; since it implies no contradiction that the course of nature may change, and that an object, seemingly like those which we have experienced, may be attended with different or contrary effects. May I not clearly and distinctly conceive that a body, falling from the clouds, and which, in all other respects, resembles snow, has yet the taste of salt or feeling of fire? Is there any more intelligible proposition than to affirm. that all the trees will flourish in December and January, and decay in May and June? Now whatever is intelligible, and can be distinctly conceived, implies no contradiction, and can never be proved false by any demonstrative argument or abstract reasoning à priori.

If we be, therefore, engaged by arguments to put trust in past experience, and make it the standard of our future judgement, these arguments must be probable only, or such as regard matter of fact and real existence, according to the division above mentioned. But that there is no argument of this kind,

must appear, if our explication of that species of reasoning be admitted as solid and satisfactory. We have said that all arguments concerning existence are founded on the relation of cause and effect; that our knowledge of that relation is derived entirely from experience; and that all our experimental conclusions proceed upon the supposition that the future will be conformable to the past. To endeavour, therefore, the proof of this last supposition by probable arguments, or arguments regarding existence, must be evidently going in a circle, and taking that for granted, which is the very point in question.

In reality, all arguments from experience are founded on the similarity which we discover among natural objects, and by which we are induced to expect effects similar to those which we have found to follow from such objects. And though none but a fool or madman will ever pretend to dispute the authority of experience, or to reject that great guide of human life, it may surely be allowed a philosopher to have so much curiosity at least as to examine the principle of human nature, which gives this mighty authority to experience, and makes us draw advantage from the similarity which nature has placed among different objects. From causes which appear similar we expect similar effects. This is the sum of all our experimental conclusions. Now it seems evident that, if this conclusion were formed by reason, it would be as perfect at first, and upon one instance. as after ever so long a course of experience. But the case is far otherwise. Nothing so like as eggs; yet no one, on account of this appearing similarity, expects the same taste and relish in all of them. It is only after a long course of uniform experiments in any kind, that we attain a firm reliance and security with regard to a particular event. Now where is that process of reasoning which, from one instance, draws a conclusion, so different from that which it infers from a hundred instances that are nowise different from that single one? This question I propose as much for the sake of information, as with an intention of raising difficulties. I canot find, I cannot imagine any such reasoning. But I keep my mind still open to instruction, if any one will vouchsafe to bestow it on me.

Should it be said that, from a number of uniform experiments, we *infer* a connexion between the sensible qualities and the secret powers; this, I must confess, seems the same difficulty, couched in different terms. The question still recurs, on what process of argument this *inference* is founded? Where is the

medium, the interposing ideas, which join propositions so very wide of each other? It is confessed that the colour, consistence, and other sensible qualities of bread appear not, of themselves. to have any connexion with the secret powers of nourishment and support. For otherwise we could infer these secret powers from the first appearance of these sensible qualities, without the aid of experience; contrary to the sentiment of all philosophers. and contrary to plain matter of fact. Here, then, is our natural state of ignorance with regard to the powers and influence of all objects. How is this remedied by experience? It only shows us a number of uniform effects, resulting from certain objects, and teaches us that those particular objects, at that particular time. were endowed with such powers and forces. When a new object. endowed with similar sensible qualities, is produced, we expect similar powers and forces, and look for a like effect. From a body of like colour and consistence with bread we expect like nourishment and support. But this surely is a step or progress of the mind, which wants to be explained. When a man says, I have found, in all past instances, such sensible qualities conjoined with such secret powers: And when he says, Similar sensible qualities will always be conjoined with similar secret powers, he is not guilty of a tautology, nor are these propositions in any respect the same. You say that the one proposition is an inference from the other. But you must confess that the inference is not intuitive; neither is it demonstrative: Of what nature is it, then? To say it is experimental, is begging the question. For all inferences from experience suppose, as their foundation, that the future will resemble the past, and that similar powers will be conjoined with similar sensible qualities. If there be any suspicion that the course of nature may change, and that the past may be no rule for the future, all experience becomes useless, and can give rise to no inference or conclusion. It is impossible, therefore, that any arguments from experience can prove this resemblance of the past to the future; since all these arguments are founded on the supposition of that resemblance. Let the course of things be allowed hitherto ever so regular; that alone, without some new argument or inference, proves not that, for the future, it will continue so. In vain do you pretend to have learned the nature of bodies from your past experience. Their secret nature, and consequently all their effects and influence, may change, without any change in their sensible qualities. This happens sometimes, and with regard to

some objects: Why may it not happen always, and with regard to all objects? What logic, what process of argument secures you against this supposition? My practice, you say, refutes my doubts. But you mistake the purport of my question. As an agent, I am quite satisfied in the point; but as a philosopher, who has some share of curiosity, I will not say scepticism, I want to learn the foundation of this inference. No reading, no enquiry has yet been able to remove my difficulty, or give me satisfaction in a matter of such importance. Can I do better than propose the difficulty to the public, even though, perhaps, I have small hopes of obtaining a solution? We shall at least, by this means, be sensible of our ignorance, if we do not augment our knowledge.

I must confess that a man is guilty of unpardonable arrogance who concludes, because an argument has escaped his own investigation, that therefore it does not really exist. I must also confess that, though all the learned, for several ages, should have employed themselves in fruitless search upon any subject, it may still, perhaps, be rash to conclude positively that the subject must, therefore, pass all human comprehension. Even though we examine all sources of our knowledge, and conclude them unfit for such a subject, there may still remain a suspicion, that the enumeration is not complete, or the examination not accurate. But with regard to the present subject, there are some considerations which seem to remove all this accusation of arrogance or suspicion of mistake.

It is certain that the most ignorant and stupid peasants nay infants, nay even brute beasts—improve by experience, and learn the qualities of natural objects, by observing the effects which result from them. When a child has felt the sensation of pain from touching the flame of a candle, he will be careful not to put his hand near any candle; but will expect a similar effect from a cause which is similar in its sensible qualities and appearance. If you assert, therefore, that the understanding of the child is led into this conclusion by any process of argument or ratiocination, I may justly require you to produce that argument; nor have you any pretence to refuse so equitable a demand. You cannot say that the argument is abstruse, and may possibly escape your enquiry; since you confess that it is obvious to the capacity of a mere infant. If you hesitate, therefore, a moment, or if, after reflection, you produce any intricate or profound argument, you, in a manner, give up the question, and confess that it is not reasoning which engages us to suppose the past resembling the future, and to expect similar effects from causes which are, to appearance, similar. This is the proposition which I intended to enforce in the present section. If I be right, I pretend not to have made any mighty discovery. And if I be wrong, I must acknowledge myself to be indeed a very backward scholar; since I cannot now discover an argument which, it seems, was perfectly familiar to me long before I was out of my cradle.

Sceptical Solution of these Doubts

PARTI

THE passion for philosophy, like that for religion, seems liable to this inconvenience, that, though it aims at the correction of our manners, and extirpation of our vices, it may only serve, by imprudent management, to foster a predominant inclination, and push the mind, with more determined resolution, towards that side which already draws too much, by the bias and propensity of the natural temper. It is certain that, while we aspire to the magnanimous firmness of the philosophic sage, and endeavour to confine our pleasures altogether without our own minds, we may, at last, render our philosophy like that of Epictetus, and other Stoics, only a more refined system of selfishness, and reason ourselves out of all virtue as well as social enjoyment. 28 While we study with attention the vanity of human life, and turn all our thoughts towards the empty and transitory nature of riches and honours, we are, perhaps, all the while flattering our natural indolence, which, hating the bustle of the world, and drudgery of business, seeks a pretence of reason to give itself a full and uncontrolled indulgence. There is, however, one species of philosophy which seems little liable to this inconvenience, and that because it strikes in with no disorderly passion of the human mind, nor can mingle itself with any natural affection or propensity; and that is the Academic or Sceptical philosophy. 29 The academics always talk of doubt and suspense of judgement, of danger in hasty determinations, of confining to very narrow bounds the enquiries of the understanding, and of renouncing all speculations which lie not

 $^{^{28}}$ Epictetus (c. 55–135 $_{\rm CE})$ was a freed slave who taught, or perhaps rather preached, a gospel of inner freedom, to be achieved through submission to fate and a rigorous detachment from everything not in our power.

²⁹ The Academy of Athens, in effect the first university, was established by Plato in about 385 BCE. Hume's main source for "Academic philosophy" will have been Cicero's *Academica* and *de Natura Deorum*, and in Cicero's time the Academy was Sceptical rather than Platonic.

within the limits of common life and practice. Nothing, therefore, can be more contrary than such a philosophy to the supine indolence of the mind, its rash arrogance, its lofty pretensions, and its superstitious credulity. Every passion is mortified by it, except the love of truth; and that passion never is, nor can be, carried to too high a degree. It is surprising, therefore, that this philosophy, which, in almost every instance, must be harmless and innocent, should be the subject of so much groundless reproach and obloquy. But, perhaps, the very circumstance which renders it so innocent is what chiefly exposes it to the public hatred and resentment. By flattering no irregular passion, it gains few partizans: By opposing so many vices and follies, it raises to itself abundance of enemies, who stigmatize it as libertine, profane, and irreligious.

Nor need we fear that this philosophy, while it endeavours to limit our enquiries to common life, should ever undermine the reasonings of common life, and carry its doubts so far as to destroy all action, as well as speculation. Nature will always maintain her rights, and prevail in the end over any abstract reasoning whatsoever. Though we should conclude, for instance, as in the foregoing section, that, in all reasonings from experience, there is a step taken by the mind which is not supported by any argument or process of the understanding; there is no danger that these reasonings, on which almost all knowledge depends, will ever be affected by such a discovery. If the mind be not engaged by argument to make this step, it must be induced by some other principle of equal weight and authority; and that principle will preserve its influence as long as human nature remains the same. What that principle is may well be worth the pains of enquiry.

Suppose a person, though endowed with the strongest faculties of reason and reflection, to be brought on a sudden into this world; he would, indeed, immediately observe a continual succession of objects, and one event following another; but he would not be able to discover anything farther. He would not, at first, by any reasoning, be able to reach the idea of cause and effect; since the particular powers, by which all natural operations are performed, never appear to the senses; nor is it reasonable to conclude, merely because one event, in one instance, precedes another, that therefore the one is the cause, the other the effect. Their conjunction may be arbitrary and casual. There may be no reason to infer the existence of one from

the appearance of the other. And in a word, such a person, without more experience, could never employ his conjecture or reasoning concerning any matter of fact, or be assured of anything beyond what was immediately present to his memory and senses.

Suppose, again, that he has acquired more experience, and has lived so long in the world as to have observed similar objects or events to be constantly conjoined together; what is the consequence of this experience? He immediately infers the existence of one object from the appearance of the other. Yet he has not, by all his experience, acquired any idea or knowledge of the secret power by which the one object produces the other; nor is it, by any process of reasoning, he is engaged to draw this inference. But still he finds himself determined to draw it: And though he should be convinced that his understanding has no part of the operation, he would nevertheless continue in the same course of thinking. There is some other principle which determines him to form such a conclusion.

This principle is Custom or Habit. For wherever the repetition of any particular act or operation produces a propensity to renew the same act or operation, without being impelled by any reasoning or process of the understanding, we always say, that this propensity is the effect of Custom. By employing that word, we pretend not to have given the ultimate reason of such a propensity. We only point out a principle of human nature. which is universally acknowledged, and which is well known by its effects. Perhaps we can push our enquiries no farther, or pretend to give the cause of this cause; but must rest contented with it as the ultimate principle, which we can assign, of all our conclusions from experience. It is sufficient satisfaction, that we can go so far, without repining at the narrowness of our faculties because they will carry us no farther. And it is certain we here advance a very intelligible proposition at least, if not a true one, when we assert that, after the constant conjunction of two objects—heat and flame, for instance, weight and solidity—we are determined by custom alone to expect the one from the appearance of the other. This hypothesis seems even the only one which explains the difficulty, why we draw from a thousand instances, an inference which we are not able to draw from one instance, that is, in no respect, different from them. Reason is incapable of any such variation. The conclusions which it draws from considering one circle are the same which it would form

upon surveying all the circles in the universe. But no man, having seen only one body move after being impelled by another, could infer that every other body will move after a like impulse. All inferences from experience, therefore, are effects of custom, not of reasoning. 30

Nothing is more usual than for writers, even, on moral, political, or physical subjects, to distinguish between reason and experience, and to suppose, that these species of argumentation are entirely different from each other. The former are taken for the mere result of our intellectual faculties, which, by considering à priori the nature of things, and examining the effects, that must follow from their operation, establish particular principles of science and philosophy. The latter are supposed to be derived entirely from sense and observation, by which we learn what has actually resulted from the operation of particular objects, and are thence able to infer, what will, for the future, result from them. Thus, for instance, the limitations and restraints of civil government, and a legal constitution, may be defended, either from reason, which reflecting on the great frailty and corruption of human nature, teaches, that no man can safely be trusted with unlimited authority; or from experience and history, which inform us of the enormous abuses, that ambition. in every age and country, has been found to make of so imprudent a confidence.

The same distinction between reason and experience is maintained in all our deliberations concerning the conduct of life; while the experienced statesman, general, physician, or merchant is trusted and followed; and the unpractised novice, with whatever natural talents endowed, neglected and despised. Though it be allowed, that reason may form very plausible conjectures with regard to the consequences of such a particular conduct in such particular circumstances; it is still supposed imperfect, without the assistance of experience, which is alone able to give stability and certainty to the maxims, derived from study and reflection.

But notwithstanding that this distinction be thus universally received, both in the active and speculative scenes of life, I shall not scruple to pronounce, that it is, at bottom, erroneous, at least, superficial.

 $^{^{30}}$ Hume had all the following five paragraphs printed as a footnote. Here as elsewhere his notes have been promoted into the text.

If we examine those arguments, which, in any of the sciences above mentioned, are supposed to be the mere effects of reasoning and reflection, they will be found to terminate, at last. in some general principle or conclusion, for which we can assign no reason but observation and experience. The only difference between them and those maxims, which are vulgarly esteemed the result of pure experience, is, that the former cannot be established without some process of thought, and some reflection on what we have observed, in order to distinguish its circumstances, and trace its consequences: Whereas in the latter, the experienced event is exactly and fully similar to that which we infer as the result of any particular situation. The history of a Tiberius or a Nero makes us dread a like tyranny, were our monarchs freed from the restraints of laws and senates:31 But the observation of any fraud or cruelty in private life is sufficient, with the aid of a little thought, to give us the same apprehension; while it serves as an instance of the general corruption of human nature, and shows us the danger which we must incur by reposing an entire confidence in mankind. In both cases, it is experience which is ultimately the foundation of our inference and conclusion.

There is no man so young and unexperienced, as not to have formed, from observation, many general and just maxims concerning human affairs and the conduct of life; but it must be confessed, that, when a man comes to put these in practice, he will be extremely liable to error, till time and farther experience both enlarge these maxims, and teach him their proper use and application. In every situation or incident, there are many particular and seemingly minute circumstances, which the man of greatest talents is, at first, apt to overlook, though on them the justness of his conclusions, and consequently the prudence of his conduct, entirely depend. Not to mention, that, to a young beginner, the general observations and maxims occur not always on the proper occasions, nor can be immediately applied with due calmness and distinction. The truth is, an unexperienced reasoner could be no reasoner at all, were he absolutely unexperienced; and when we assign that character to any one, we mean it only in a comparative sense, and suppose him possessed of experience, in a smaller and more imperfect degree.

³¹ Tiberius and Nero were both Roman Emperors in the first century CE.

Custom, then, is the great guide of human life. It is that principle alone which renders our experience useful to us, and makes us expect, for the future, a similar train of events with those which have appeared in the past. Without the influence of custom, we should be entirely ignorant of every matter of fact beyond what is immediately present to the memory and senses. We should never know how to adjust means to ends, or to employ our natural powers in the production of any effect. There would be an end at once of all action, as well as of the chief part of speculation.

But here it may be proper to remark, that though our conclusions from experience carry us beyond our memory and senses, and assure us of matters of fact which happened in the most distant places and most remote ages, yet some fact must always be present to the senses or memory, from which we may first proceed in drawing these conclusions. A man, who should find in a desert country the remains of pompous buildings, would conclude that the country had, in ancient times, been cultivated by civilized inhabitants; but did nothing of this nature occur to him, he could never form such an inference. We learn the events of former ages from history; but then we must peruse the volumes in which this instruction is contained, and thence carry up our inferences from one testimony to another. till we arrive at the evewitnesses and spectators of these distant events. In a word, if we proceed not upon some fact, present to the memory or senses, our reasonings would be merely hypothetical; and however the particular links might be connected with each other, the whole chain of inferences would have nothing to support it, nor could we ever, by its means, arrive at the knowledge of any real existence. If I ask why you believe any particular matter of fact, which you relate, you must tell me some reason; and this reason will be some other fact, connected with it. But as you cannot proceed after this manner, in infinitum, you must at last terminate in some fact, which is present to your memory or senses; or must allow that your belief is entirely without foundation.

What, then, is the conclusion of the whole matter? A simple one; though, it must be confessed, pretty remote from the common theories of philosophy. All belief of matter of fact or real existence is derived merely from some object, present to the memory or senses, and a customary conjunction between that and some other object. Or in other words; having found, in many

instances, that any two kinds of objects—flame and heat, snow and cold—have always been conjoined together; if flame or snow be presented anew to the senses, the mind is carried by custom to expect heat or cold, and to *believe* that such a quality does exist, and will discover itself upon a nearer approach. This belief is the necessary result of placing the mind in such circumstances. ³² It is an operation of the soul, when we are so situated, as unavoidable as to feel the passion of love, when we receive benefits; or hatred, when we meet with injuries. All these operations are a species of natural instincts, which no reasoning or process of the thought and understanding is able either to produce or to prevent.

At this point, it would be very allowable for us to stop our philosophical researches. In most questions we can never make a single step farther; and in all questions we must terminate here at last, after our most restless and curious enquiries. But still our curiosity will be pardonable, perhaps commendable, if it carry us on to still farther researches, and make us examine more accurately the nature of this *belief*, and of the *customary conjunction*, whence it is derived. By this means we may meet with some explications and analogies that will give satisfaction; at least to such as love the abstract sciences, and can be entertained with speculations, which, however accurate, may still retain a degree of doubt and uncertainty. As to readers of a different taste; the remaining part of this section is not calculated for them, and the following enquiries may well be understood, though it be neglected.

PART II

NOTHING is more free than the imagination of man; and though it cannot exceed that original stock of ideas furnished by the internal and external senses, it has unlimited power of mixing,

 $^{^{32}}$ Hume's argument is not circular. If he is right that we tend to expect similar results from similar causes, though this principle is not rationally necessary, the principle can legitimately be applied to itself as well as to particular instances of it. That is, the mind by custom expects the sun to rise tomorrow, owing to its having risen many times previously. It also accepts the principle that similar causes produce similar effects since it has proved true in the past.

compounding, separating, and dividing these ideas, in all the varieties of fiction and vision. It can feign a train of events, with all the appearance of reality, ascribe to them a particular time and place, conceive them as existent, and paint them out to itself with every circumstance, that belongs to any historical fact, which it believes with the greatest certainty. Wherein, therefore. consists the difference between such a fiction and belief? It lies not merely in any peculiar idea, which is annexed to such a conception as commands our assent, and which is wanting to every known fiction. For as the mind has authority over all its ideas, it could voluntarily annex this particular idea to any fiction, and consequently be able to believe whatever it pleases; contrary to what we find by daily experience. We can, in our conception, join the head of a man to the body of a horse; but it is not in our power to believe that such an animal has ever really existed.

It follows, therefore, that the difference between fiction and belief lies in some sentiment or feeling, which is annexed to the latter, not to the former, and which depends not on the will, nor can be commanded at pleasure. It must be excited by nature, like all other sentiments: and must arise from the particular situation, in which the mind is placed at any particular juncture. Whenever any object is presented to the memory or senses, it immediately, by the force of custom, carries the imagination to conceive that object, which is usually conjoined to it; and this conception is attended with a feeling or sentiment, different from the loose reveries of the fancy. In this consists the whole nature of belief. For as there is no matter of fact which we believe so firmly that we cannot conceive the contrary, there would be no difference between the conception assented to and that which is rejected, were it not for some sentiment which distinguishes the one from the other. If I see a billiard-ball moving towards another, on a smooth table, I can easily conceive it to stop upon contact. This conception implies no contradiction; but still it feels very differently from that conception by which I represent to myself the impulse and the communication of motion from one ball to another.

Were we to attempt a *definition* of this sentiment, we should, perhaps, find it a very difficult, if not an impossible task; in the same manner as if we should endeavour to define the feeling of cold or passion of anger, to a creature who never had any experience of these sentiments. Belief is the true and proper

name of this feeling; and no one is ever at a loss to know the meaning of that term: because every man is every moment conscious of the sentiment represented by it. It may not, however, be improper to attempt a description of this sentiment; in hopes we may, by that means, arrive at some analogies, which may afford a more perfect explication of it. I say, then, that belief is nothing but a more vivid, lively, forcible, firm, steady conception of an object, than what the imagination alone is ever able to attain.33 This variety of terms, which may seem so unphilosophical, is intended only to express that act of the mind. which renders realities, or what is taken for such, more present to us than fictions, causes them to weigh more in the thought. and gives them a superior influence on the passions and imagination. Provided we agree about the thing, it is needless to dispute about the terms. The imagination has the command over all its ideas, and can join and mix and vary them, in all the ways possible. It may conceive fictitious objects with all the circumstances of place and time. It may set them, in a manner, before our eyes, in their true colours, just as they might have existed. But as it is impossible that this faculty of imagination can ever, of itself, reach belief, it is evident that belief consists not in the peculiar nature or order of ideas, but in the manner of their conception, and in their feeling to the mind. I confess, that it is impossible perfectly to explain this feeling or manner of conception. We may make use of words which express something near it. But its true and proper name, as we observed before, is belief; which is a term that every one sufficiently understands in common life. And in philosophy, we can go no farther than assert, that belief is something felt by the mind, which distinguishes the ideas of the judgement from the fictions of the imagination. It gives them more weight and influence; makes them appear of greater importance; enforces them in the mind: and renders them the governing principle of our actions. I hear at present, for instance, a person's voice, with whom I am acquainted; and the sound comes as from the next room. This impression of my senses immediately conveys my thought to the person, together with all the surrounding objects. I paint them out to myself as existing at present, with the same qualities and

³³ It follows that a conception about a real object not immediately present to the mind is intermediate in force between an impression of an object present to the mind and an idea of an imaginary object.

relations, of which I formerly knew them possessed. These ideas take faster hold of my mind, than ideas of an enchanted castle. They are very different to the feeling, and have a much greater influence of every kind, either to give pleasure or pain, joy or sorrow.

Let us, then, take in the whole compass of this doctrine, and allow, that the sentiment of belief is nothing but a conception more intense and steady than what attends the mere fictions of the imagination, and that this *manner* of conception arises from a customary conjunction of the object with something present to the memory or senses: I believe that it will not be difficult, upon these suppositions, to find other operations of the mind analogous to it, and to trace up these phenomena to principles still more general.

We have already observed that nature has established connexions among particular ideas, and that no sooner one idea occurs to our thoughts than it introduces its correlative, and carries our attention towards it, by a gentle and insensible movement. These principles of connexion or association we have reduced to three, namely, Resemblance, Contiguity and Causation; which are the only bonds that unite our thoughts together. and beget that regular train of reflection or discourse, which, in a greater or less degree, takes place among all mankind. Now here arises a question, on which the solution of the present difficulty will depend. Does it happen, in all these relations. that, when one of the objects is presented to the senses or memory, the mind is not only carried to the conception of the correlative, but reaches a steadier and stronger conception of it than what otherwise it would have been able to attain? This seems to be the case with that belief which arises from the relation of cause and effect. And if the case be the same with the other relations or principles of association, this may be established as a general law, which takes place in all the operations of the mind.

We may, therefore, observe, as the first experiment to our present purpose, that, upon the appearance of the picture of an absent friend, our idea of him is evidently enlivened by the *resemblance*, and that every passion, which that idea occasions, whether of joy or sorrow, acquires new force and vigour. In producing this effect, there concur both a relation and a present impression. Where the picture bears him no resemblance, at least was not intended for him, it never so much as conveys our

thought to him: And where it is absent, as well as the person, though the mind may pass from the thought of the one to that of the other, it feels its idea to be rather weakened than enlivened by that transition. We take a pleasure in viewing the picture of a friend, when it is set before us; but when it is removed, rather choose to consider him directly than by reflection in an image, which is equally distant and obscure.

The ceremonies of the Roman Catholic religion may be considered as instances of the same nature. The devotees of that superstition usually plead in excuse for the mummeries, with which they are upbraided, that they feel the good effect of those external motions, and postures, and actions, in enlivening their devotion and quickening their fervour, which otherwise would decay, if directed entirely to distant and immaterial objects. We shadow out the objects of our faith, say they, in sensible types and images, and render them more present to us by the immediate presence of these types, than it is possible for us to do merely by an intellectual view and contemplation. Sensible objects have always a greater influence on the fancy than any other: and this influence they readily convey to those ideas to which they are related, and which they resemble. I shall only infer from these practices, and this reasoning, that the effect of resemblance in enlivening the ideas is very common; and as in every case a resemblance and a present impression must concur, we are abundantly supplied with experiments to prove the reality of the foregoing principle.

We may add force to these experiments by others of a different kind, in considering the effects of *contiguity* as well as of resemblance. It is certain that distance diminishes the force of every idea, and that, upon our approach to any object; though it does not discover itself to our senses; it operates upon the mind with an influence, which imitates an immediate impression. The thinking on any object readily transports the mind to what is contiguous; but it is only the actual presence of an object, that transports it with a superior vivacity. When I am a few miles from home, whatever relates to it touches me more nearly than when I am two hundred leagues distant; though even at that distance the reflecting on any thing in the neighbourhood of friends or family naturally produces an idea of them. But as in this latter case, both the objects of the mind are ideas; notwithstanding there is an easy transition between them; that transition alone is not able to give a superior vivacity to any of the ideas, for want of some immediate impression.34

No one can doubt but causation has the same influence as the other two relations of resemblance and contiguity. Superstitious people are fond of the reliques of saints and holy men, for the same reason, that they seek after types or images, in order to enliven their devotion, and give them a more intimate and strong conception of those exemplary lives, which they desire to imitate. Now it is evident, that one of the best reliques, which a devotee could procure, would be the handywork of a saint; and if his cloaths and furniture are ever to be considered in this light, it is because they were once at his disposal, and were moved and affected by him; in which respect they are to be considered as imperfect effects, and as connected with him by a shorter chain of consequences than any of those, by which we learn the reality of his existence.

Suppose, that the son of a friend, who had been long dead or absent, were presented to us; it is evident, that this object would instantly revive its correlative idea, and recal to our thoughts all past intimacies and familiarities, in more lively colours than they would otherwise have appeared to us. This is another phaenomenon, which seems to prove the principle above mentioned.

We may observe, that, in these phaenomena, the belief of the correlative object is always presupposed; without which the relation could have no effect. The influence of the picture supposes, that we *believe* our friend to have once existed.

 $^{^{34}}$ Here Hume in a footnote quotes, in the original Latin, a passage from Book V, 2 of Cicero's de Finibus. In translation that passage reads as follows: "Thereupon Piso remarked: Whether it is a natural instinct or a mere illusion, I can't say; but one's emotions are more strongly aroused by seeing the places that tradition records to have been the favourite resort of men of note in former days, than by hearing about their deeds or reading their writings. My own feelings at the present moment are a case in point. I am reminded of Plato, the first philosopher, so we are told, that made a practice of holding discussion in this place; and indeed the garden close at hand yonder not only recalls his memory but seems to bring the actual man before my eyes. This was the haunt of Speusippus, of Xenocrates, and of Xenocrates's pupil Polemo, who used to sit on the very seat we see over there. For my own part even the sight of our senate-house at home (I mean the Curia Hostilia, not the present new building, which looks to my eyes smaller since its enlargement) used to call up to me thoughts of Scipio, Cato, Laelius, and chief of all, my grandfather; such powers of suggestion do places possess. No wonder the scientific training of the memory is based upon locality."

Contiguity to home can never excite our ideas of home, unless we believe that it really exists. Now I assert, that this belief, where it reaches beyond the memory or senses, is of a similar nature, and arises from similar causes, with the transition of thought and vivacity of conception here explained. When I throw a piece of dry wood into a fire, my mind is immediately carried to conceive, that it augments, not extinguishes the flame. This transition of thought from the cause to the effect proceeds not from reason. It derives its origin altogether from custom and experience. And as it first begins from an object, present to the senses, it renders the idea or conception of flame more strong and lively than any loose, floating reverie of the imagination. That idea arises immediately. The thought moves instantly towards it. and conveys to it all that force of conception. which is derived from the impression present to the senses. When a sword is levelled at my breast, does not the idea of wound and pain strike me more strongly, than when a glass of wine is presented to me, even though by accident this idea should occur after the appearance of the latter object? But what is there in this whole matter to cause such a strong conception, except only a present object and a customary transition to the idea of another object, which we have been accustomed to conjoin with the former? This is the whole operation of the mind, in all our conclusions concerning matter of fact and existence; and it is a satisfaction to find some analogies, by which it may be explained. The transition from a present object does in all cases give strength and solidity to the related idea.

Here, then, is a kind of pre-established harmony between the course of nature and the succession of our ideas; and though the powers and forces, by which the former is governed, be wholly unknown to us; yet our thoughts and conceptions have still, we find, gone on in the same train with the other works of nature. Custom is that principle, by which this correspondence has been effected; so necessary to the subsistence of our species, and the regulation of our conduct, in every circumstance and occurrence of human life. Had not the presence of an object instantly excited the idea of those objects, commonly conjoined with it, all our knowledge must have been limited to the narrow sphere of our memory and senses; and we should never have been able to adjust means to ends, or employ our natural powers, either to the producing of good, or avoiding of evil. Those, who delight in the discovery and contemplation of *final causes*, have

here ample subject to employ their wonder and admiration.³⁵

I shall add, for a further confirmation of the foregoing theory, that, as this operation of the mind, by which we infer like effects from like causes, and vice versa, is so essential to the subsistence of all human creatures, it is not probable, that it could be trusted to the fallacious deductions of our reason, which is slow in its operations; appears not, in any degree, during the first years of infancy; and at best is, in every age and period of human life, extremely liable to error and mistake. It is more conformable to the ordinary wisdom of nature to secure so necessary an act of the mind, by some instinct or mechanical tendency, wnich may be infallible in its operations, may discover itself at the first appearance of life and thought, and may be independent of all the laboured deductions of the understanding. As nature has taught us the use of our limbs, without giving us the knowledge of the muscles and nerves, by which they are actuated: so has she implanted in us an instinct, which carries forward the thought in a correspondent course to that which she has established among external objects; though we are ignorant of those powers and forces, on which this regular course and succession of objects totally depends.

³⁵ "Final causes" = the end or goal of a causal process, one of the four types of causes given by Aristotle (the others being 'efficient', 'material', and 'formal'). Hume's comment is satirical, since proponents of final causes would be likely to claim that they showed rational agency in nature, an assumption Hume rejects.

Of Probability

Mr. Locke divides all arguments into demonstrative and probable. In this view, we must say, that it is only probable all men must die, or that the sun will rise to-morrow. But to conform our language more to common use, we ought to divide arguments into *demonstrations*, *proofs* and *probabilities*. By proofs meaning such arguments from experience as leave no room for doubt or opposition.³⁶

Though there be no such thing as *Chance* in the world; our ignorance of the real cause of any event has the same influence on the understanding, and begets a like species of belief or opinion.

There is certainly a probability, which arises from a superiority of chances on any side; and according as this superiority encreases, and surpasses the opposite chances, the probability receives a proportionable encrease, and begets still a higher degree of belief or assent to that side, in which we discover the superiority. If a dye were marked with one figure or number of spots on four sides, and with another figure or number of spots on the two remaining sides, it would be more probable, that the former would turn up than the latter; though, if it had a thousand sides marked in the same manner, and only one side different, the probability would be much higher, and our belief or expectation of the event more steady and secure. This process of the thought or reasoning may seem trivial and obvious; but to those who consider it more narrowly, it may, perhaps, afford matter for curious speculation.

It seems evident, that, when the mind looks forward to discover the event, which may result from the throw of such a dye, it considers the turning up of each particular side as alike probable; and this is the very nature of chance, to render all the particular events, comprehended in it, entirely equal. But

 $^{^{36}}$ Hume put these three sentences as a footnote to the title of this Section VI. They are here placed in the body of his text, in the position at which he clearly intended them to be read.

§VI OF PROBABILITY 99

finding a greater number of sides concur in the one event than in the other, the mind is carried more frequently to that event, and meets its oftener, in revolving the various possibilities or chances, on which the ultimate result depends. This concurrence of several views in one particular event begets immediately, by an inexplicable contrivance of nature, the sentiment of belief, and gives that event the advantage over its antagonist. which is supported by a smaller number of views, and recurs less frequently to the mind. If we allow, the belief is nothing but a firmer and stronger conception of an object than what attends the mere fictions of the imagination, this operation may, perhaps, in some measure, be accounted for. The concurrence of these several views or glimpses imprints the idea more strongly on the imagination: gives it superior force and vigour; renders its influence on the passions and affections more sensible; and in a word, begets that reliance or security, which constitutes the nature of belief and opinion.

The case is the same with the probability of causes, as with that of chance. There are some causes, which are entirely uniform and constant in producing a particular effect; and no instance has ever yet been found of any failure or irregularity in their operation. Fire has always burned, and water suffocated every human creature: The production of motion by impulse and gravity is an universal law, which has hitherto admitted of no exception. But there are other causes, which have been found more irregular and uncertain; nor has rhubarb always proved a purge, or opium a soporific to every one, who has taken these medicines. It is true, when any cause fails of producing its usual effect, philosophers ascribe not this to any irregularity in nature: but suppose, that some secret causes, in the particular structure of parts, have prevented the operation. Our reasonings, however, and conclusions concerning the event are the same as if this principle had no place. Being determined by custom to transfer the past to the future, in all our inferences: where the past has been entirely regular and uniform, we expect the event with the greatest assurance, and leave no room for any contrary supposition. But where different effects have been found to follow from causes, which are to appearance exactly similar, all these various effects must occur to the mind in transferring the past to the future, and enter into our consideration, when we determine the probability of the event. Though we give the preference to that which has been found most usual, and believe that this effect will exist, we must not overlook the other effects, but must assign to each of them a particular weight and authority, in proportion as we have found it to be more or less frequent. It is more probable, in almost every country of Europe. that there will be frost sometime in January, than that the weather will continue open throughout that whole month: though this probability varies according to the different climates, and approaches to a certainty in the more northern kingdoms. Here then it seems evident, that, when we transfer the past to the future, in order to determine the effect, which will result from any cause, we transfer all the different events, in the same proportion as they have appeared in the past, and conceive one to have existed a hundred times, for instance, another ten times, and another once. As a great number of views do here concur in one event, they fortify and confirm it to the imagination, beget that sentiment which we call belief, and give its object the preference above the contrary event, which is not supported by an equal number of experiments, and recurs not so frequently to the thought in transferring the past to the future. Let any one try to account for this operation of the mind upon any of the received systems of philosophy, and he will be sensible of the difficulty. For my part, I shall think it sufficient, if the present hints excite the curiosity of philosophers, and make them sensible how defective all common theories are in treating of such curious and such sublime subjects.

Of the Idea of necessary Connexion

PARTI

The great advantage of the mathematical sciences above the moral consists in this, that the ideas of the former, being sensible,37 are always clear and determinate, the smallest distinction between them is immediately perceptible, and the same terms are still expressive of the same ideas, without ambiguity or variation. An oval is never mistaken for a circle, nor an hyperbola for an ellipsis. The isosceles and scalenum are distinguished by boundaries more exact than vice and virtue, right and wrong. If any term be defined in geometry, the mind readily, of itself, substitutes, on all occasions, the definition for the term defined: Or even when no definition is employed, the object itself may be presented to the senses, and by that means be steadily and clearly apprehended. But the finer sentiments of the mind, the operations of the understanding, the various agitations of the passions, though really in themselves distinct. easily escape us, when surveyed by reflection; nor is it in our power to recal the original object, as often as we have occasion to contemplate it. Ambiguity, by this means, is gradually introduced into our reasonings: Similar objects are readily taken to be the same: And the conclusion becomes at last very wide of the premises.

One may safely, however, affirm, that, if we consider these sciences in a proper light, their advantages and disadvantages nearly compensate each other, and reduce both of them to a state of equality. If the mind, with greater facility, retains the ideas of geometry clear and determinate, it must carry on a much longer and more intricate chain of reasoning, and compare ideas much wider of each other, in order to reach the abstruser truths of that science. And if moral ideas are apt, without extreme care, to fall into obscurity and confusion, the inferences are always much

 $^{^{37}}$ That is, a mathematical figure is exactly what it appears to the senses to be: it has no "secret powers and causes".

shorter in these disquisitions, and the intermediate steps, which lead to the conclusion, much fewer than in the sciences which treat of quantity and number. In reality, there is scarcely a proposition in Euclid so simple, as not to consist of more parts, than are to be found in any moral reasoning which runs not into chimera and conceit. Where we trace the principles of the human mind through a few steps, we may be very well satisfied with our progress; considering how soon nature throws a bar to all our enquiries concerning causes, and reduces us to an acknowledgment of our ignorance. The chief obstacle, therefore, to our improvement in the moral or metaphysical sciences is the obscurity of the ideas, and ambiguity of the terms. The principal difficulty in the mathematics is the length of inferences and compass of thought, requisite to the forming of any conclusion. And, perhaps, our progress in natural philosophy is chiefly retarded by the want of proper experiments and phaenomena. which are often discovered by chance and cannot always be found, when requisite, even by the most diligent and prudent enquiry. As moral philosophy seems hitherto to have received less improvement than either geometry or physics, we may conclude, that, if there be any difference in this respect among these sciences, the difficulties, which obstruct the progress of the former, require superior care and capacity to be surmounted.

There are no ideas, which occur in metaphysics, more obscure and uncertain, than those of *power*, *force*, *energy* or *necessary connexion*, of which it is every moment necessary for us to treat in all our disquisitions. We shall, therefore, endeavour, in this section, to fix, if possible, the precise meaning of these terms, and thereby remove some part of that obscurity, which is so much complained of in this species of philosophy.

It seems a proposition, which will not admit of much dispute, that all our ideas are nothing but copies of our impressions, or, in other words, that it is impossible for us to think of anything, which we have not antecedently felt, either by our external or internal senses. I have endeavoured (in Section II, above) to explain and prove this proposition, and have expressed my hopes, that, by a proper application of it, men may reach a greater clearness and precision in philosophical reasonings, than what they have hitherto been able to attain. Complex ideas may, perhaps, be well known by definition, which is nothing but an enumeration of those parts or simple ideas, that compose them. But when we have pushed up definitions to the

most simple ideas, and find still some ambiguity and obscurity; what resource are we then possessed of? By what invention can we throw light upon these ideas, and render them altogether precise and determinate to our intellectual view? Produce the impressions or original sentiments, from which the ideas are copied. These impressions are all strong and sensible. They admit not of ambiguity. They are not only placed in a full light themselves, but may throw light on their correspondent ideas, which lie in obscurity. And by this means, we may, perhaps, attain a new microscope or species of optics, 38 by which, in the moral sciences, the most minute, and most simple ideas may be so enlarged as to fall readily under our apprehension, and be equally known with the grossest and most sensible ideas, that can be the object of our enquiry.

To be fully acquainted, therefore, with the idea of power or necessary connexion, let us examine its impression; and in order to find the impression with greater certainty, let us search for it in all the sources, from which it may possibly be derived.

When we look about us towards external objects, and consider the operation of causes, we are never able, in a single instance, to discover any power or necessary connexion; any quality, which binds the effect to the cause, and renders the one an infallible consequence of the other. We only find, that the one does actually, in fact, follow the other. The impulse of one billiard-ball is attended with motion in the second. This is the whole that appears to the *outward* senses. The mind feels no sentiment or *inward* impression from this succession of objects: Consequently, there is not, in any single, particular instance of cause and effect, any thing which can suggest the idea of power or necessary connexion.

From the first appearance of an object, we never can conjecture what effect will result from it. But were the power or energy of any cause discoverable by the mind, we could foresee the effect, even without experience; and might, at first, pronounce with certainty concerning it, by the mere dint of thought and reasoning.³⁹

 $^{^{38}}$ Hume draws a parallel between the philosophy of the mind, which proceeds by analyzing ideas into impressions, and optics, which uses the microscope. The latter science had made great progress in the seventeenth century through contributions by Newton and others.

³⁹ Hume's conclusion that we cannot perceive causal powers directly has

In reality, there is no part of matter, that does ever, by its sensible qualities, discover any power or energy, or give us ground to imagine, that it could produce any thing, or be followed by any other object, which we could denominate its effect. Solidity, extension, motion; these qualities are all complete in themselves, and never point out any other event which may result from them. The scenes of the universe are continually shifting, and one object follows another in an uninterrupted succession: but the power or force, which actuates the whole machine, is entirely concealed from us, and never discovers itself in any of the sensible qualities of body. We know, that, in fact, heat is a constant attendant of flame; but what is the connexion between them, we have no room so much as to conjecture or imagine. It is impossible, therefore, that the idea of power can be derived from the contemplation of bodies, in single instances of their operation; because no bodies ever discover any power, which can be the original of this idea.

Mr. Locke, in his chapter 'Of Power', says that, finding from experience, that there are several new productions in matter, and concluding that there must somewhere be a power capable of producing them, we arrive at last by this reasoning at the idea of power. But no reasoning can ever give us a new, original, simple idea; as this philosopher himself confesses. This, therefore, can never be the origin of that idea.⁴⁰

Since, therefore, external objects as they appear to the senses, give us no idea of power or necessary connexion, by their operation in particular instances, let us see, whether this idea be derived from reflection on the operations of our own minds, and be copied from any internal impression. It may be said, that we are every moment conscious of internal power; while we feel, that, by the simple command of our will, we can move the organs of our body, or direct the faculties of our mind. An act of volition produces motion in our limbs, or raises a new idea in our imagination. This influence of the will we know by consciousness. Hence we acquire the idea of power or energy; and are certain, that we ourselves and all other intelligent beings are

CONTINUED FROM PAGE 103

been questioned by Albert Michotte, *The Perception of Causality* (London, 1962). Many philosophers, however, have not accepted Michotte's experiments as refuting Hume.

⁴⁰ The sentences in parentheses were originally a footnote.

possessed of power. This idea, then, is an idea of reflection, since it arises from reflecting on the operations of our own mind, and on the command which is exercised by will, both over the organs of the body and faculties of the soul.

We shall proceed to examine this pretension;⁴¹ and first with regard to the influence of volition over the organs of the body. This influence, we may observe, is a fact, which, like all other natural events, can be known only by experience, and can never be foreseen from any apparent energy or power in the cause, which connects it with the effect, and renders the one an infallible consequence of the other. The motion of our body follows upon the command of our will. Of this we are every moment conscious. But the means, by which this is effected; the energy, by which the will performs so extraordinary an operation; of this we are so far from being immediately conscious, that it must for ever escape our most diligent enquiry.

For *first*; is there any principle in all nature more mysterious than the union of soul with body; by which a supposed spiritual substance acquires such an influence over a material one, that the most refined thought is able to actuate the grossest matter? Were we empowered, by a secret wish, to remove mountains, or control the planets in their orbit; this extensive authority would not be more extraordinary, nor more beyond our comprehension. But if by consciousness we perceived any power or energy in the will, we must know this power; we must know its connexion with the effect; we must know the secret union of soul and body, and the nature of both these substances; by which the one is able to operate, in so many instances, upon the other.⁴²

Secondly, We are not able to move all the organs of the body with a like authority; though we cannot assign any reason besides experience, for so remarkable a difference between one and the other. Why has the will an influence over the tongue and fingers, not over the heart or liver? This question would never embarrass us, were we conscious of a power in the former case, not in the latter. We should then perceive, independent of experience, why the authority of will over the organs of the body is circumscribed within such particular limits. Being in that

^{41 &}quot;Pretension" = 'contention' in present-day usage.

⁴² Hume never doubts or denies the existence of consciousness. What he did challenge in *A Treatise of Human Nature* is the assumption that we have an idea of a spiritual substance which is the subject of consciousness.

case fully acquainted with the power or force, by which it operates, we should also know, why its influence reaches precisely to such boundaries, and no farther.

A man, suddenly struck with a palsy in the leg or arm, or who had newly lost those members, frequently endeavours, at first, to move them, and employ them in their usual offices. Here he is as much conscious of power to command such limbs, as a man in perfect health is conscious of power to actuate any member which remains in its natural state and condition. But consciousness never deceives. ⁴³ Consequently, neither in the one case nor in the other, are we ever conscious of any power. We learn the influence of our will from experience alone. And experience only teaches us, how one event constantly follows another; without instructing us in the secret connexion, which binds them together, and renders them inseparable.

Thirdly. We learn from anatomy, that the immediate object of power in voluntary motion, is not the member itself which is moved, but certain muscles, and nerves, and animal spirits, and perhaps, something still more minute and more unknown, through which the motion is successively propagated, ere it reach the member itself whose motion is the immediate object of volition. Can there be a more certain proof, that the power, by which this whole operation is performed, so far from being directly and fully known by an inward sentiment or consciousness, is, to the last degree, mysterious and unintelligible? Here the mind wills a certain event: Immediately another event, unknown to ourselves, and totally different from the one intended, is produced: This event produces another, equally unknown: Till at last, through a long succession, the desired event is produced. But if the original power were felt, it must be known: Were it known, its effect must also be known; since all power is relative to its effect. And vice versa, if the effect be not known, the power cannot be known nor felt. How indeed can we be conscious of a power to move our limbs, when we have no such power: but only that to move certain animal spirits, which, though they produce at last the motion of our limbs, yet operate in such a manner as is wholly beyond our comprehension?

We may, therefore, conclude from the whole, I hope, without any temerity, though with assurance; that our idea of power is

⁴³ This is an assumption reminiscent of Descartes.

not copied from any sentiment or consciousness of power within ourselves, when we give rise to animal motion, or apply our limbs to their proper use and office. That their motion follows the command of the will is a matter of common experience, like other natural events: But the power or energy by which this is effected, like that in other natural events, is unknown and inconceivable.⁴⁴

It may be pretended, that the resistance which we meet with in bodies, obliging us frequently to exert our force, and call up all our power, this gives us the idea of force and power. It is this nisus. 45 or strong endeavour, of which we are conscious, that is the original impression from which this idea is copied. But, first, we attribute power to a vast number of objects, where we never can suppose this resistance or exertion of force to take place; 46 to the Supreme Being, who never meets with any resistance; to the mind in its command over its ideas and limbs, in common thinking and motion, where the effect follows immediately upon the will, without any exertion or summoning up of force; to inanimate matter, which is not capable of this sentiment. Secondly. This sentiment of an endeavour to overcome resistance has no known connexion with any event: What follows it, we know by experience; but could not know it à priori. It must, however, be confessed, that the animal nisus, which we experience, though it can afford no accurate precise idea of power, enters very much into that vulgar, inaccurate idea, which is formed of it.

Shall we then assert, that we are conscious of a power or energy in our own minds, when, by an act or command of our will, we raise up a new idea, fix the mind to the contemplation of it, turn it on all sides, and at last dismiss it for some other idea, when we think that we have surveyed it with sufficient accuracy? I believe the same arguments will prove, that even this command of the will gives us no real idea of force or energy.

First, It must be allowed, that, when we know a power, we know that very circumstance in the cause, by which it is enabled

⁴⁴ The next paragraph was originally a footnote.

^{45 &}quot;Nisus" = 'striving after a goal.'

⁴⁶ Hume's argument is that the feeling of effort, "nisus", is not essential to the idea of power, since we conceive of beings who have power without nisus. Therefore, the idea of power is not derived from the impression of nisus.

to produce the effect: For these are supposed to be synonimous. We must, therefore, know both the cause and effect, and the relation between them. But do we pretend to be acquainted with the nature of the human soul and the nature of an idea, or the aptitude of the one to produce the other? This is a real creation; a production of something out of nothing: Which implies a power so great, that it may seem, at first sight, beyond the reach of any being, less than infinite. At least it must be owned, that such a power is not felt, nor known, nor even conceivable by the mind. We only feel the event, namely, the existence of an idea, consequent to a command of the will: But the manner, in which this operation is performed, the power by which it is produced, is entirely beyond our comprehension.

Secondly, The command of the mind over itself is limited, as well as its command over the body; and these limits are not known by reason, or any acquaintance with the nature of cause and effect, but only by experience and observation, as in all other natural events and in the operation of external objects. Our authority over our sentiments and passions is much weaker than that over our ideas; and even the latter authority is circumscribed within very narrow boundaries. Will any one pretend to assign the ultimate reason of these boundaries, or show why the power is deficient in one case, not in another?

Thirdly, This self-command is very different at different times. A man in health possesses more of it than one languishing with sickness. We are more master of our thoughts in the morning than in the evening: Fasting, than after a full meal. Can we give any reason for these variations, except experience? Where then is the power, of which we pretend to be conscious? Is there not here, either in a spiritual or material substance, or both, some secret mechanism or structure of parts, upon which the effect depends, and which, being entirely unknown to us, renders the power or energy of the will equally unknown and incomprehensible?

Volition is surely an act of the mind, with which we are sufficiently acquainted. Reflect upon it. Consider it on all sides. Do you find anything in it like this creative power, by which it raises from nothing a new idea, and with a kind of *Fiat*, imitates the omnipotence of its Maker, if I may be allowed so to speak, who called forth into existence all the various scenes of nature? So far from being conscious of this energy in the will, it requires as certain experience as that of which we are possessed, to

convince us that such extraordinary effects do ever result from a simple act of volition.

The generality of mankind never find any difficulty in accounting for the more common and familiar operations of nature—such as the descent of heavy bodies, the growth of plants, the generation of animals, or the nourishment of bodies by food: But suppose that, in all these cases, they perceive the very force or energy of the cause, by which it is connected with its effect, and is for ever infallible in its operation. They acquire, by long habit, such a turn of mind, that, upon the appearance of the cause, they immediately expect with assurance its usual attendant, and hardly conceive it possible that any other event could result from it. It is only on the discovery of extraordinary phaenomena, such as earthquakes, pestilence, and prodigies of any kind, that they find themselves at a loss to assign a proper cause, and to explain the manner in which the effect is produced by it. It is usual for men, in such difficulties, to have recourse to some invisible intelligent principle⁴⁷ as the immediate cause of that event which surprises them, and which, they think, cannot be accounted for from the common powers of nature. But philosophers, who carry their scrutiny a little farther, immediately perceive that, even in the most familiar events, the energy of the cause is as unintelligible as in the most unusual. and that we only learn by experience the frequent Conjunction of objects, without being ever able to comprehend anything like Connexion between them. Here, then, many philosophers think themselves obliged by reason to have recourse, on all occasions. to the same principle, which the vulgar never appeal to but in cases that appear miraculous and supernatural. They acknowledge mind and intelligence to be, not only the ultimate and original cause of all things, but the immediate and sole cause of every event which appears in nature. They pretend that those objects which are commonly denominated causes, are in reality nothing but occasions; and that the true and direct principle of every effect is not any power or force in nature, but a volition of

⁴⁷ Here Hume had a footnote consisting of three Greek words better known in the Latin, *deus ex machina*. This expression, 'a god out of a machine', refers to a stage device standard in the ancient Greek theatre. Sitting or standing on a low trolley an actor was literally wheeled out onto the stage, usually an actor representing a god, who then proceeded to sort everything out, and so satisfactorily conclude the action of the play.

the Supreme Being, who wills that such particular objects should for ever by conjoined with each other. 48 Instead of saying that one billiard-ball moves another by a force which it has derived from the author of nature, it is the Deity himself, they say, who, by a particular volition, moves the second ball, being determined to this operation by the impulse of the first ball; in consequence of those general laws which he has laid down to himself in the government of the universe. But philosophers advancing still in their inquiries, discover that, as we are totally ignorant of the power on which depends the mutual operation of bodies, we are no less ignorant of that power on which depends the operation of mind on body, or of body on mind; nor are we able, either from our senses or consciousness, to assign the ultimate principle in one case more than in the other. The same ignorance, therefore, reduces them to the same conclusion. They assert that the Deity is the immediate cause of the union between soul and body; and that they are not the organs of sense, which, being agitated by external objects, produce sensations in the mind; but that it is a particular volition of our omnipotent Maker, which excites such a sensation, in consequence of such a motion in the organ. In like manner, it is not any energy in the will that produces local motion in our members: It is God himself, who is pleased to second our will, in itself impotent, and to command that motion which we erroneously attribute to our own power and efficacy. Nor do philosophers stop at this conclusion. They sometimes extend the same inference to the mind itself, in its internal operations. Our mental vision or conception of ideas is nothing but a revelation made to us by our Maker. When we voluntarily turn our thoughts to any object, and raise up its image in the fancy, it is not the will which creates that idea: It is the universal Creator, who discovers it to the mind, and renders it present to us.

Thus, according to these philosophers, every thing is full of God. Not content with the principle, that nothing exists but by his will, that nothing possesses any power but by his concession: They rob nature, and all created beings, of every power, in order to render their dependence on the Deity still more sensible and immediate. They consider not that, by this theory, they dimin-

⁴⁸ Hume probably has in mind here the doctrine of Nicolas Malebranche (1638–1715) who advocated the Occasionalist view of causation in his *De la recherche de la vérité* and other works.

ish, instead of magnifying, the grandeur of those attributes, which they affect so much to celebrate. It argues surely more power in the Deity to delegate a certain degree of power to inferior creatures than to produce every thing by his own immediate volition. It argues more wisdom to contrive at first the fabric of the world with such perfect foresight that, of itself, and by its proper operation, it may serve all the purposes of providence, than if the great Creator were obliged every moment to adjust its parts, and animate by his breath all the wheels of that stupendous machine.

But if we would have a more philosophical⁴⁹ confutation of this theory, perhaps the two following reflections may suffice.

First, it seems to me that this theory of the universal energy and operation of the Supreme Being is too bold ever to carry conviction with it to a man, sufficiently apprized of the weakness of human reason, and the narrow limits to which it is confined in all its operations. Though the chain of arguments which conduct to it were ever so logical, there must arise a strong suspicion, if not an absolute assurance, that it has carried us quite beyond the reach of our faculties, when it leads to conclusions so extraordinary, and so remote from common life and experience. We are got into fairy land, long ere we have reached the last steps of our theory; and there we have no reason to trust our common methods of argument, or to think that our usual analogies and probabilities have any authority. Our line is too short to fathom such immense abysses. And however we may flatter ourselves that we are guided, in every step which we take, by a kind of verisimilitude and experience, we may be assured that this fancied experience has no authority when we thus apply it to subjects that lie entirely out of the sphere of experience. But on this we shall have occasion to touch afterwards (in Section XII. below).

Secondly, I cannot perceive any force in the arguments on which this theory is founded. We are ignorant, it is true, of the manner in which bodies operate on each other: Their force or energy is entirely incomprehensible: But are we not equally ignorant of the manner or force by which a mind, even the

⁴⁹ The argument given so far is not "philosophical", since it has proceeded from the idea of a Deity, a being that has not been proved to exist. A "philosophical" argument must proceed by analyzing our ideas and impressions, without doubtful assumptions.

supreme mind, operates either on itself or on body? Whence, I beseech you, do we acquire any idea of it? We have no sentiment or consciousness of this power in ourselves. We have no idea of the Supreme Being but what we learn from reflection on our own faculties. Were our ignorance, therefore, a good reason for rejecting any thing, we should be led into that principle of denying all energy in the Supreme Being as much as in the grossest matter. We surely comprehend as little the operations of one as of the other. Is it more difficult to conceive that motion may arise from impulse than that it may arise from volition? All we know is our profound ignorance in both cases. 50

I need not examine at length the vis inertiae⁵¹ which is so much talked of in the new philosophy, and which is ascribed to matter. We find by experience, that a body at rest or in motion continues for ever in its present state, till put from it by some new cause; and that a body impelled takes as much motion from the impelling body as it acquires itself. These are facts. When we call this a vis inertiae, we only mark these facts.⁵² without pretending to have any idea of the inert power; in the same manner as, when we talk of gravity, we mean certain effects, without comprehending that active power. It was never the meaning of Sir Isaac Newton to rob second causes of all force or energy; though some of his followers have endeavoured to establish that theory upon his authority.⁵³ On the contrary, that great philosopher had recourse to an etherial active fluid to explain his universal attraction; though he was so cautious and modest as to allow, that it was a mere hypothesis, not to be insisted on, without more experiments. I must confess, that there is something in the fate of opinions a little extraordinary. DES CARTES insinuated that doctrine of the universal and sole efficacy of the Deity, without insisting on it. MALEBRANCHE and other Cartesians made it the foundation of all their philosophy. It had, however, no authority in England, Locke, Clarke, and CUDWORTH, never so much as take notice of it, but suppose all along, that matter has a real, though subordinate and derived

⁵⁰ The next paragraph was originally a footnote.

^{51 &}quot;Vis inertiae" = 'force of inertia'.

⁵² Compare with the famous passage of Molière, on the 'dormitive power' of opium.

⁵³ Newton is mentioned since the principle of inertia is stated in his first law of motion.

power. By what means has it become so prevalent among our modern metaphysicians?⁵⁴

PART II

But to hasten to a conclusion of this argument, which is already drawn out to too great a length: We have sought in vain for an idea of power or necessary connexion in all the sources from which we could suppose it to be derived. It appears that, in single instances of the operation of bodies, we never can, by our utmost scrutiny, discover any thing but one event following another; without being able to comprehend any force or power by which the cause operates, or any connexion between it and its supposed effect. The same difficulty occurs in contemplating the operations of mind on body—where we observe the motion of the latter to follow upon the volition of the former, but are not able to observe or conceive the tie which binds together the motion and volition, or the energy by which the mind produces this effect. The authority of the will over its own faculties and ideas is not a whit more comprehensible: So that, upon the whole, there appears not, throughout all nature, any one instance of connexion which is conceivable by us. All events seem entirely loose and separate. One event follows another; but we never can observe any tie between them. They seem conjoined, but never connected. And as we can have no idea of any thing which never appeared to our outward sense or inward sentiment, the necessary conclusion seems to be that we have no idea of connexion or power at all, and that these words are absolutely without any meaning, when employed either in philosophical reasonings or common life.

But there still remains one method of avoiding this conclusion, and one source which we have not yet examined. When any

⁵⁴ The spelling 'Des Cartes' helps to explain why the adjective is 'Cartesian', not 'Descartesian'. The Latin form of 'Descartes' is 'Cartesius'. Samuel Clarke (1675–1729) was an English philosopher-theologian who at Cambridge became a friend and disciple of Sir Isaac Newton (1642–1727). Clarke served as Newton's mouthpiece in the *Leibniz-Clarke Correspondence*. Ralph Cudworth (1617–88) was a leading Cambridge Platonist, who compiled *The True Intellectual System of the Universe* and *A Treatise concerning Eternal and Immutable Morality*.

natural object or event is presented, it is impossible for us, by any sagacity or penetration, to discover, or even conjecture, without experience, what event will result from it, or to carry our foresight beyond that object which is immediately present to the memory and senses. Even after one instance or experiment, where we have observed a particular event to follow upon another, we are not entitled to form a general rule, or foretell what will happen in like cases; it being justly esteemed an unpardonable temerity to judge of the whole course of nature from one single experiment, however accurate or certain. But when one particular species of event has always, in all instances. been conjoined with another, we make no longer any scruple of foretelling one upon the appearance of the other, and of employing that reasoning, which can alone assure us of any matter of fact or existence. We then call the one object. Cause: the other, Effect. We suppose that there is some connexion between them; some power in the one, by which it infallibly produces the other, and operates with the greatest certainty and strongest necessity.

It appears, then, that this idea of a necessary connexion among events arises from a number of similar instances which occur of the constant conjunction of these events; nor can that idea ever be suggested by any one of these instances, surveyed in all possible lights and positions. But there is nothing in a number of instances, different from every single instance, which is supposed to be exactly similar; except only, that after a repetition of similar instances, the mind is carried by habit, upon the appearance of one event, to expect its usual attendant. and to believe that it will exist. This connexion, therefore, which we feel in the mind, this customary transition of the imagination from one object to its usual attendant, is the sentiment or impression from which we form the idea of power or necessary connexion. Nothing farther is in the case. Contemplate the subject on all sides; you will never find any other origin of that idea. This is the sole difference between one instance, from which we can never receive the idea of connexion, and a number of similar instances, by which it is suggested. The first time a man saw the communication of motion by impulse, as by the shock of two billiard balls, he could not pronounce that the one event was connected: but only that it was conjoined with the other. After he has observed several instances of this nature, he then pronounces them to be *connected*. What alteration has happened to give rise to this new idea of *connexion*? Nothing but that he now *feels* these events to be *connected* in his imagination, and can readily foretell the existence of one from the appearance of the other. When we say, therefore, that one object is connected with another, we mean only that they have acquired a connexion in our thought, and give rise to this inference, by which they become proofs of each other's existence: A conclusion which is somewhat extraordinary, but which seems founded on sufficient evidence. Nor will its evidence be weakened by any general diffidence of the understanding, or sceptical suspicion concerning every conclusion which is new and extraordinary. No conclusions can be more agreeable to scepticism than such as make discoveries concerning the weakness and narrow limits of human reason and capacity.⁵⁵

And what stronger instance can be produced of the surprising ignorance and weakness of the understanding than the present? For surely, if there be any relation among objects which it imports to us to know perfectly, it is that of cause and effect. On this are founded all our reasonings concerning matter of fact or existence. By means of it alone we attain any assurance concerning objects which are removed from the present testimony of our memory and senses. The only immediate utility of all sciences, is to teach us, how to control and regulate future events by their causes. Our thoughts and enquiries are, therefore, every moment, employed about this relation: Yet so imperfect are the ideas which we form concerning it, that it is impossible to give any just definition of cause, except what is drawn from something extraneous and foreign to it. Similar objects are always conjoined with similar. Of this we have experience. Suitably to this experience, therefore, we may define a cause to be an object, followed by another, and where all the objects similar to the first are followed by objects similar to the second. Or in other words where, if the first object had not been, the second never had existed. 56 The appearance of a cause always

 $^{^{55}}$ Hume introduces this so that his argument will not be vulnerable to the point he has raised against Occasionalism, viz., that it deals with matters beyond the grasp of human beings.

⁵⁶ The second of these two formulations, as we insisted in the Introduction, is neither equivalent to nor deducible from the first. And, whereas the first does epitomize Hume's account of causation, the second introduces an essential notion for which that account does not provide.

conveys the mind, by a customary transition, to the idea of the effect. Of this also we have experience.⁵⁷ We may, therefore, suitably to this experience, form another definition of cause, and call it, an object followed by another, and whose appearance always conveys the thought to that other. But though both these definitions be drawn from circumstances foreign to the cause, we cannot remedy this inconvenience, or attain any more perfect definition, which may point out that circumstance in the cause, which gives it a connexion with its effect. We have no idea of this connexion, nor even any distinct notion what it is we desire to know, when we endeavour at a conception of it. We say, for instance, that the vibration of this string is the cause of this particular sound. But what do we mean by that affirmation? We either mean that this vibration is followed by this sound, and that all similar vibrations have been followed by similar sounds: Or, that this vibration is followed by this sound, and that upon the appearance of one the mind anticipates the senses, and forms immediately an idea of the other. We may consider the relation of cause and effect in either of these two lights; but beyond these, we have no idea of it.58

According to these explications and definitions, the idea of power is relative as much as that of cause; and both have a reference to an effect, or some other event constantly conjoined with the former. When we consider the unknown circumstance of an object, by which the degree or quantity of its effect is fixed and determined, we call that its power: And accordingly, it is allowed by all philosophers, that the effect is the measure of the power. But if they had any idea of power, as it is in itself, why could not they measure it in itself? The dispute whether the force of a body in motion be as its velocity, or the square of its velocity; this dispute, I say, needed not be decided by comparing its effects in equal or unequal times; but by a direct mensuration and comparison.

As to the frequent use of the words, Force, Power, Energy, &c., which every where occur in common conversation, as well as in philosophy; that is no proof, that we are acquainted, in any instance, with the connecting principle between cause and effect, or can account ultimately for the production of one thing by another. These words, as commonly used, have very loose

⁵⁷ "This" of which we have experience, refers to the preceding sentence.

⁵⁸ The next two paragraphs were originally printed as a footnote.

meanings annexed to them; and their ideas are very uncertain and confused. No animal can put external bodies in motion without the sentiment of a *nisus* or endeavour; and every animal has a sentiment or feeling from the stroke or blow of an external object, that is in motion. These sensations, which are merely animal, and from which we can \grave{a} priori draw no inference, we are apt to transfer to inanimate objects, and to suppose, that they have some such feelings, whenever they transfer or receive motion. With regard to energies, which are exerted, without our annexing to them any idea of communicated motion, we consider only the constant experienced conjunction of the events; and as we *feel* a customary connexion between the ideas, we transfer that feeling to the objects; as nothing is more usual than to apply to external bodies every internal sensation, which they occasion.

To recapitulate, therefore, the reasonings of this section: Every idea is copied from some preceding impression or sentiment; and where we cannot find any impression, we may be certain that there is no idea. In all single instances of the operation of bodies or minds, there is nothing that produces any impression, nor consequently can suggest any idea, of power or necessary connexion. But when many uniform instances appear, and the same object is always followed by the same event: we then begin to entertain the notion of cause and connexion. We then feel a new sentiment or impression, to wit, a customary connexion in the thought or imagination between one object and its usual attendant; and this sentiment is the original of that idea which we seek for. For as this idea arises from a number of similar instances, and not from any single instance it must arise from that circumstance, in which the number of instances differ from every individual instance. But this customary connexion or transition of the imagination is the only circumstance in which they differ. In every other particular they are alike. The first instance which we saw of motion communicated by the shock of two billiard balls (to return to this obvious illustration) is exactly similar to any instance that may, at present, occur to us; except only, that we could not, at first, infer one event from the other: which we are enabled to do at present, after so long a course of uniform experience. I know not whether the reader will readily apprehend this reasoning. I am afraid that, should I multiply words about it, or throw it into a greater variety of lights, it would only become more obscure and intricate. In all abstract reasonings there is one point of view which, if we can happily hit.

we shall go farther towards illustrating the subject than by all the eloquence and copious expression in the world. This point of view we should endeavour to reach, and reserve the flowers of rhetoric for subjects which are more adapted to them.

Of Liberty and Necessity

PARTI

It might reasonably be expected in questions which have been canvassed and disputed with great eagerness, since the first origin of science and philosophy, that the meaning of all the terms, at least, should have been agreed upon among the disputants; and our enquiries, in the course of two thousand years, been able to pass from words to the true and real subject of the controversy. For how easy may it seem to give exact definitions of the terms employed in reasoning, and make these definitions, not the mere sound of words, the object of future scrutiny and examination? But if we consider the matter more narrowly,⁵⁹ we shall be apt to draw a quite opposite conclusion. From this circumstance alone, that a controversy has been long kept on foot, and remains still undecided, we may presume that there is some ambiguity in the expression, and that the disputants affix different ideas to the terms employed in the controversy. For as the faculties of the mind are supposed to be naturally alike in every individual; otherwise nothing could be more fruitless than to reason or dispute together; it were impossible, if men affix the same ideas to their terms, that they could so long form different opinions of the same subject; especially when they communicate their views, and each party turn themselves on all sides, in search of arguments which may give them the victory over their antagonists. It is true, if men attempt the discussion of questions which lie entirely beyond the reach of human capacity, such as those concerning the origin of worlds, or the economy of the intellectual system or region of spirits, they may long beat the air in their fruitless contests, and never arrive at any determinate conclusion. But if the question regard any subject of common life and experience, nothing, one would think, could preserve the dispute so long undecided but some ambiguous expressions, which keep the antagonists still at a distance, and hinder them from grappling with each other.

⁵⁹ "Narrowly" = 'strictly' or 'exactly' in present-day usage.

This has been the case in the long disputed question concerning liberty and necessity; and to so remarkable a degree that, if I be not much mistaken, we shall find, that all mankind, both learned and ignorant, have always been of the same opinion with regard to this subject, and that a few intelligible definitions would immediately have put an end to the whole controversy. I own that this dispute has been so much canvassed on all hands, and has led philosophers into such a labyrinth of obscure sophistry, that it is no wonder, if a sensible reader indulge his ease so far as to turn a deaf ear to the proposal of such a question, from which he can expect neither instruction nor entertainment. But the state of the argument here proposed may, perhaps, serve to renew his attention; as it has more novelty, promises at least some decision of the controversy, and will not much disturb his ease by any intricate or obscure reasoning.

I hope, therefore, to make it appear that all men, have ever agreed in the doctrine both of necessity and of liberty, according to any reasonable sense, which can be put on these terms; and that the whole controversy has hitherto turned merely upon words. We shall begin with examining the doctrine of necessity.

It is universally allowed that matter, in all its operations, is actuated by a necessary force, and that every natural effect is so precisely determined by the energy of its cause that no other effect, in such particular circumstances, could possibly have resulted from it. The degree and direction of every motion is, by the laws of nature, prescribed with such exactness that a living creature may as soon arise from the shock of two bodies, as motion, in any other degree or direction than what is actually produced by it. Would we, therefore, form a just and precise idea of *necessity*, we must consider whence that idea arises when we apply it to the operation of bodies.

It seems evident that, if all the scenes of nature were continually shifted in such a manner that no two events bore any resemblance to each other, but every object was entirely new, without any similitude to whatever had been seen before, we should never, in that case, have attained the least idea of necessity, or of a connexion among these objects. We might say, upon such a supposition, that one object or event has followed another; not that one was produced by the other. The relation of cause and effect must be utterly unknown to mankind. Inference and reasoning concerning the operations of nature would, from that moment, be at an end; and the memory and senses remain

the only canals, by which the knowledge of any real existence could possibly have access to the mind. Our idea, therefore, of necessity and causation arises entirely from the uniformity observable in the operations of nature, where similar objects are constantly conjoined together, and the mind is determined by custom to infer the one from the appearance of the other. These two circumstances form the whole of that necessity, which we ascribe to matter. Beyond the constant *conjunction* of similar objects, and the consequent *inference* from one to the other, we have no notion of any necessity or connexion.

If it appear, therefore, that all mankind have ever allowed, without any doubt or hesitation, that these two circumstances take place in the voluntary actions of men, and in the operations of mind; it must follow, that all mankind have ever agreed in the doctrine of necessity, and that they have hitherto disputed, merely for not understanding each other.

As to the first circumstance, the constant and regular conjunction of similar events, we may possibly satisfy ourselves by the following considerations. It is universally acknowledged that there is a great uniformity among the actions of men, in all nations and ages, and that human nature remains still the same, in its principles and operations. The same motives always produce the same actions: The same events follow from the same causes. Ambition, avarice, self-love, vanity, friendship, generosity, public spirit: these passions, mixed in various degrees, and distributed through society, have been, from the beginning of the world, and still are, the source of all the actions and enterprises. which have ever been observed among mankind. Would you know the sentiments, inclinations, and course of life of the Greeks and Romans? Study well the temper and actions of the French and English: You cannot be much mistaken in transferring to the former most of the observations which you have made with regard to the latter. Mankind are so much the same, in all times and places, that history informs us of nothing new or strange in this particular. Its chief use is only to discover the constant and universal principles of human nature, by showing men in all varieties of circumstances and situations, and furnishing us with materials from which we may form our observations and become acquainted with the regular springs of human action and behaviour. These records of wars, intrigues, factions, and revolutions, are so many collections of experiments, by which the politician or moral philosopher fixes the

principles of his science, in the same manner as the physician or natural philosopher becomes acquainted with the nature of plants, minerals, and other external objects, by the experiments which he forms concerning them. Nor are the earth, water, and other elements, examined by Aristotle, and Hippocrates, more like to those which at present lie under our observation than the men described by Polybius and Tacitus are to those who now govern the world. 60

Should a traveller, returning from a far country, bring us an account of men, wholly different from any with whom we were ever acquainted; men, who were entirely divested of avarice, ambition, or revenge; who knew no pleasure but friendship, generosity, and public spirit; we should immediately, from these circumstances, detect the falsehood, and prove him a liar, with the same certainty as if he had stuffed his narration with stories of centaurs and dragons, miracles and prodigies. And if we would explode any forgery in history, we cannot make use of a more convincing argument, than to prove, that the actions ascribed to any person are directly contrary to the course of nature, and that no human motives, in such circumstances, could ever induce him to such a conduct. The veracity of Quintus Curtius is as much to be suspected, when he describes the supernatural courage of Alexander, 61 by which he was hurried on singly to attack multitudes, as when he describes his supernatural force and activity, by which he was able to resist them. So readily and universally do we acknowledge a uniformity in human motives and actions as well as in the operations of body.

Hence likewise the benefit of that experience, acquired by long life and a variety of business and company, in order to instruct us in the principles of human nature, and regulate our future conduct, as well as speculation. By means of this guide,

 $^{^{60}}$ Hippocrates of Cos (c. 460–c. 377 BCE), often called the Father of Medicine, is a legendary figure about whom precious little can be said to be firmly known. The Hippocratic Oath, still sworn by many of those proposing to practice medicine in non-socialist countries, was surely not composed by Hippocrates himself. Polybius (c. 205–c. 118 BCE) and Tacitus (c. 56–c. 120 CE) were historians writing in, respectively, Greek and Latin.

 $^{^{61}}$ Quintus Curtius Rufus (first century $_{\rm CE})$ wrote a long, unmeritorious account of *The Deeds of Alexander the Great*. Alexander (356–323 $_{\rm BCE})$ led the armies of Macedon(ia) to the conquest of most of the kingdoms of the then known world.

we mount up to the knowledge of men's inclinations and motives. from their actions, expressions, and even gestures; and again. descend to the interpretation of their actions from our knowledge of their motives and inclinations. The general observations treasured up by a course of experience, give us the clue of human nature, and teach us to unravel all its intricacies. Pretexts and appearances no longer deceive us. Public declarations pass for the spacious colouring of a cause. And though virtue and honour be allowed their proper weight and authority, that perfect disinterestedness, so often pretended to, is never expected in multitudes and parties; seldom in their leaders; and scarcely even in individuals of any rank or station. But were there no uniformity in human actions, and were every experiment which we could form of this kind irregular and anomalous, it were impossible to collect any general observations concerning mankind; and no experience, however accurately digested by reflection, would ever serve to any purpose. Why is the aged husbandman more skilful in his calling than the young beginner but because there is a certain uniformity in the operation of the sun, rain, and earth towards the production of vegetables; and experience teaches the old practitioner the rules by which this operation is governed and directed?

We must not, however, expect that this uniformity of human actions should be carried to such a length as that all men, in the same circumstances, will always act precisely in the same manner, without making any allowance for the diversity of characters, prejudices, and opinions. Such a uniformity in every particular, is found in no part of nature. On the contrary, from observing the variety of conduct in different men, we are enabled to form a greater variety of maxims, which still suppose a degree of uniformity and regularity.

Are the manners of men different in different ages and countries? We learn thence the great force of custom and education, which mould the human mind from its infancy and form it into a fixed and established character. Is the behaviour and conduct of the one sex very unlike that of the other? It is thence we become acquainted with the different characters which nature has impressed upon the sexes, and which she preserves with constancy and regularity. Are the actions of the same person much diversified in the different periods of his life, from infancy to old age? This affords room for many general observations concerning the gradual change of our sentiments

and inclinations, and the different maxims which prevail in the different ages of human creatures. Even the characters, which are peculiar to each individual, have a uniformity in their influence; otherwise our acquaintance with the persons and our observation of their conduct could never teach us their dispositions, or serve to direct our behaviour with regard to them.

I grant it possible to find some actions, which seem to have no regular connexion with any known motives, and are exceptions to all the measures of conduct which have ever been established for the government of men. But if we would willingly know what judgement should be formed of such irregular and extraordinary actions, we may consider the sentiments commonly entertained with regard to those irregular events which appear in the course of nature, and the operations of external objects. All causes are not conjoined to their usual effects with like uniformity. An artificer, who handles only dead matter, may be disappointed of his aim, as well as the politician, who directs the conduct of sensible and intelligent agents.

The vulgar, who take things according to their first appearance. attribute the uncertainty of events to such an uncertainty in the causes as makes the latter often fail of their usual influence; though they meet with no impediment in their operation. But philosophers, observing that, almost in every part of nature, there is contained a vast variety of springs and principles, which are hid, by reason of their minuteness or remoteness, find, that it is at least possible the contrariety of events may not proceed from any contingency in the cause, but from the secret operation of contrary causes. This possibility is converted into certainty by farther observation, when they remark that, upon an exact scrutiny, a contrariety of effects always betrays a contrariety of causes, and proceeds from their mutual opposition. A peasant can give no better reason for the stopping of any clock or watch than to say that it does not commonly go right: But an artist easily perceives that the same force in the spring or pendulum has always the same influence on the wheels; but fails of its usual effect, perhaps by reason of a grain of dust, which puts a stop to the whole movement. From the observation of several parallel instances, philosophers form a maxim that the connexion between all causes and effects is equally necessary, and that its seeming uncertainty in some instances proceeds from the secret opposition of contrary causes.

Thus, for instance, in the human body, when the usual symptoms of health or sickness disappoint our expectation; when medicines operate not with their wonted powers; when irregular events follow from any particular cause; the philosopher and physician are not surprised at the matter, nor are ever tempted to deny, in general, the necessity and uniformity of those principles by which the animal economy is conducted. They know that a human body is a mighty complicated machine: That many secret powers lurk in it, which are altogether beyond our comprehension: That to us it must often appear very uncertain in its operations: And that therefore the irregular events, which outwardly discover themselves, can be no proof that the laws of nature are not observed with the greatest regularity in its internal operations and government.

The philosopher, if he be consistent, must apply the same reasoning to the actions and volitions of intelligent agents. The most irregular and unexpected resolutions of men may frequently be accounted for by those who know every particular circumstance of their character and situation. A person of an obliging disposition gives a peevish answer: But he has the toothache, or has not dined. A stupid fellow discovers an uncommon alacrity in his carriage: But he has met with a sudden piece of good fortune. Or even when an action, as sometimes happens, cannot be particularly accounted for, either by the person himself or by others; we know, in general, that the characters of men are, to a certain degree, inconstant and irregular. This is, in a manner, the constant character of human nature; though it be applicable, in a more particular manner, to some persons who have no fixed rule for their conduct, but proceed in a continued course of caprice and inconstancy. The internal principles and motives may operate in a uniform manner, notwithstanding these seeming irregularities; in the same manner as the winds, rain, clouds, and other variations of the weather are supposed to be governed by steady principles; though not easily discoverable by human sagacity and enquiry.

Thus it appears, not only that the conjunction between motives and voluntary actions is as regular and uniform as that between the cause and effect in any part of nature; but also that this regular conjunction has been universally acknowledged among mankind, and has never been the subject of dispute, either in philosophy or common life. Now, as it is from past experience that we draw all inferences concerning the future,

and as we conclude that objects will always be conjoined together which we find to have always been conjoined; it may seem superfluous to prove that this experienced uniformity in human actions is a source whence we draw *inferences* concerning them. But in order to throw the argument into a greater variety of lights we shall also insist, though briefly, on this latter topic.

The mutual dependence of men is so great in all societies that scarce any human action is entirely complete in itself, or is performed without some reference to the actions of others, which are requisite to make it answer fully the intention of the agent. The poorest artificer, who labours alone, expects at least the protection of the magistrate, to ensure him the enjoyment of the fruits of his labour. He also expects that, when he carries his goods to market, and offers them at a reasonable price, he shall find purchasers, and shall be able, by the money he acquires, to engage others to supply him with those commodities which are requisite for his subsistence. In proportion as men extend their dealings, and render their intercourse with others more complicated, they always comprehend, in their schemes of life, a greater variety of voluntary actions, which they expect, from the proper motives, to co-operate with their own. In all these conclusions they take their measures from past experience, in the same manner as in their reasonings concerning external objects; and firmly believe that men, as well as all the elements, are to continue, in their operations, the same that they have ever found them. A manufacturer reckons upon the labour of his servants for the execution of any work as much as upon the tools which he employs, and would be equally surprised were his expectations disappointed. In short, this experimental inference and reasoning concerning the actions of others enters so much into human life that no man, while awake, is ever a moment without employing it. Have we not reason, therefore, to affirm that all mankind have always agreed in the doctrine of necessity according to the foregoing definition and explication of it?

Nor have philosophers ever entertained a different opinion from the people in this particular. For, not to mention that almost every action of their life supposes that opinion, there are even few of the speculative parts of learning to which it is not essential. What would become of *history*, had we not a dependence on the veracity of the historian according to the experience which we have had of mankind? How could *politics* be a science,

if laws and forms of government had not a uniform influence upon society? Where would be the foundation of *morals*, if particular characters had no certain or determinate power to produce particular sentiments, and if these sentiments had no constant operation on actions? And with what pretence could we employ our *criticism* upon any poet or polite author, if we could not pronounce the conduct and sentiments of his actors either natural or unnatural to such characters, and in such circumstances? It seems almost impossible, therefore, to engage either in science or action of any kind without acknowledging the doctrine of necessity, and this *inference* from motives to voluntary actions, from characters to conduct.

And indeed, when we consider how aptly natural and moral evidence link together, and form only one chain of argument, we shall make no scruple to allow that they are of the same nature. and derived from the same principles. A prisoner who has neither money nor interest, discovers the impossibility of his escape, as well when he considers the obstinacy of the gaoler, as the walls and bars with which he is surrounded; and, in all attempts for his freedom, chooses rather to work upon the stone and iron of the one, than upon the inflexible nature of the other. The same prisoner, when conducted to the scaffold, foresees his death as certainly from the constancy and fidelity of his guards, as from the operation of the axe or wheel. His mind runs along a certain train of ideas: The refusal of the soldiers to consent to his escape; the action of the executioner; the separation of the head and body; bleeding, convulsive motions, and death. Here is a connected chain of natural causes and voluntary actions; but the mind feels no difference between them in passing from one link to another: Nor is less certain of the future event than if it were connected with the objects present to the memory or senses, by a train of causes, cemented together by what we are pleased to call a physical necessity. The same experienced union has the same effect on the mind, whether the united objects be motives, volition, and actions; or figure and motion. We may change the names of things; but their nature and their operation on the understanding never change.

Were a man, whom I know to be honest and opulent, and with whom I live in intimate friendship, to come into my house, where I am surrounded with my servants, I rest assured that he is not to stab me before he leaves it in order to rob me of my silver standish; and I no more suspect this event than the falling of the

house itself, which is new, and solidly built and founded.—But he may have been seized with a sudden and unknown frenzy.— So may a sudden earthquake arise, and shake and tumble my house about my ears. I shall therefore change the suppositions. I shall say that I know with certainty that he is not to put his hand into the fire and hold it there till it be consumed: And this event. I think I can foretell with the same assurance, as that, if he throw himself out at the window, and meet with no obstruction. he will not remain a moment suspended in the air. No suspicion of an unknown frenzy can give the least possibility to the former event, which is so contrary to all the known principles of human nature. A man who at noon leaves his purse full of gold on the pavement at Charing-Cross, 62 may as well expect that it will fly away like a feather, as that he will find it untouched an hour after. Above one half of human reasonings contain inferences of a similar nature, attended with more or less degrees of certainty proportioned to our experience of the usual conduct of mankind in such particular situations.

I have frequently considered, what could possibly be the reason why all mankind, though they have ever, without hesitation, acknowledged the doctrine of necessity in their whole practice and reasoning, have yet discovered such a reluctance to acknowledge it in words, and have rather shown a propensity, in all ages, to profess the contrary opinion. The matter, I think, may be accounted for after the following manner. If we examine the operations of body, and the production of effects from their causes, we shall find that all our faculties can never carry us farther in our knowledge of this relation than barely to observe that particular objects are constantly conjoined together, and that the mind is carried, by a customary transition, from the appearance of one to the belief of the other. But though this conclusion concerning human ignorance be the result of the strictest scrutiny of this subject, men still entertain a strong propensity to believe that they penetrate farther into the powers of nature, and perceive something like a necessary connexion between the cause and the effect. When again they turn their reflections towards the operations of their own minds, and feel no such connexion of the motive and the action; they are thence apt to suppose, that there is a difference between the

 $^{^{62}}$ A populous place in central London: A New Yorker nowadays might have said 'Times Square'.

effects which result from material force, and those which arise from thought and intelligence. But being once convinced that we know nothing farther of causation of any kind than merely the constant conjunction of objects, and the consequent inference of the mind from one to another, and finding that these two circumstances are universally allowed to have place in voluntary actions; we may be more easily led to own the same necessity common to all causes. And though this reasoning may contradict the systems of many philosophers, in ascribing necessity to the determinations of the will, we shall find, upon reflection, that they dissent from it in words only, not in their real sentiment. Necessity, according to the sense in which it is here taken, has never yet been rejected, nor can ever, I think, be rejected by any philosopher. It may only, perhaps, be pretended that the mind can perceive, in the operations of matter, some farther connexion between the cause and effect; and a connexion that has not place in the voluntary actions of intelligent beings. Now whether it be so or not, can only appear upon examination; and it is incumbent on these philosophers to make good their assertion, by defining or describing that necessity, and point it out to us in the operations of material causes.

It would seem, indeed, that men begin at the wrong end of this question concerning liberty and necessity, when they enter upon it by examining the faculties of the soul, the influence of the understanding, and the operations of the will. Let them first discuss a more simple question, namely, the operations of body and of brute unintelligent matter; and try whether they can there form any idea of causation and necessity, except that of a constant conjunction of objects, and subsequent inference of the mind from one to another. If these circumstances form. in reality, the whole of that necessity, which we conceive in matter, and if these circumstances be also universally acknowledged to take place in the operations of the mind, the dispute is at an end; at least, must be owned to be thenceforth merely verbal. But as long as we will rashly suppose, that we have some farther idea of necessity and causation in the operations of external objects; at the same time, that we can find nothing farther in the voluntary actions of the mind; there is no possibility of bringing the question to any determinate issue, while we proceed upon so erroneous a supposition. The only method of undeceiving us is to mount up higher: to examine the narrow extent of science when applied to material causes; and to convince ourselves that all we

know of them is the constant conjunction and inference above mentioned. We may, perhaps, find that it is with difficulty we are induced to fix such narrow limits to human understanding: But we can afterwards find no difficulty when we come to apply this doctrine to the actions of the will. For as it is evident that these have a regular conjunction with motives and circumstances and characters, and as we always draw inferences from one to the other, we must be obliged to acknowledge in words that necessity, which we have already avowed, in every deliberation of our lives, and in every step of our conduct and behaviour. We have already avowed.

The prevalence of the doctrine of liberty may be accounted for, from another cause, viz. a false sensation or seeming experience which we have, or may have, of liberty or indifference, in many of our actions. The necessity of any action, whether of matter or of mind, is not, properly speaking, a quality in the agent, but in any thinking or intelligent being, who may consider the action; and it consists chiefly in the determination of his thoughts to infer the existence of that action from some preceding objects; as liberty, when opposed to necessity, is nothing but the want of that determination, and a certain looseness or indifference, which we feel, in passing, or not passing, from the idea of one object to that of any succeeding one. Now we may observe, that, though, in reflecting on human actions, we seldom feel such a looseness, or indifference, but are commonly able to infer them with considerable certainty from their motives, and from the dispositions of the agent; yet it frequently happens, that, in *performing* the actions themselves, we are sensible of something like it: And as all resembling objects are readily taken for each other, this has been employed as a demonstrative and even intuitive proof of human liberty. We feel, that our actions are subject to our will, on most occasions; and imagine we feel, that the will itself is subject to nothing. because, when by a denial of it we are provoked to try, we feel, that it moves easily every way, and produces an image of itself

 $^{^{63}}$ Hume does not outright deny that bodies are connected by a stronger tie than constant conjunction. Instead, he denies only that we have any idea of such a power.

⁶⁴ The next paragraph was originally printed as a footnote. In its concluding sentences Hume recognizes what Sir Karl Popper has since christened the Oedipus Effect, defined by him as "the influence of an item of information upon the situation to which the information refers".

(or a *Velleity*, as it is called in the schools) even on that side, on which it did not settle. This image, or faint motion, we persuade ourselves, could, at that time, have been compleated into the thing itself; because, should that be denied, we find, upon a second trial, that, at present, it can. We consider not, that the fantastical⁶⁵ desire of shewing liberty, is here the motive of our actions. And it seems certain, that, however we may imagine we feel a liberty within ourselves, a spectator can commonly infer our actions from our motives and character; and even where he cannot, he concludes in general, that he might, were he perfectly acquainted with every circumstance of our situation and temper, and the most secret springs of our complexion and disposition. Now this is the very essence of necessity, according to the foregoing doctrine.

But to proceed in this reconciling project with regard to the question of liberty and necessity; the most contentious question of metaphysics, the most contentious science; it will not require many words to prove, that all mankind have ever agreed in the doctrine of liberty as well as in that of necessity, and that the whole dispute, in this respect also, has been hitherto merely verbal. For what is meant by liberty, when applied to voluntary actions? We cannot surely mean that actions have so little connexion with motives, inclinations, and circumstances, that one does not follow with a certain degree of uniformity from the other, and that one affords no inference by which we can conclude the existence of the other. For these are plain and acknowledged matters of fact. By liberty, then, we can only mean a power of acting or not acting, according to the determinations of the will; that is, if we choose to remain at rest, we may; if we choose to move, we also may. Now this hypothetical liberty is universally allowed to belong to every one who is not a prisoner and in chains. Here, then, is no subject of dispute.

Whatever definition we may give of liberty, we should be careful to observe two requisite circumstances; *first*, that it be consistent with plain matter of fact; *secondly*, that it be consistent with itself. If we observe these circumstances, and render our definition intelligible, I am persuaded that all mankind will be found of one opinion with regard to it.

It is universally allowed that nothing exists without a cause of its existence, and that chance, when strictly examined, is a

^{65 &}quot;Fantastical" = 'false' in present-day usage.

mere negative word, and means not any real power which has anywhere a being in nature. But it is pretended that some causes are necessary, some not necessary. Here then is the advantage of definitions. Let any one define a cause, without comprehending,66 as a part of the definition, a necessary connexion with its effect; and let him show distinctly the origin of the idea, expressed by the definition; and I shall readily give up the whole controversy. But if the foregoing explication of the matter be received, this must be absolutely impracticable. Had not objects a regular conjunction with each other, we should never have entertained any notion of cause and effect; and this regular conjunction produces that inference of the understanding, which is the only connexion, that we can have any comprehension of. Whoever attempts a definition of cause. exclusive of these circumstances, will be obliged either to employ unintelligible terms or such as are synonymous to the term which he endeavours to define.⁶⁷ Thus, if a cause be defined. that which produces any thing; it is easy to observe, that producing is synonimous to causing. In like manner, if a cause be defined, that by which any thing exists; this is liable to the same objection. For what is meant by these words, by which? Had it been said, that a cause is that after which any thing constantly exists; we should have understood the terms. For this is, indeed, all we know of the matter. And this constancy forms the very essence of necessity, nor have we any other idea of it. And if the definition above mentioned be admitted; liberty, when opposed to necessity, not to constraint, is the same thing with chance: which is universally allowed to have no existence.

PART II

THERE is no method of reasoning more common, and yet none more blameable, than, in philosophical disputes, to endeavour the refutation of any hypothesis, by a pretence of its dangerous consequences to religion and morality. When any opinion leads to absurdities, it is certainly false; but it is not certain that an opinion is false, because it is of dangerous consequence. Such topics, therefore, ought entirely to be forborne; as serving

^{66 &}quot;Comprehending" = 'including in the definition'.

⁶⁷ The next six sentences were originally printed as a footnote.

nothing to the discovery of truth, but only to make the person of an antagonist odious. This I observe in general, without pretending to draw any advantage from it. I frankly submit to an examination of this kind, and shall venture to affirm that the doctrines, both of necessity and of liberty, as above explained, are not only consistent with morality, but are absolutely essential to its support.

Necessity may be defined two ways, conformably to the two definitions of cause, of which it makes an essential part. It consists either in the constant conjunction of like objects, or in the inference of the understanding from one object to another. Now necessity, in both these senses, (which, indeed, are at bottom the same) has universally, though tacitly, in the schools. in the pulpit, and in common life, been allowed to belong to the will of man; and no one has ever pretended to deny that we can draw inferences concerning human actions, and that those inferences are founded on the experienced union of like actions. with like motives, inclinations, and circumstances. The only particular in which any one can differ, is, that either, perhaps, he will refuse to give the name of necessity to this property of human actions: But as long as the meaning is understood. I hope the word can do no harm: Or that he will maintain it possible to discover something farther in the operations of matter. But this, it must be acknowledged, can be of no consequence to morality or religion, whatever it may be to natural philosophy or metaphysics. We may here be mistaken in asserting that there is no idea of any other necessity or connexion in the actions of body: But surely we ascribe nothing to the actions of the mind, but what everyone does, and must readily allow of. We change no circumstance in the received orthodox system with regard to the will, but only in that with regard to material objects and causes. Nothing, therefore, can be more innocent, at least, than this doctrine.

All laws being founded on rewards and punishments, it is supposed as a fundamental principle, that these motives have a regular and uniform influence on the mind, and both produce the good and prevent the evil actions. We may give to this influence what name we please; but, as it is usually conjoined with the action, it must be esteemed a *cause*, and be looked upon as an instance of that necessity, which we would here establish.

The only proper object of hatred or vengeance is a person or creature, endowed with thought and consciousness; and when

any criminal or injurious actions excite that passion, it is only by their relation to the person, or connexion with him. Actions are. by their very nature, temporary and perishing; and where they proceed not from some cause in the character and disposition of the person who performed them, they can neither redound to his honour, if good; nor infamy, if evil. The actions themselves may be blameable; they may be contrary to all the rules of morality and religion: But the person is not answerable for them; and as they proceeded from nothing in him that is durable and constant, and leave nothing of that nature behind them, it is impossible he can, upon their account, become the object of punishment or vengeance. According to the principle, therefore, which denies necessity, and consequently causes, a man is as pure and untainted, after having committed the most horrid crime, as at the first moment of his birth, nor is his character anywise concerned in his actions, since they are not derived from it. and the wickedness of the one can never be used as a proof of the depravity of the other.

Men are not blamed for such actions as they perform ignorantly and casually, whatever may be the consequences. Why? but because the principles of these actions are only momentary, and terminate in them alone. Men are less blamed for such actions as they perform hastily and unpremeditately than for such as proceed from deliberation. For what reason? but because a hasty temper, though a constant cause or principle in the mind, operates only by intervals, and infects not the whole character. Again, repentance wipes off every crime, if attended with a reformation of life and manners. How is this to be accounted for? but by asserting that actions render a person criminal merely as they are proofs of criminal principles in the mind; and when, by an alteration of these principles, they cease to be just proofs, they likewise cease to be criminal. But, except upon the doctrine of necessity, they never were just proofs, and consequently never were criminal.

It will be equally easy to prove, and from the same arguments, that *liberty*, according to that definition above mentioned, in which all men agree, is also essential to morality, and that no human actions, where it is wanting, are susceptible of any moral qualities, or can be the objects either of approbation or dislike. For as actions are objects of our moral sentiment, so far only as they are indications of the internal character, passions, and affections; it is impossible that they can give rise

either to praise or blame, where they proceed not from these principles, but are derived altogether from external violence.

I pretend not to have obviated or removed all objections to this theory, with regard to necessity and liberty. I can foresee other objections, derived from topics which have not here been treated of. It may be said, for instance, that, if voluntary actions be subjected to the same laws of necessity with the operations of matter, there is a continued chain of necessary causes, preordained and pre-determined, reaching from the original cause of all to every single volition of every human creature. No contingency anywhere in the universe; no indifference; no liberty. While we act, we are, at the same time, acted upon. The ultimate Author of all our volitions is the Creator of the world. who first bestowed motion on this immense machine, and placed all beings in that particular position, whence every subsequent event, by an inevitable necessity, must result. Human actions. therefore, either can have no moral turpitude at all, as proceeding from so good a cause; or if they have any turpitude, they must involve our Creator in the same guilt, while he is acknowledged to be their ultimate cause and author. For as a man, who fired a mine, is answerable for all the consequences whether the train he employed be long or short; so wherever a continued chain of necessary causes is fixed, that Being, either finite or infinite, who produces the first, is likewise the author of all the rest, and must both bear the blame and acquire the praise which belong to them. Our clear and unalterable ideas of morality establish this rule, upon unquestionable reasons, when we examine the consequences of any human action; and these reasons must still have greater force when applied to the volitions and intentions of a Being infinitely wise and powerful. Ignorance or impotence may be pleaded for so limited a creature as man; but those imperfections have no place in our Creator. He foresaw. he ordained, he intended all those actions of men, which we so rashly pronounce criminal. And we must therefore conclude, either that they are not criminal, or that the Deity, not man, is accountable for them. But as either of these positions is absurd and impious, it follows, that the doctrine from which they are deduced cannot possibly be true, as being liable to all the same objections. An absurd consequence, if necessary, proves the original doctrine to be absurd; in the same manner as criminal actions render criminal the original cause, if the connexion between them be necessary and inevitable.

This objection consists of two parts, which we shall examine separately; *First*, that, if human actions can be traced up, by a necessary chain, to the Deity, they can never be criminal; on account of the infinite perfection of that Being from whom they are derived, and who can intend nothing but what is altogether good and laudable. Or, *Secondly*, if they be criminal, we must retract the attribute of perfection, which we ascribe to the Deity, and must acknowledge him to be the ultimate author of guilt and moral turpitude in all his creatures.

The answer to the first objection seems obvious and convincing. There are many philosophers who, after an exact scrutiny of all the phenomena of nature, conclude, that the WHOLE, considered as one system, is, in every period of its existence, ordered with perfect benevolence; and that the utmost possible happiness will, in the end, result to all created beings, without any mixture of positive or absolute ill and misery. Every physical ill, say they, makes an essential part of this benevolent system, and could not possibly be removed, even by the Deity himself, considered as a wise agent, without giving entrance to greater ill, or excluding greater good, which will result from it. From this theory, some philosophers, and the ancient Stoics among the rest, derived a topic of consolation under all afflictions, while they taught their pupils that those ills under which they laboured were, in reality, goods to the universe; and that to an enlarged view, which could comprehend the whole system of nature, every event became an object of joy and exultation. 68 But though this topic be specious⁶⁹ and sublime, it was soon found in practice weak and ineffectual. You would surely more irritate than appease a man lying under the racking pains of the gout by preaching up to him the rectitude of those general laws, which produced the malignant humours in his body, and led them through the proper canals, to the sinews and nerves, where they now excite such acute torments. These enlarged views may, for a moment, please the imagination of a speculative man, who is placed in ease and security; but neither can they dwell with constancy on his mind, even though undisturbed by the emotions of pain or passion; much less can they maintain their

 $^{^{68}}$ Doctrines of this sort were advocated by the Roman philosopher Seneca and by Marcus Aurelius.

^{69 &}quot;Specious" = 'appealing' in present-day usage.

ground when attacked by such powerful antagonists. The affections take a narrower and more natural survey of their object; and by an economy, more suitable to the infirmity of human minds, regard alone the beings around us, and are actuated by such events as appear good or ill to the private system.

The case is the same with moral as with physical ill. It cannot reasonably be supposed, that those remote considerations, which are found of so little efficacy with regard to one, will have a more powerful influence with regard to the other. The mind of man is so formed by nature that, upon the appearance of certain characters, dispositions, and actions, it immediately feels the sentiment of approbation or blame; nor are there any emotions more essential to its frame and constitution. The characters which engage our approbation are chiefly such as contribute to the peace and security of human society; as the characters which excite blame are chiefly such as tend to public detriment and disturbance: Whence it may reasonably be presumed, that the moral sentiments arise, either mediately or immediately, from a reflection of these opposite interests. What though philosophical meditations establish a different opinion or conjecture; that everything is right with regard to the WHOLE. and that the qualities, which disturb society, are, in the main, as beneficial, and are as suitable to the primary intention of nature as those which more directly promote its happiness and welfare? Are such remote and uncertain speculations able to counterbalance the sentiments which arise from the natural and immediate view of the objects? A man who is robbed of a considerable sum; does he find his vexation for the loss anywise diminished by these sublime reflections? Why then should his moral resentment against the crime be supposed incompatible with them? Or why should not the acknowledgment of a real distinction between vice and virtue be reconcileable to all speculative systems of philosophy, as well as that of a real distinction between personal beauty and deformity? Both these distinctions are founded in the natural sentiments of the human mind: And these sentiments are not to be controuled or altered by any philosophical theory or speculation whatsoever.

The *second* objection admits not of so easy and satisfactory an answer; nor is it possible to explain distinctly, how the Deity can be the mediate cause of all the actions of men, without being the author of sin and moral turpitude. 70 These are mysteries, which mere natural and unassisted reason is very unfit to handle: and whatever system she embraces, she must find herself involved in inextricable difficulties, and even contradictions, at every step which she takes with regard to such subjects. To reconcile the indifference and contingency of human actions with prescience; or to defend absolute decrees, and yet free the Deity from being the author of sin, has been found hitherto to exceed all the power of philosophy. Happy, if she be thence sensible of her temerity, when she pries into these sublime mysteries; and leaving a scene so full of obscurities and perplexities, return, with suitable modesty, to her true and proper province, the examination of common life; where she will find difficulties enough to employ her enquiries, without launching into so boundless an ocean of doubt, uncertainty, and contradiction!

 $^{^{70}}$ The view that God causes all human actions yet is not the author of sin is found among Calvinists in particular. See, for example, the Westminster Confession of 1647.

Of the Reason of Animals

ALL our reasonings concerning matter of fact are founded on a species of Analogy, which leads us to expect from any cause the same events, which we have observed to result from similar causes. Where the causes are entirely similar, the analogy is perfect, and the inference, drawn from it, is regarded as certain and conclusive: nor does any man ever entertain a doubt, where he sees a piece of iron, that it will have weight and cohesion of parts; as in all other instances, which have ever fallen under his observation. But where the objects have not so exact a similarity. the analogy is less perfect, and the inference is less conclusive; though still it has some force, in proportion to the degree of similarity and resemblance. The anatomical observations. formed upon one animal, are, by this species of reasoning, extended to all animals; and it is certain, that when the circulation of the blood, for instance, is clearly proved to have place in one creature, as a frog, or fish, it forms a strong presumption, that the same principle has place in all. These analogical observations may be carried farther, even to this science, of which we are now treating; and any theory, by which we explain the operations of the understanding, or the origin and connexion of the passions in man, will acquire additional authority, if we find, that the same theory is requisite to explain the same phenomena in all other animals. We shall make trial of this, with regard to the hypothesis, by which we have, in the foregoing discourse, endeavoured to account for all experimental reasonings; and it is hoped, that this new point of view will serve to confirm all our former observations.

First, It seems evident, that animals as well as men learn many things from experience, and infer, that the same events will always follow from the same causes. By this principle they become acquainted with the more obvious properties of external objects, and gradually, from their birth, treasure up a knowledge of the nature of fire, water, earth, stones, heights, depths, &c., and of the effects which result from their operation. The ignorance and inexperience of the young are here plainly

distinguishable from the cunning and sagacity of the old, who have learned, by long observation, to avoid what hurt them, and to pursue what gave ease or pleasure. A horse, that has been accustomed to the field, becomes acquainted with the proper height which he can leap, and will never attempt what exceeds his force and ability. An old greyhound will trust the more fatiguing part of the chace to the younger, and will place himself so as to meet the hare in her doubles; nor are the conjectures, which he forms on this occasion, founded in any thing but his observation and experience.

This is still more evident from the effects of discipline and education on animals, who, by the proper application of rewards and punishments, may be taught any course of action, the most contrary to their natural instincts and propensities. Is it not experience, which renders a dog apprehensive of pain, when you menace him, or lift up the whip to beat him? Is it not even experience, which makes him answer to his name, and infer, from such an arbitrary sound, that you mean him rather than any of his fellows, and intend to call him, when you pronounce it in a certain manner, and with a certain tone and accent?

In all these cases, we may observe, that the animal infers some fact beyond what immediately strikes his senses; and that this inference is altogether founded on past experience, while the creature expects from the present object the same consequences, which it has always found in its observation to result from similar objects.

Secondly. It is impossible, that this inference of the animal can be founded on any process of argument or reasoning, by which he concludes, that like events must follow like objects, and that the course of nature will always be regular in its operations. For if there be in reality any arguments of this nature, they surely lie too abstruse for the observation of such imperfect understandings; since it may well employ the utmost care and attention of a philosophic genius to discover and observe them. Animals, therefore, are not guided in these inferences by reasoning: Neither are children: Neither are the generality of mankind, in their ordinary actions and conclusions: Neither are philosophers themselves, who, in all the active parts of life, are, in the main, the same with the vulgar, and are governed by the same maxims. Nature must have provided some other principle, of more ready, and more general use and application; nor can an operation of such immense consequence in life, as that of inferring effects from causes, be trusted to the uncertain process of reasoning and argumentation. Were this doubtful with regard to men, it seems to admit of no question with regard to the brute creation; and the conclusion being once firmly established in the one, we have a strong presumption, from all the rules of analogy, that it ought to be universally admitted, without any exception or reserve. It is custom alone, which engages animals, from every object, that strikes their senses, to infer its usual attendant, and carries their imagination, from the appearance of the one, to conceive the other, in that particular manner, which we denominate *belief*. No other explication can be given of this operation, in all the higher, as well as lower classes of sensitive beings, which fall under our notice and observation.

But though animals learn many parts of their knowledge from observation, there are also many parts of it, which they derive from the original hand of nature; which much exceed the share of capacity they possess on ordinary occasions; and in which they improve, little or nothing, by the longest practice and experience. These we denominate Instincts, and are so ant to admire as something very extraordinary, and inexplicable by all the disquisitions of human understanding. But our wonder will. perhaps, cease or diminish, when we consider, that the experimental reasoning itself, which we possess in common with beasts, and on which the whole conduct of life depends, is nothing but a species of instinct or mechanical power, that acts in us unknown to ourselves; and in its chief operations, is not directed by any such relations or comparisons of ideas, as are the proper objects of our intellectual faculties. Though the instinct be different, yet still it is an instinct, which teaches a man to avoid the fire; as much as that, which teaches a bird, with such exactness, the art of incubation, and the whole economy and order of its nursery.71

Since all reasonings concerning facts or causes is derived merely from custom, it may be asked how it happens, that men so much surpass animals in reasoning, and one man so much surpasses another? Has not the same custom the same influence on all?

We shall here endeavour briefly to explain the great differ-

⁷¹ The digression which follows, and which here concludes Section IX, was originally printed as a long note to the last paragraph but one, above. It has, therefore, rarely received the attention it deserves.

ence in human understandings: After which the reason of the difference between men and animals will easily be comprehended.

- 1. When we have lived any time, and have been accustomed to the uniformity of nature, we acquire a general habit, by which we always transfer the known to the unknown, and conceive the latter to resemble the former. By means of this general habitual principle, we regard even one experiment as the foundation of reasoning, and expect a similar event with some degree of certainty, where the experiment has been made accurately, and free from all foreign circumstances. It is therefore considered as a matter of great importance to observe the consequences of things; and as one man may very much surpass another in attention and memory and observation, this will make a very great difference in their reasoning.
- 2. Where there is a complication of causes to produce any effect, one mind may be much larger than another, and better able to comprehend the whole system of objects, and to infer justly their consequences.
- 3. One man is able to carry on a chain of consequences to a greater length than another.
- 4. Few men can think long without running into a confusion of ideas, and mistaking one for another; and there are various degrees of this infirmity.
- 5. The circumstance, on which the effect depends, is frequently involved in other circumstances, which are foreign and extrinsic. The separation of it often requires great attention, accuracy, and subtilty.
- 6. The forming of general maxims from particular observation is a very nice operation; and nothing is more usual, from haste or a narrowness of mind, which sees not on all sides, than to commit mistakes in this particular.
- 7. When we reason from analogies, the man, who has the greater experience or the greater promptitude of suggesting analogies, will be the better reasoner.
- 8. Byasses from prejudice, education, passion, party, &c. hang more upon one mind than another.
- 9. After we have acquired a confidence in human testimony, books and conversation enlarge much more the sphere of one man's experience and thought than those of another.

It would be easy to discover many other circumstances that make a difference in the understandings of men.

SECTION X Of Miracles

PARTI

THERE is, in Dr. Tillotson's writings, an argument against the real presence, which is as concise, and elegant, and strong as any argument can possibly be supposed against a doctrine, so little worthy of a serious refutation. 72 It is acknowledged on all hands, says that learned prelate, that the authority, either of the scripture or of tradition, is founded merely in the testimony of the apostles, who were eve-witnesses to those miracles of our Saviour, by which he proved his divine mission. Our evidence, then, for the truth of the Christian religion is less than the evidence for the truth of our senses; because, even in the first authors of our religion, it was no greater; and it is evident it must diminish in passing from them to their disciples; nor can any one rest such confidence in their testimony, as in the immediate object of his senses. But a weaker evidence can never destroy a stronger; and therefore, were the doctrine of the real presence ever so clearly revealed in scripture, it were directly contrary to the rules of just reasoning to give our assent to it. It contradicts sense, though both the scripture and tradition, on which it is

⁷² John Tillotson (1630-94) put forward this argument, which Hume summarizes, in his Discourse against Transubstantiation, published in 1684. seven years before he was appointed Archbishop of Canterbury. For Tillotson to have urged such an argument in that context is surprising. For it suggests that he failed to appreciate what the nub of the peculiarly Roman Catholic doctrine of transubstantiation actually is. Tillotson is apparently mistaking it to assert that at the Mass Christ is really present, in a sense which is flagrantly contrary to all experience. The dogma in fact is less straightforward, and less easily intelligible. It does indeed begin by asserting a real presence, but this is immediately qualified in a way which should forestall any unsophisticated objections. The point comes out well in the second Canon adopted by the Council of Trent 'On the sacrament of the most holy Eucharist'. This Canon anathematizes anyone who "shall say that in the most holy sacrament of the Eucharist the substance of bread and wine remains . . . and shall deny that marvellous and singular conversion of the whole substance of the bread into the body, and of the whole substance of the wine into the blood, with the appearances of bread and wine remaining; which conversion the Catholic Church most aptly calls transubstantiation".

supposed to be built, carry not such evidence with them as sense; when they are considered merely as external evidences, and are not brought home to every one's breast, by the immediate operation of the Holy Spirit.

Nothing is so convenient as a decisive argument of this kind, which must at least *silence* the most arrogant bigotry and superstition, and free us from their impertinent solicitations. I flatter myself, that I have discovered an argument of a like nature, which, if just, will, with the wise and learned, be an everlasting check to all kinds of superstitious delusion, and consequently, will be useful as long as the world endures. For so long, I presume, will the accounts of miracles and prodigies be found in all history, sacred and profane.

Though experience be our only guide in reasoning concerning matters of fact; it must be acknowledged, that this guide is not altogether infallible, but in some cases is apt to lead us into errors. One, who in our climate, should expect better weather in any week of June than in one of December, would reason justly. and conformably to experience; but it is certain, that he may happen, in the event, to find himself mistaken. However, we may observe, that, in such a case, he would have no cause to complain of experience; because it commonly informs us beforehand of the uncertainty, by that contrariety of events, which we may learn from a diligent observation. All effects follow not with like certainty from their supposed causes. Some events are found, in all countries and all ages, to have been constantly conjoined together: Others are found to have been more variable, and sometimes to disappoint our expectations; so that, in our reasonings concerning matter of fact, there are all imaginable degrees of assurance, from the highest certainty to the lowest species of moral evidence. 73

A wise man, therefore, proportions his belief to the evidence. In such conclusions as are founded on an infallible experience, he expects the event with the last degree of assurance, and regards his past experience as a full *proof* of the future existence of that event. In other cases, he proceeds with more caution: He

⁷³ "Moral evidence" here means evidence from and about matters of fact. The contrast is with matters which can be demonstrated as deducible from logically necessary truths. It is the same use of the word 'moral' as in the fossil phrase 'moral certainty'.

§X PT I OF MIRACLES 145

weighs the opposite experiments:⁷⁴ He considers which side is supported by the greater number of experiments: to that side he inclines, with doubt and hesitation; and when at last he fixes his judgement, the evidence exceeds not what we properly call *probability*. All probability, then, supposes an opposition of experiments and observations, where the one side is found to overbalance the other, and to produce a degree of evidence, proportioned to the superiority. A hundred instances or experiments on one side, and fifty on another, afford a doubtful expectation of any event; though a hundred uniform experiments, with only one that is contradictory, reasonably beget a pretty strong degree of assurance. In all cases, we must balance the opposite experiments, where they are opposite, and deduct the smaller number from the greater, in order to know the exact force of the superior evidence.

To apply these principles to a particular instance; we may observe, that there is no species of reasoning more common. more useful, and even necessary to human life, than that which is derived from the testimony of men, and the reports of evewitnesses and spectators. This species of reasoning, perhaps. one may deny to be founded on the relation of cause and effect. I shall not dispute about a word. It will be sufficient to observe that our assurance in any argument of this kind is derived from no other principle than our observation of the veracity of human testimony, and of the usual conformity of facts to the reports of witnesses. It being a general maxim, that no objects have any discoverable connexion together, and that all the inferences, which we can draw from one to another, are founded merely on our experience of their constant and regular conjunction; it is evident, that we ought not to make an exception to this maxim in favour of human testimony, whose connexion with any event seems, in itself, as little necessary as any other. Were not the memory tenacious to a certain degree; had not men commonly an inclination to truth and a principle of probity; were they not sensible to shame, when detected in a falsehood: Were not these. I say, discovered by experience to be qualities, inherent in human

⁷⁴ Although he sometimes draws conclusions which only actively experimental evidence would warrant, Hume, in a way which perhaps confused him as much as it does us, used the words 'experiment' and 'experimental' as if they were synonymous with 'experience' and 'experiential'.

nature, we should never repose the least confidence in human testimony. A man delirious, or noted for falsehood and villany, has no manner authority with us.

And as the evidence, derived from witnesses and human testimony, is founded on past experience, so it varies with the experience, and is regarded either as a proof or a probability, according as the conjunction between any particular kind of report and any kind of object has been found to be constant or variable. There are a number of circumstances to be taken into consideration in all judgements of this kind; and the ultimate standard, by which we determine all disputes, that may arise concerning them, is always derived from experience and observation. Where this experience is not entirely uniform on any side, it is attended with an unavoidable contrariety in our judgements, and with the same opposition and mutual destruction of argument as in every other kind of evidence. We frequently hesitate concerning the reports of others. We balance the opposite circumstances, which cause any doubt or uncertainty; and when we discover a superiority on any side, we incline to it; but still with a diminution of assurance, in proportion to the force of its antagonist.

This contrariety of evidence, in the present case, may be derived from several different causes; from the opposition of contrary testimony; from the character or number of the witnesses; from the manner of their delivering their testimony; or from the union of all these circumstances. We entertain a suspicion concerning any matter of fact, when the witnesses contradict each other; when they are but few, or of a doubtful character; when they have an interest in what they affirm; when they deliver their testimony with hesitation, or on the contrary, with too violent asseverations. There are many other particulars of the same kind, which may diminish or destroy the force of any argument, derived from human testimony.

Suppose, for instance, that the fact, which the testimony endeavours to establish, partakes of the extraordinary and the marvellous; in that case, the evidence, resulting from the testimony, admits of a diminution, greater or less, in proportion as the fact is more or less unusual. The reason why we place any credit in witnesses and historians, is not derived from any connexion, which we perceive a priori, between testimony and reality, but because we are accustomed to find a conformity between them. But when the fact attested is such a one as has

§X PT I OF MIRACLES 147

seldom fallen under our observation, here is a contest of two opposite experiences; of which the one destroys the other, as far as its force goes, and the superior can only operate on the mind by the force, which remains. The very same principle of experience, which gives us a certain degree of assurance in the testimony of witnesses, gives us also, in this case, another degree of assurance against the fact, which they endeavour to establish; from which contradiction there necessarily arises a counterpoize, and mutual destruction of belief and authority.

I should not believe such a story were it told me by Cato, was a proverbial saying in Rome, even during the lifetime of that philosophical patriot (Plutarch, *Life of Cato*)⁷⁵. The incredibility of a fact, it was allowed, might invalidate so great an authority.

The Indian prince, who refused to believe the first relations concerning the effects of frost, reasoned justly; and it naturally required very strong testimony to engage his assent to facts, that arose from a state of nature, with which he was unacquainted, and which bore so little analogy to those events, of which he had had constant and uniform experience. Though they were not contrary to his experience, they were not conformable to it.⁷⁶

No Indian, it is evident, could have experience that water did not freeze in cold climates. This is placing nature in a situation quite unknown to him; and it is impossible for him to tell a priori what will result from it. It is making a new experiment, the consequence of which is always uncertain. One may sometimes conjecture from analogy what will follow; but still this is but conjecture. And it must be confessed, that, in the present case of freezing, the event follows contrary to the rules of analogy, and is such as a rational Indian would not look for. The operations of cold upon water are not gradual, according to the degrees of cold: but whenever it comes to the freezing point, the water passes in a moment, from the utmost liquidity to perfect hardness. Such an event, therefore, may be denominated extraordinary, and requires a pretty strong testimony, to render it credible to people in a warm climate: But still it is not miraculous, nor contrary to uniform experience of the course of nature in cases where all the

 $^{^{75}}$ Cato the Younger (95–46 $_{\rm BCE})$ was a Roman politician and a Stoic, hence 'philosophical'. The reference in Part II of Section V, above, is to Cato the Elder (234–149 $_{\rm BCE}).$

⁷⁶ The following paragraph was originally printed as a footnote.

circumstances are the same. The inhabitants of Sumatra have always seen water fluid in their own climate, and the freezing of their rivers ought to be deemed a prodigy: But they never saw water in Muscovy during the winter; and therefore they cannot reasonably be positive what would there be the consequence.

But in order to encrease the probability against the testimony of witnesses, let us suppose, that the fact, which they affirm, instead of being only marvellous, is really miraculous; and suppose also, that the testimony considered apart and in itself, amounts to an entire proof; in that case, there is proof against proof, of which the strongest must prevail, but still with a diminution of its force, in proportion to that of its antagonist.

A miracle is a violation of the laws of nature: and as a firm and unalterable experience has established these laws, the proof against a miracle, from the very nature of the fact, is as entire as any argument from experience can possibly be imagined. Why is it more than probable, that all men must die; that lead cannot, of itself, remain suspended in the air; that fire consumes wood, and is extinguished by water; unless it be, that these events are found agreeable to the laws of nature, and there is required a violation of these laws, or in other words, a miracle to prevent them? Nothing is esteemed a miracle, if it ever happen in the common course of nature. It is no miracle that a man, seemingly in good health, should die on a sudden: because such a kind of death, though more unusual than any other, has yet been frequently observed to happen. But it is a miracle, that a dead man should come to life; because that has never been observed in any age or country. There must, therefore, be a uniform experience against every miraculous event, otherwise the event would not merit that appellation. And as a uniform experience amounts to a proof, there is here a direct and full proof, from the nature of the fact, against the existence of any miracle; nor can such a proof be destroyed, or the miracle rendered credible, but by an opposite proof, which is superior. 77

Sometimes an event may not, *in itself, seem* to be contrary to the laws of nature, and yet, if it were real, it might, by reason of some circumstances, be denominated a miracle; because, in *fact*, it is contrary to these laws. Thus if a person, claiming a divine

⁷⁷ Hume's argument is that the evidence in favor of a law of nature is always at least as strong as the testimonial evidence for the occurrence of an event inconsistent with that law.

§X PT I OF MIRACLES 149

authority, should command a sick person to be well, a healthful man to fall down dead, the clouds to pour rain, the winds to blow. in short, should order many natural events, which immediately follow upon his command; these might justly be esteemed miracles, because they are really, in this case, contrary to the laws of nature. For if any suspicion remain, that the event and command concurred by accident, there is no miracle and no transgression of the laws of nature. If this suspicion be removed, there is evidently a miracle, and a transgression of these laws: because nothing can be more contrary to nature than that the voice or command of a man should have such an influence. A miracle may be accurately defined, a transgression of a law of nature by a particular volition of the Deity, or by the interposition of some invisible agent. A miracle may either be discoverable by men or not. This alters not its nature and essence. The raising of a house or ship into the air is a visible miracle. The raising of a feather, when the wind wants ever so little of a force requisite for that purpose, is as real a miracle, though not so sensible with regard to us.78

The plain consequence is (and it is a general maxim worthy of our attention), 'That no testimony is sufficient to establish a miracle, unless the testimony be of such a kind, that its falsehood would be more miraculous, than the fact, which it endeavours to establish; and even in that case there is a mutual destruction of arguments, and the superior only gives us an assurance suitable to that degree of force, which remains, after deducting the inferior.' When anyone tells me, that he saw a dead man restored to life, I immediately consider with myself. whether it be more probable, that this person should either deceive or be deceived, or that the fact, which he relates, should really have happened. I weigh the one miracle against the other: and according to the superiority, which I discover, I pronounce my decision, and always reject the greater miracle. If the falsehood of his testimony would be more miraculous, than the event which he relates; then, and not till then, can he pretend to command my belief or opinion. 79

⁷⁸ This paragraph was originally printed as a footnote.

⁷⁹ A problem for Hume is to account for some people's belief in miracles based on testimony. He is not only arguing that we have no reasonable grounds to accept the occurrence of a miracle based on testimony but also that the mind *in fact* operates in the way he describes. This problem he attempts to solve in the next few pages.

PART II

In the foregoing reasoning we have supposed, that the testimony, upon which a miracle is founded, may possibly amount to an entire proof, and that the falsehood of that testimony would be a real prodigy: But it is easy to shew, that we have been a great deal too liberal in our concession, and that there never was a miraculous event established on so full an evidence.

For *first*, there is not to be found, in all history, any miracle attested by a sufficient number of men, of such unquestioned good-sense, education, and learning, as to secure us against all delusion in themselves; of such undoubted integrity, as to place them beyond all suspicion of any design to deceive others; of such credit and reputation in the eyes of mankind, as to have a great deal to lose in case of their being detected in any falsehood; and at the same time, attesting facts performed in such a public manner and in so celebrated a part of the world, as to render the detection unavoidable: All which circumstances are requisite to give us a full assurance in the testimony of men.

Secondly. We may observe in human nature a principle which, if strictly examined, will be found to diminish extremely the assurance, which we might, from human testimony, have, in any kind of prodigy. The maxim, by which we commonly conduct ourselves in our reasonings, is, that the objects, of which we have no experience, resemble those, of which we have; that what we have found to be most usual is always most probable; and that where there is an opposition of arguments, we ought to give the preference to such as are founded on the greatest number of past observations. But though, in proceeding by this rule, we readily reject any fact which is unusual and incredible in an ordinary degree: vet in advancing farther, the mind observes not always the same rule; but when anything is affirmed utterly absurd and miraculous, it rather the more readily admits of such a fact. upon account of that very circumstance, which ought to destroy all its authority. The passion of surprise and wonder, arising from miracles, being an agreeable emotion, gives a sensible tendency towards the belief of those events, from which it is derived. And this goes so far, that even those who cannot enjoy this pleasure immediately, nor can believe those miraculous events, of which they are informed, yet love to partake of the satisfaction at second-hand or by rebound, and place a pride and delight in exciting the admiration of others.

§X PT II OF MIRACLES 151

With what greediness are the miraculous accounts of travellers received, their descriptions of sea and land monsters. their relations of wonderful adventures, strange men, and uncouth manners? But if the spirit of religion join itself to the love of wonder, there is an end of common sense; and human testimony, in these circumstances, loses all pretensions to authority. A religionist may be an enthusiast, 80 and imagine he sees what has no reality: he may know his narrative to be false. and vet persevere in it, with the best intentions in the world, for the sake of promoting so holy a cause: or even where this delusion has not place, vanity, excited by so strong a temptation, operates on him more powerfully than on the rest of mankind in any other circumstances; and self-interest with equal force. His auditors may not have, and commonly have not, sufficient judgement to canvass his evidence: what judgement they have. they renounce by principle, in these sublime and mysterious subjects: or if they were ever so willing to employ it, passion and a heated imagination disturb the regularity of its operations. Their credulity increases his impudence: and his impudence overpowers their credulity.

Eloquence, when at its highest pitch, leaves little room for reason or reflection; but addressing itself entirely to the fancy or the affections, captivates the willing hearers, and subdues their understanding. Happily, this pitch it seldom attains. But what a Tully or a Demosthenes could scarcely effect over a Roman or Athenian audience, every *Capuchin*, every itinerant or stationary teacher can perform over the generality of mankind, and in a higher degree, by touching such gross and vulgar passions.⁸¹

The many instances of forged miracles, and prophecies, and supernatural events, which, in all ages, have either been detected by contrary evidence, or which detect themselves by their absurdity, prove sufficiently the strong propensity of mankind to the extraordinary and the marvellous, and ought reasonably to beget a suspicion against all relations of this kind. This is our natural way of thinking, even with regard to the most

⁸⁰ "Enthusiast" in the eighteenth century meant 'fanatic'. Bishop Joseph Butler said to John Wesley that "enthusiasm is a very horrid thing", a typical eighteenth-century English attitude.

⁸¹ 'Tully' was a nickname for Marcus Tullius Cicero. Demosthenes (384–322 BCE) was an Athenian orator and politician, a leader in resistance to the conquests of Philip of Macedon. A Capuchin is a Friar of the Order of St. Francis.

common and most credible events. For instance: There is no kind of report which rises so easily, and spreads so quickly, especially in country places and provincial towns, as those concerning marriages; insomuch that two young persons of equal condition never see each other twice, but the whole neighbourhood immediately join them together. The pleasure of telling a piece of news so interesting, of propagating it, and of being the first reporters of it, spreads the intelligence. And this is so well known, that no man of sense gives attention to these reports, till he find them confirmed by some greater evidence. Do not the same passions, and others still stronger, incline the generality of mankind to believe and report, with the greatest vehemence and assurance, all religious miracles?

Thirdly. It forms a strong presumption against all supernatural and miraculous relations, that they are observed chiefly to abound among ignorant and barbarous nations; or if a civilized people has ever given admission to any of them, that people will be found to have received them from ignorant and barbarous ancestors, who transmitted them with that inviolable sanction and authority, which always attend received opinions. When we peruse the first histories of all nations, we are apt to imagine ourselves transported into some new world; where the whole frame of nature is disjointed, and every element performs its operations in a different manner, from what it does at present. Battles, revolutions, pestilence, famine and death, are never the effect of those natural causes, which we experience. Prodigies, omens, oracles, judgements, quite obscure the few natural events, that are intermingled with them. But as the former grow thinner every page, in proportion as we advance nearer the enlightened ages, we soon learn that there is nothing mysterious or supernatural in the case, but that all proceeds from the usual propensity of mankind towards the marvellous, and that, though this inclination may at intervals receive a check from sense and learning, it can never be thoroughly extirpated from human nature.

It is strange, a judicious reader is apt to say, upon the perusal of these wonderful historians, that such prodigious events never happen in our days. But it is nothing strange, I hope, that men should lie in all ages. You must surely have seen instances enough of that frailty. You have yourself heard many such marvellous relations started, which, being treated with scorn by all the wise and judicious, have at last been abandoned

§X PT II OF MIRACLES 153

even by the vulgar. Be assured, that those renowned lies, which have spread and flourished to such a monstrous height, arose from like beginnings; but being sown in a more proper soil, shot up at last into prodigies almost equal to those which they relate.

It was a wise policy in that false prophet, Alexander, who though now forgotten, was once so famous, to lay the first scene of his impostures in Paphlagonia, where, as Lucian tells us, the people were extremely ignorant and stupid, and ready to swallow even the grossest delusion.⁸² People at a distance, who are weak enough to think the matter at all worth enquiry, have no opportunity of receiving better information. The stories come magnified to them by a hundred circumstances. Fools are industrious in propagating the imposture; while the wise and learned are contented, in general, to deride its absurdity, without informing themselves of the particular facts, by which it may be distinctly refuted. And thus the impostor above mentioned was enabled to proceed, from his ignorant Paphlagonians, to the enlisting of votaries, even among the Grecian philosophers, and men of the most eminent rank and distinction in Rome: nay, could engage the attention of that sage emperor Marcus Aurelius, 83 so far as to make him trust the success of a military expedition to his delusive prophecies.

The advantages are so great, of starting an imposture among an ignorant people, that, even though the delusion should be too gross to impose on the generality of them (which, though seldom, is sometimes the case) it has a much better chance for succeeding in remote countries, than if the first scene had been laid in a city renowned for arts and knowledge. The most ignorant and barbarous of these barbarians carry the report abroad. None of their countrymen have a large correspondence, or sufficient credit and authority to contradict and beat down the delusion. Men's inclination to the marvellous has full opportunity to display itself. And thus a story, which is universally exploded in the place where it was first started, shall pass

⁸² Lucian (second century CE) was a Greek author, who wrote *Alexander*, or *The False Prophet*, a rollicking exposure of that otherwise unmemorable worker of fraudulent miracles, Alexander of Abonoteichos. Paphlagonia was an area of Northern Asia Minor, now part of Turkey.

 $^{^{83}}$ Marcus Aurelius (121–180 $_{\rm CE})$ was a Stoic philosopher and author of the famous Meditations. At the time referred to he was Roman Emperor and thus ruler of Paphlagonia.

for certain at a thousand miles distance. But had Alexander fixed his residence at Athens, the philosophers of that renowned mart of learning had immediately spread, throughout the whole Roman empire, their sense of the matter; which, being supported by so great authority, and displayed by all the force of reason and eloquence, had entirely opened the eyes of mankind. It is true; Lucian, passing by chance through Paphlagonia, had an opportunity of performing this good office. But, though much to be wished, it does not always happen, that every Alexander meets with a Lucian, ready to expose and detect his impostures.

I may add as a fourth reason, which diminishes the authority of prodigies, that there is no testimony for any, even those which have not been expressly detected, that is not opposed by an infinite number of witnesses; so that not only the miracle destroys the credit of testimony, but the testimony destroys itself. To make this the better understood, let us consider, that, in matters of religion, whatever is different is contrary; and that it is impossible the religions of ancient Rome. of Turkey, of Siam, and of China should, all of them, be established on any solid foundation. Every miracle, therefore pretended to have been wrought in any of these religions (and all of them abound in miracles), as its direct scope is to establish the particular system to which it is attributed; so has it the same force, though more indirectly, to overthrow every other system. In destroying a rival system, it likewise destroys the credit of those miracles, on which that system was established; so that all the prodigies of different religions are to be regarded as contrary facts, and the evidences of these prodigies, whether weak or strong, as opposite to each other. According to this method of reasoning, when we believe any miracle of Mahomet or his successors, we have for our warrant the testimony of a few barbarous Arabians:84 And on the other hand, we are to regard the authority of Titus Livius, Plutarch, 85 Tacitus, and, in short, of all the authors and witnesses, Grecian, Chinese, and Roman Catholic, who have related any miracle in their particular religion; I say, we are to regard their testimony in the same light

 $^{^{84}}$ Mahomet, or Mohammed (c. 570–632), born in Mecca, was the Prophet of Islam.

 $^{^{85}}$ Titus Livius, or Livy (59 $_{\rm BCE-17~CE}$), was a Roman historian of Rome. Plutarch (c. 46–120 $_{\rm CE}$) was a Greek writer, best known as the author of a series of comparative, parallel biographies.

§X PT II OF MIRACLES 155

as if they had mentioned that Mahometan miracle, and had in express terms contradicted it, with the same certainty as they have for the miracle they relate. This argument may appear over subtile and refined; but is not in reality different from the reasoning of a judge, who supposes, that the credit of two witnesses, maintaining a crime against any one, is destroyed by the testimony of two others, who affirm him to have been two hundred leagues distant, at the same instant when the crime is said to have been committed.

One of the best attested miracles in all profane history, is that which Tacitus reports of Vespasian,86 who cured a blind man in Alexandria, by means of his spittle, and a lame man by the mere touch of his foot; in obedience to a vision of the god Serapis,87 who had enjoined them to have recourse to the Emperor, for these miraculous cures. The story may be seen in that fine historian;88 where every circumstance seems to add weight to the testimony, and might be displayed at large with all the force of argument and eloquence, if any one were now concerned to enforce the evidence of that exploded and idolatrous superstition. The gravity, solidity, age, and probity of so great an emperor, who, through the whole course of his life. conversed in a familiar manner with his friends and courtiers. and never affected those extraordinary airs of divinity assumed by Alexander and Demetrius.89 The historian, a cotemporary writer, noted for candour and veracity, and withal, the greatest

 $^{^{86}}$ Vespasian (9–79 $\scriptscriptstyle \mathrm{CE}$) was a soldier and a Roman Emperor.

 $^{^{87}}$ Serapis, or Sarapis, was a god worshipped in Ptolemaic Egypt from the late fourth century $_{\rm BCE}$ onwards.

 $^{^{88}}$ Hume here has a footnote giving a reference to the *Histories* of Tacitus, adding that Suetonius (c. 69–c. 140 ce) "gives nearly the same account" in his *Life of Vespasian*. But the reference given in the first printing of Hume's first *Enquiry* was incorrect, and a further error was introduced in the edition of 1756. It should have been to *Histories* IV, 81.

It appears that for over two hundred years—indeed until the present Editor was working on his *Hume's Philosophy of Belief*—no one ever tried to check what exactly the two passages actually said. The reward of scholarly virtue was then to discover that the better of our two authorities recorded that Vespasian's army surgeons had reported that there were—to put it in modern terms—no organic lesions; which suggests that the alleged cures would have been within the limits of psychosomatic possibility.

The improving, and perhaps even exhilarating, morals are obvious.

89 "Alexander" here is Alexander the Great. Demetrius is Demetrius I of
Macedonia (336–283 BCE). After his Eastern conquests, Alexander took over
the quasi-divine attributes ascribed to the Persian Emperor.

and most penetrating genius, perhaps, of all antiquity; and so free from any tendency to credulity, that he even lies under the contrary imputation, of atheism and profaneness: The persons, from whose authority he related the miracle, of established character for judgement and veracity, as we may well presume; eye-witnesses of the fact, and confirming their testimony, after the Flavian family was despoiled of the empire, and could no longer give any reward, as the price of a lie. *Utrumque*, *qui interfuere*, *nunc quoque memorant*, *postquam nullum mendacio pretium*. ⁹⁰ To which if we add the public nature of the facts, as related, it will appear, that no evidence can well be supposed stronger for so gross and so palpable a falsehood.

There is also a memorable story related by Cardinal de Retz, which may well deserve our consideration.91 When that intriguing politician fled into Spain, to avoid the persecution of his enemies, he passed through Saragossa, the capital of Arragon, where he was shewn, in the cathedral, a man, who had served seven years as a doorkeeper, and was well known to every body in town, that had ever paid his devotions at that church. He had been seen, for so long a time, wanting a leg; but recovered that limb by the rubbing of holy oil upon the stump; and the cardinal assures us that he saw him with two legs. This miracle was vouched by all the canons of the church; and the whole company in town were appealed to for a confirmation of the fact; whom the cardinal found, by their zealous devotion, to be thorough believers of the miracle. Here the relater was also contemporary to the supposed prodigy, of an incredulous and libertine character, as well as of great genius; the miracle of so singular a nature as could scarcely admit of a counterfeit, and the witnesses very numerous, and all of them, in a manner, spectators of the fact, to which they gave their testimony. And what adds mightily to the force of the evidence, and may double our surprise on this occasion, is, that the cardinal himself, who relates the story, seems not to give any credit to it, and consequently cannot be suspected of any concurrence in the holy fraud. He considered

 $^{^{90}}$ The Flavian family were, here, Vespasian and his two Emperor sons, Titus (c. 40–81 $_{\rm CE})$ and Domitian (51–96 $_{\rm CE})$. The Latin, which is a characteristic comment made by Tacitus, translates: 'Those who were present mention both incidents even now, when there is no reward for telling a lie'.

⁹¹ Cardinal de Retz (1614–79) was an Archbishop of Paris, author of some once widely-read *Mémoires*.

§X PT II OF MIRACLES 157

justly, that it was not requisite, in order to reject a fact of this nature, to be able accurately to disprove the testimony, and to trace its falsehood, through all the circumstances of knavery and credulity which produced it. He knew, that, as this was commonly altogether impossible at any small distance of time and place; so was it extremely difficult, even where one was immediately present, by reason of the bigotry, ignorance, cunning, and roguery of a great part of mankind. He therefore concluded, like a just reasoner, that such an evidence carried falsehood upon the very face of it, and that a miracle, supported by any human testimony, was more properly a subject of derision than of argument.

There surely never was a greater number of miracles ascribed to one person, than those, which were lately said to have been wrought in France upon the tomb of Abbé Paris, the famous Jansenist, with whose sanctity the people were so long deluded. 92 The curing of the sick, giving hearing to the deaf, and sight to the blind, were every where talked of as the usual effects of that holy sepulchre. But what is more extraordinary; many of the miracles were immediately proved upon the spot, before judges of unquestioned integrity, attested by witnesses of credit and distinction, in a learned age, and on the most eminent theatre that is now in the world. Nor is this all: a relation of them. was published and dispersed every where; nor were the *Jesuits*. though a learned body, supported by the civil magistrate, and determined enemies to those opinions,93 in whose favour the miracles were said to have been wrought, ever able distinctly to refute or detect them. Where shall we find such a number of circumstances, agreeing to the corroboration of one fact? And what have we to oppose to such a cloud of witnesses, but the

⁹² The Abbé Paris was François de Paris (1690–1727), a follower of Cornelius Jansen (1585–1638), a Bishop of Ypres in Flanders. In his 1640 Augustinus Jansen propounded doctrines of moral austerity and of the dependence of human virtue upon Divine grace, doctrines adopted by the convent of Port-Royal and by all those, such as Blaise Pascal and the authors of the Port-Royal Logic, who associated with it. Jesuits are members of the Society of Jesus; an order originally founded for the purpose of promoting the Counter-Reformation, and an order owing (and until very recently yielding) a special obedience to the Popes.

⁹³ The Jesuits strongly opposed the Jansenists, who accused them of moral laxity. Pascal's *Lettres provinciales* (1656–1657), a series of 18 letters, is devoted to an attack on Jesuit casuistry, i.e., application of moral principles to particular cases.

absolute impossibility or miraculous nature of the events, which they relate? And this surely, in the eyes of all reasonable people, will alone be regarded as a sufficient refutation.⁹⁴

This book was writ by Mons. Montgeron, counsellor or judge of the parliament of Paris, a man of figure and character, who was also a martyr to the cause, and is now said to be somewhere in a dungeon on account of his book.

There is another book in three volumes (called *Recueil des Miracles de l' Abbé Paris*) giving an account of many of these miracles, and accompanied with prefatory discourses, which are very well written. There runs, however, through the whole of these a ridiculous comparison between the miracles of our Saviour and those of the Abbé; wherein it is asserted, that the evidence for the latter is equal to that for the former: As if the testimony of men could ever be put in the balance with that of God himself, who conducted the pen of the inspired writers. If these writers, indeed, were to be considered merely as human testimony, the French author is very moderate in his comparison; since he might, with some appearance of reason, pretend, that the Jansenist miracles much surpass the other in evidence and authority. The following circumstances are drawn from authentic papers, inserted in the above-mentioned book.

Many of the miracles of Abbé Paris were proved immediately by witnesses before the officiality or bishop's court at Paris, under the eye of cardinal Noailles, whose character for integrity and capacity was never contested even by his enemies.

His successor in the archbishopric was an enemy to the Jansenists, and for that reason promoted to the see by the court. Yet 22 rectors or *curés* of Paris, with infinite earnestness, press him to examine those miracles, which they assert to be known to the whole world, and undisputably certain: But he wisely forbore.

The Molinist party 95 had tried to discredit these miracles in

⁹⁴ The next twelve paragraphs were originally printed as a monster note. Some subsequent editions of the first *Enquiry* have turned it into a kind of appendix. But it deserves to be read. So, to increase the chances that it will be, it, like all Hume's other and shorter notes, has here been assimilated into the main text. At the height of the whole affair Hume was himself in France, living at La Flèche in Touraine, site of the crack Jesuit school which had educated Descartes, and working on the composition of his own *Treatise*.

 $^{^{95}}$ Followers of Luis de Molina (1535–1600), believers in free will, and hence anti-Jansenists. They were usually Jesuits.

§X PT II OF MIRACLES 159

one instance, that of Mademoiselle le Franc. But, besides that their proceedings were in many respects the most irregular in the world, particularly in citing only a few of the Jansenist witnesses, whom they tampered with: Besides this, I say, they soon found themselves overwhelmed by a cloud of new witnesses, one hundred and twenty in number, most of them persons of credit and substance in Paris, who gave oath for the miracle. This was accompanied with a solemn and earnest appeal to the parliament. But the parliament were forbidden by authority to meddle in the affair. It was at last observed, that where men are heated by zeal and enthusiasm, there is no degree of human testimony so strong as may not be procured for the greatest absurdity: And those who will be so silly as to examine the affair by that medium, and seek particular flaws in the testimony, are almost sure to be confounded. It must be a miserable imposture, indeed, that does not prevail in that contest.

All who have been in France about that time have heard of the reputation of Mons. Heraut, the *lieutenant de Police*, whose vigilance, penetration, activity, and extensive intelligence have been much talked of. This magistrate, who by the nature of his office is almost absolute, was invested with full powers, on purpose to suppress or discredit these miracles; and he frequently seized immediately, and examined the witnesses and subjects of them: But never could reach any thing satisfactory against them.

In the case of Mademoiselle Thibaut he sent the famous De Sylva to examine her; whose evidence is very curious. The physician declares, that it was impossible she could have been so ill as was proved by witnesses; because it was impossible she could, in so short a time, have recovered so perfectly as he found her. He reasoned, like a man of sense, from natural causes; but the opposite party told him, that the whole was a miracle, and that his evidence was the very best proof of it.

The Molinists were in a sad dilemma. They durst not assert the absolute insufficiency of human evidence, to prove a miracle. They were obliged to say, that these miracles were wrought by witchcraft and the devil. But they were told, that this was the resource of the Jews of old.⁹⁶

No Jansenist was ever embarrassed to account for the

⁹⁶ In questioning the miracles of Christ.

cessation of the miracles, when the church-yard was shut up by the king's edict. It was the touch of the tomb, which produced these extraordinary effects; and when no one could approach the tomb, no effects could be expected. God, indeed, could have thrown down the walls in a moment; but he is master of his own graces and works, and it belongs not to us to account for them. He did not throw down the walls of every city like those of Jericho, on the sounding of the rams horns, nor break up the prison of every apostle, like that of St. Paul.

No less a man, than the Duc de Chatillon, a duke and peer of France, of the highest rank and family, gives evidence of a miraculous cure, performed upon a servant of his, who had lived several years in his house with a visible and palpable infirmity.

I shall conclude with observing, that no clergy are more celebrated for strictness of life and manners than the secular clergy of France, particularly the rectors or curés of Paris, who bear testimony to these impostures.

The learning, genius, and probity of the gentlemen, and the austerity of the nuns of Port-Royal, have been much celebrated all over Europe. Yet they all give evidence for a miracle, wrought on the niece of the famous Pascal, whose sanctity of life, as well as extraordinary capacity, is well known. The famous Racine⁹⁷ gives an account of this miracle in his famous history of Port-Royal, and fortifies it with all the proofs, which a multitude of nuns, priests, physicians, and men of the world, all of them of undoubted credit, could bestow upon it. Several men of letters, particularly the bishop of Tournay, thought this miracle so certain, as to employ it in the refutation of atheists and freethinkers. The queen-regent of France, who was extremely prejudiced against the Port-Royal, sent her own physician to examine the miracle, who returned an absolute convert. In short, the supernatural cure was so uncontestable, that it saved. for a time, that famous monastery from the ruin with which it was threatened by the Jesuits. Had it been a cheat, it had certainly been detected by such sagacious and powerful antagonists, and must have hastened the ruin of the contrivers. Our divines, who can build up a formidable castle from such

⁹⁷ Jean Racine (1639–1699), author of *Andromaque*, *Phèdre*, *Athalie*, and other plays. He was educated at the Jansenist school at Port Royal, and buried in the Port Royal abbey, ten years before it was destroyed by the French king following the Pope's condemnation of Jansenism.

§X PT II OF MIRACLES 161

despicable materials; what a prodigious fabric could they have reared from these and many other circumstances, which I have not mentioned! How often would the great names of Pascal, Racine, Arnauld, Nicole, have resounded in our ears? But if they be wise, they had better adopt the miracle, as being more worth, a thousand times, than all the rest of their collection. Besides, it may serve very much to their purpose. For that miracle was really performed by the touch of an authentic holy prickle of the holy thorn, which composed the holy crown, which, &c.

Is the consequence just, because some human testimony has the utmost force and authority in some cases, when it relates the battle of Philippi or Pharsalia for instance; that therefore all kinds of testimony must, in all cases, have equal force and authority? Suppose that the Cæsarean and Pompeian factions had, each of them, claimed the victory in these battles, and that the historians of each party had uniformly ascribed the advantage to their own side; how could mankind, at this distance, have been able to determine between them? The contrariety is equally strong between the miracles related by Herodotus or Plutarch, and those delivered by Mariana, Bede, or any monkish historian.

The wise lend a very academic¹⁰⁰ faith to every report which favours the passion of the reporter; whether it magnifies his country, his family, or himself, or in any other way strikes in with his natural inclinations and propensities. But what greater temptation than to appear a missionary, a prophet, an ambassador from heaven? Who would not encounter many dangers and difficulties, in order to attain so sublime a character? Or if, by the help of vanity and a heated imagination, a man has first

⁹⁸ After the long digression about the evidence in the case of the alleged miracles at the tomb of the Abbé Paris, Hume is resuming his main argument. Philippi was a city in Macedonia near which in 42 BCE the armies of Octavian, the future first Emperor Augustus, and Mark Antony defeated the republican forces under Brutus and Cassius. See Shakespeare's *Julius Caesar*, Act V. Pharsalia was a city in Thessaly where in 48 BCE Julius Caesar himself defeated Pompey, his rival for dominion of the Roman world.

⁹⁹ Herodotus, who flourished in the earlier part of the fifth century BCE, was a Greek from Halicarnassus in Asia Minor, often hailed as the Father of History. Juan Mariana (1536–1623) was a Spanish Jesuit. St. Bede, the Venerable Bede (c. 673–735), is sometimes spoken of as the father of—more particularly—English history.

^{100 &}quot;Academic" = 'sceptical', after the sceptics who took over the Academy founded by Plato. The most important of these was Carneades.

made a convert of himself, and entered seriously into the delusion; who ever scruples to make use of pious frauds, in support of so holy and meritorious a cause?

The smallest spark may here kindle into the greatest flame; because the materials are always prepared for it. The *avidum genus auricularum*, ¹⁰¹ the gazing populace, receive greedily, without examination, whatever sooths superstition, and promotes wonder.

How many stories of this nature have, in all ages, been detected and exploded in their infancy? How many more have been celebrated for a time, and have afterwards sunk into neglect and oblivion? Where such reports, therefore, fly about, the solution of the phenomenon is obvious; and we judge in conformity to regular experience and observation, when we account for it by the known and natural principles of credulity and delusion. And shall we, rather than have a recourse to so natural a solution, allow of a miraculous violation of the most established laws of nature?

I need not mention the difficulty of detecting a falsehood in any private or even public history, at the place, where it is said to happen; much more when the scene is removed to ever so small a distance. Even a court of judicature, with all the authority, accuracy, and judgement, which they can employ, find themselves often at a loss to distinguish between truth and falsehood in the most recent actions. But the matter never comes to any issue, if trusted to the common method of altercation and debate and flying rumours; especially when men's passions have taken part on either side.

In the infancy of new religions, the wise and learned commonly esteem the matter too inconsiderable to deserve their attention or regard. And when afterwards they would willingly detect the cheat, in order to undeceive the deluded multitude, the season is now past, and the records and witnesses, which might clear up the matter, have perished beyond recovery.

No means of detection remain, but those which must be drawn from the very testimony itself of the reporters: and these, though always sufficient with the judicious and knowing, are

 $^{^{101}}$ Titus Lucretius Carus (99/96–55/51 $_{\rm BCE})$ wrote a Latin didactic poem expounding Epicurean philosophy, $de\ Rerum\ Natura\ (On\ the\ Nature\ of\ Things).$ Book IV lines 593–94 read:

 $[\]dot{}$. . . ut omne humanum genus est avidum nimis auricularum (As all mankind is too eager for hearsay).

§X PT II OF MIRACLES 163

commonly too fine to fall under the comprehension of the vulgar.

Upon the whole, then, it appears, that no testimony for any kind of miracle has ever amounted to a probability, much less to a proof; and that, even supposing it amounted to a proof, it would be opposed by another proof; derived from the very nature of the fact, which it would endeavour to establish. It is experience only. which gives authority to human testimony; and it is the same experience, which assures us of the laws of nature. When, therefore, these two kinds of experience are contrary, we have nothing to do but substract the one from the other, and embrace an opinion, either on one side or the other, with that assurance which arises from the remainder. But according to the principle here explained, this substraction, with regard to all popular religions, amounts to an entire annihilation; and therefore we may establish it as a maxim, that no human testimony can have such force as to prove a miracle, and make it a just foundation for any such system of religion.

I beg the limitations here made may be remarked, when I say, that a miracle can never be proved, so as to be the foundation of a system of religion. For I own, that otherwise, there may possibly be miracles, or violations of the usual course of nature. of such a kind as to admit of proof from human testimony: though, perhaps, it will be impossible to find any such in all the records of history. Thus, suppose, all authors, in all languages. agree, that, from the first of January 1600, there was a total darkness over the whole earth for eight days: suppose that the tradition of this extraordinary event is still strong and lively among the people: that all travellers, who return from foreign countries, bring us accounts of the same tradition, without the least variation or contradiction; it is evident, that our present philosophers, instead of doubting the fact, ought to receive it as certain, and ought to search for the causes whence it might be derived. The decay, corruption, and dissolution of nature, is an event rendered probable by so many analogies, that any phenomenon, which seems to have a tendency towards that catastrophe, comes within the reach of human testimony, if that testimony be very extensive and uniform.

But suppose, that all the historians who treat of England, should agree, that, on the first of January 1600, Queen Elizabeth died; that both before and after her death she was seen by her physicians and the whole court, as is usual with persons of her rank; that her successor was acknowledged and proclaimed by the parliament; and that, after being interred a month, she

again appeared, resumed the throne, and governed England for three years: I must confess that I should be surprised at the concurrence of so many odd circumstances, but should not have the least inclination to believe so miraculous an event. I should not doubt of her pretended death, and of those other public circumstances that followed it: I should only assert it to have been pretended, and that it neither was, nor possibly could be real. You would in vain object to me the difficulty, and almost impossibility of deceiving the world in an affair of such consequence; the wisdom and solid judgement of that renowned queen; with the little or no advantage which she could reap from so poor an artifice: All this might astonish me: but I would still reply, that the knavery and folly of men are such common phenomena, that I should rather believe the most extraordinary events to arise from their concurrence, than admit of so signal a violation of the laws of nature.

But should this miracle be ascribed to any new system of religion; men, in all ages, have been so much imposed on by ridiculous stories of that kind, that this very circumstance would be a full proof of a cheat, and sufficient, with all men of sense, not only to make them reject the fact, but even reject it without farther examination. Though the Being to whom the miracle is ascribed, be, in this case, Almighty, it does not, upon that account, become a whit more probable; since it is impossible for us to know the attributes or actions of such a Being. otherwise than from the experience which we have of his productions, in the usual course of nature. This still reduces us to past observation, and obliges us to compare the instances of the violation of truth in the testimony of men, with those of the violation of the laws of nature by miracles, in order to judge which of them is most likely and probable. As the violations of truth are more common in the testimony concerning religious miracles, than in that concerning any other matter of fact; this must diminish very much the authority of the former testimony, and make us form a general resolution, never to lend any attention to it, with whatever specious pretence it may be covered.

Lord $Bacon^{102}$ seems to have embraced the same principles

¹⁰² Francis Bacon (1561–1626) is often rated the first in the long line of British empiricist philosophers. The passage quoted is Aphorism 29 from Book II of Bacon's *Novum Organum*, in which he tried to improve upon previous conceptions of scientific method.

§X PT II OF MIRACLES 165

of reasoning. 'We ought,' says he, 'to make a collection or particular history of all monsters and prodigious births or productions, and in a word of every thing new, rare, and extraordinary in nature. But this must be done with the most severe scrutiny, lest we depart from truth. Above all, every relation must be considered as suspicious, which depends in any degree upon religion, as the prodigies of Livy: ¹⁰³ And no less so, every thing that is to be found in the writers of natural magic or alchimy, or such authors, who seem, all of them, to have an unconquerable appetite for falsehood and fable' (*Novum Organum*, II, aph. 29).

I am the better pleased with the method of reasoning here delivered, as I think it may serve to confound those dangerous friends or disguised enemies to the Christian Religion, who have undertaken to defend it by the principles of human reason. Our most holy religion is founded on *Faith*, not on reason; and it is a sure method of exposing it to put it to such a trial as it is, by no means, fitted to endure. To make this more evident, let us examine those miracles, related in scripture; and not to lose ourselves in too wide a field, let us confine ourselves to such as we find in the *Pentateuch*, ¹⁰⁴ which we shall examine, according to the principles of these pretended Christians, 105 not as the word or testimony of God himself, but as the production of a mere human writer and historian. Here then we are first to consider a book, presented to us by a barbarous and ignorant people, written in an age when they were still more barbarous. and in all probability long after the facts which it relates. corroborated by no concurring testimony, and resembling those fabulous accounts, which every nation gives of its origin. Upon reading this book, we find it full of prodigies and miracles. It gives an account of a state of the world and of human nature entirely different from the present: Of our fall from that state: Of the age of man, extended to near a thousand years: Of the destruction of the world by a deluge: Of the arbitrary choice of

 $^{^{103}}$ The Roman historian Livy's Histories frequently record what Hume terms "marvellous events" or "prodigies" accompanying the growth of Roman power.

^{104 &#}x27;Pentateuch' is the collective name for the first five books of the Bible (Genesis, Exodus, Leviticus, Numbers, and Deuteronomy), also known as 'the five books of Moses', 'the Book of the Law', or 'Torah'.

¹⁰⁵ "Pretended Christians"—because Hume wants to suggest that such rationalizing forfeits their claim to be true adherents of the Christian Faith.

one people, as the favourites of heaven; and that people the countrymen of the author: Of their deliverance from bondage by prodigies the most astonishing imaginable: I desire any one to lay his hand upon his heart, and after a serious consideration declare, whether he thinks that the falsehood of such a book, supported by such a testimony, would be more extraordinary and miraculous than all the miracles it relates; which is, however, necessary to make it be received, according to the measures of probability above established.

What we have said of miracles may be applied, without any variation, to prophecies; and indeed, all prophecies are real miracles, and as such only, can be admitted as proofs of any revelation. If it did not exceed the capacity of human nature to foretell future events, it would be absurd to employ any prophecy as an argument for a divine mission or authority from heaven. So that, upon the whole, we may conclude, that the *Christian Religion* not only was at first attended with miracles, but even at this day cannot be believed by any reasonable person without one. Mere reason is insufficient to convince us of its veracity: And whoever is moved by *Faith* to assent to it, is conscious of a continued miracle in his own person, which subverts all the principles of his understanding, and gives him a determination to believe what is most contrary to custom and experience.

Of a particular Providence and of a future State

I was lately engaged in conversation with a friend who loves sceptical paradoxes; where, though he advanced many principles, of which I can by no means approve, yet as they seem to be curious, and to bear some relation to the chain of reasoning carried on throughout this enquiry, I shall here copy them from my memory as accurately as I can, in order to submit them to the judgement of the reader.

Our conversation began with my admiring the singular good fortune of philosophy, which, as it requires entire liberty above all other privileges, and chiefly flourishes from the free opposition of sentiments and argumentation, received its first birth in an age and country of freedom and toleration, and was never cramped, even in its most extravagant principles, by any creeds, confessions, or penal statutes. For, except the banishment of Protagoras. 106 and the death of Socrates, which last event proceeded partly from other motives, there are scarcely any instances to be met with, in ancient history, of this bigotted jealousy, with which the present age is so much infested. Epicurus¹⁰⁷ lived at Athens to an advanced age, in peace and tranquillity: Epicureans¹⁰⁸ were even admitted to receive the sacerdotal character, and to officiate at the altar, in the most sacred rites of the established religion: And the public encouragement¹⁰⁹ of pensions and salaries was afforded equally, by the

¹⁰⁶ Protagoras (fifth century BCE) was one of the earliest and most successfully influential of the set of Greek educationist-philosophers known as the Sophists. His relativism—"man is the measure of all things"—is discussed in Plato's *Theaetetus*.

 $^{^{107}}$ Epicurus (341–270 $_{\rm BCE}$) founded his school in 307 $_{\rm BCE}$. His main debt was to the atomism of Democritus of Abdera (c. 460–c. 370 $_{\rm BCE}$), the subject of the thesis for which in April 1841 the then newly-founded University of Jena awarded Karl Marx what amounted to a Ph.D. by post. By far the most agreeable sourcebook for the ideas of Epicurus is the $de\ Rerum\ Natura$ by his Roman convert Lucretius.

 $^{^{108}}$ Hume here refers, by its Greek title, in a footnote, to Lucian's $\it The Carousal, or the Lapiths$.

¹⁰⁹ Hume here refers, by its Greek title, in a footnote, to Lucian's Eunuch.

wisest of all the Roman emperors¹¹⁰ to the professors of every sect of philosophy. How requisite such kind of treatment was to philosophy, in her early youth, will easily be conceived, if we reflect, that, even at present, when she may be supposed more hardy and robust, she bears with much difficulty the inclemency of the seasons, and those harsh winds of calumny and persecution, which blow upon her.

You admire, says my friend, as the singular good fortune of philosophy, what seems to result from the natural course of things, and to be unavoidable in every age and nation. This pertinacious bigotry, of which you complain, as so fatal to philosophy, is really her offspring, who, after allying with superstition, separates himself entirely from the interest of his parent, and becomes her most inveterate enemy and persecutor. Speculative dogmas of religion, the present occasions of such furious dispute, could not possibly be conceived or admitted in the early ages of the world; when mankind, being wholly illiterate, formed an idea of religion more suitable to their weak apprehension, and composed their sacred tenets of such tales chiefly as were the objects of traditional belief, more than of argument or disputation. After the first alarm, therefore, was over, which arose from the new paradoxes and principles of the philosophers: these teachers seem ever after, during the ages of antiquity, to have lived in great harmony with the established superstition, and to have made a fair partition of mankind between them; the former claiming all the learned and wise, the latter possessing all the vulgar and illiterate.

It seems then, say I, that you leave politics entirely out of the question, and never suppose, that a wise magistrate can justly be jealous of certain tenets of philosophy, such as those of Epicurus, which, denying a divine existence, and consequently a providence and a future state, seem to loosen, in a great measure, the ties of morality, and may be supposed, for that reason, pernicious to the peace of civil society.

I know, replied he, that in fact these persecutions never, in any age, proceeded from calm reason, or from experience of the pernicious consequences of philosophy; but arose entirely from passion and prejudice. But what if I should advance farther, and

 $^{^{110}}$ The allusion is to Marcus Aurelius. Hume in a footnote mentions as his authorities Lucian and Dio Cassius, but without providing any more precise reference.

assert, that if Epicurus had been accused before the people, by any of the *sycophants* or informers of those days, he could easily have defended his cause, and proved his principles of philosophy to be as salutary as those of his adversaries, who endeavoured, with such zeal, to expose him to the public hatred and jealousy?

I wish, said I, you would try your eloquence upon so extraordinary a topic, and make a speech for Epicurus, which might satisfy, not the mob of Athens, if you will allow that ancient and polite city to have contained any mob, but the more philosophical part of his audience, such as might be supposed capable of comprehending his arguments.

The matter would not be difficult, upon such conditions, replied he: And if you please, I shall suppose myself Epicurus for a moment, and make you stand for the Athenian people, and shall deliver you such an harangue as will fill all the urn with white beans, and leave not a black one to gratify the malice of my adversaries.¹¹¹

Very well: Pray proceed upon these suppositions.

I come hither, O ye Athenians, to justify in your assembly what I maintained in my school, and I find myself impeached by furious antagonists, instead of reasoning with calm and dispassionate enquirers. Your deliberations, which of right should be directed to questions of public good, and the interest of the commonwealth, are diverted to the disquisitions of speculative philosophy; and these magnificent, but perhaps fruitless enquiries, take place of your more familiar but more useful occupations. But so far as in me lies, I will prevent this abuse. We shall not here dispute concerning the origin and government of worlds. We shall only enquire how far such questions concern the public interest. And if I can persuade you, that they are entirely indifferent to the peace of society and security of government, I hope that you will presently send us back to our schools, there to examine, at leisure, the question the most sublime, but at the same time, the most speculative of all philosophy.

The religious philosophers, not satisfied with the tradition of your forefathers, and doctrine of your priests (in which I willingly acquiesce), indulge a rash curiosity, in trying how far they can establish religion upon the principles of reason; and

 $^{^{111}}$ Voting in Athenian trials was conducted by each juror placing a bean in a jar: white for innocent, black for guilty.

they thereby excite, instead of satisfying, the doubts, which naturally arise from a diligent and scrutinous enquiry. They paint, in the most magnificent colours, the order, beauty, and wise arrangement of the universe; and then ask, if such a glorious display of intelligence could proceed from the fortuitous concourse of atoms, or if chance could produce what the greatest genius can never sufficiently admire. I shall not examine the justness of this argument. Is shall allow it to be as solid as my antagonists and accusers can desire. It is sufficient, if I can prove, from this very reasoning, that the question is entirely speculative, and that, when, in my philosophical disquisitions, I deny a providence and a future state, I undermine not the foundations of society, but advance principles, which they themselves, upon their own topics, if they argue consistently, must allow to be solid and satisfactory.

You then, who are my accusers, have acknowledged, that the chief or sole argument for a divine existence (which I never questioned) is derived from the order of nature; where there appear such marks of intelligence and design that you think it extravagant to assign for its cause, either chance, or the blind and unguided force of matter. You allow, that this is an argument drawn from effects to causes. From the order of the work, you infer, that there must have been project and forethought in the workman. If you cannot make out this point, you allow, that your conclusion fails; and you pretend not to establish the conclusion in a greater latitude than the phenomena of nature will justify. These are your concessions. I desire you to mark the consequences.

When we infer any particular cause from an effect, we must proportion the one to the other, and can never be allowed to ascribe to the cause any qualities, but what are exactly sufficient to produce the effect. A body of ten ounces raised in any scale may serve as a proof, that the counterbalancing weight exceeds ten ounces; but can never afford a reason that it exceeds a hundred. If the cause, assigned for any effect, be not sufficient to produce it, we must either reject that cause, or add to it such qualities as will give it a just proportion to the effect. But if we ascribe to it farther qualities, or affirm it capable of producing other effects, we can only indulge the licence of conjecture, and

¹¹² Hume did so in his *Dialogues concerning Natural Religion*.

arbitrarily suppose the existence of qualities and energies, without reason or authority.

The same rule holds, whether the cause assigned be brute unconscious matter, or a rational intelligent being. If the cause be known only by the effect, we never ought to ascribe to it any qualities, beyond what are precisely requisite to produce the effect: Nor can we, by any rules of just reasoning, return back from the cause, and infer other effects from it, beyond those by which alone it is known to us. No one, merely from the sight of one of Zeuxis's pictures113 could know, that he was also a statuary or architect, and was an artist no less skilful in stone and marble than in colours. The talents and taste, displayed in the particular work before us; these we may safely conclude the workman to be possessed of. The cause must be proportioned to the effect; and if we exactly and precisely proportion it, we shall never find in it any qualities, that point farther, or afford an inference concerning any other design or performance. Such qualities must be somewhat beyond what is merely requisite for producing the effect, which we examine.

Allowing, therefore, the gods to be the authors of the existence or order of the universe; it follows, that they possess that precise degree of power, intelligence, and benevolence, which appears in their workmanship; but nothing farther can ever be proved, except we call in the assistance of exaggeration and flattery to supply the defects of argument and reasoning. So far as the traces of any attributes, at present, appear, so far may we conclude these attributes to exist. The supposition of farther attributes is mere hypothesis; much more the supposition, that, in distant regions of space or periods of time, there has been, or will be, a more magnificent display of these attributes, and a scheme of administration more suitable to such imaginary virtues. We can never be allowed to mount up from the universe, the effect, to Jupiter, the cause; 114 and then descend downwards. to infer any new effect from that cause; as if the present effects alone were not entirely worthy of the glorious attributes, which we ascribe to that deity. The knowledge of the cause being derived solely from the effect, they must be exactly adjusted to

 $^{^{113}\,}Zeuxis$ (fifth century $_{\rm BCE})$ was a Greek painter, born in Heraclea in Southern Italy.

¹¹⁴ Jupiter, identified with the Greek Zeus, was the chief Roman god.

each other; and the one can never refer to anything farther, or be the foundation of any new inference and conclusion.

You find certain phenomena in nature. You seek a cause or author. You imagine that you have found him. You afterwards become so enamoured of this offspring of your brain, that you imagine it impossible, but he must produce something greater and more perfect than the present scene of things, which is so full of ill and disorder. You forget, that this superlative intelligence and benevolence are entirely imaginary, or, at least, without any foundation in reason; and that you have no ground to ascribe to him any qualities, but what you see he has actually exerted and displayed in his productions. Let your gods, therefore, O philosophers, be suited to the present appearances of nature: and presume not to alter these appearances by arbitrary suppositions, in order to suit them to the attributes, which you so fondly ascribe to your deities.

When priests and poets, supported by your authority, O Athenians, talk of a golden or silver age, which preceded the present state of vice and misery. I hear them with attention and with reverence. But when philosophers, who pretend to neglect authority, and to cultivate reason, hold the same discourse, I pay them not, I own, the same obsequious submission and pious deference. I ask; who carried them into the celestial regions. who admitted them into the councils of the gods, who opened to them the book of fate, that they thus rashly affirm, that their deities have executed, or will execute, any purpose beyond what has actually appeared? If they tell me, that they have mounted on the steps or by the gradual ascent of reason, and by drawing inferences from effects to causes. I still insist, that they have aided the ascent of reason by the wings of imagination; otherwise they could not thus change their manner of inference, and argue from causes to effects; presuming, that a more perfect production than the present world would be more suitable to such perfect beings as the gods, and forgetting that they have no reason to ascribe to these celestial beings any perfection or any attribute, but what can be found in the present world.

Hence all the fruitless industry to account for the ill appearances of nature, and save the honour of the gods; while we must acknowledge the reality of that evil and disorder, with which the world so much abounds. The obstinate and intractable qualities of matter, we are told, or the observance of general laws, or some such reason, is the sole cause, which controlled the

power and benevolence of Jupiter, and obliged him to create mankind and every sensible creature so imperfect and so unhappy. These attributes then, are, it seems, beforehand, taken for granted, in their greatest latitude. And upon that supposition, I own that such conjectures may, perhaps, be admitted as plausible solutions of the ill phenomena. But still I ask; Why take these attributes for granted, or why ascribe to the cause any qualities but what actually appear in the effect? Why torture your brain to justify the course of nature upon suppositions, which, for aught you know, may be entirely imaginary, and of which there are to be found no traces in the course of nature?

The religious hypothesis, therefore, must be considered only as a particular method of accounting for the visible phenomena of the universe: but no just reasoner will ever presume to infer from it any single fact, and alter or add to the phenomena, in any single particular. If you think, that the appearances of things prove such causes, it is allowable for you to draw an inference concerning the existence of these causes. In such complicated and sublime subjects, every one should be indulged in the liberty of conjecture and argument. But here you ought to rest. If you come backward, and arguing from your inferred causes, conclude, that any other fact has existed, or will exist, in the course of nature, which may serve as a fuller display of particular attributes: I must admonish you, that you have departed from the method of reasoning, attached to the present subject, and have certainly added something to the attributes of the cause. beyond what appears in the effect; otherwise you could never, with tolerable sense or propriety, add anything to the effect, in order to render it more worthy of the cause.

Where, then, is the odiousness of that doctrine, which I teach in my school, or rather, which I examine in my gardens? Or what do you find in this whole question, wherein the security of good morals, or the peace and order of society, is in the least concerned?

I deny a providence, you say, and supreme governor of the world, who guides the course of events, and punishes the vicious with infamy and disappointment, and rewards the virtuous with honour and success, in all their undertakings. But surely, I deny not the course itself of events, which lies open to every one's inquiry and examination. I acknowledge, that, in the present order of things, virtue is attended with more peace of mind than vice, and meets with a more favourable reception from the

world. I am sensible, that, according to the past experience of mankind, friendship is the chief joy of human life, and moderation the only source of tranquillity and happiness. I never balance between the virtuous and the vicious course of life; but am sensible, that, to a well-disposed mind, every advantage is on the side of the former. And what can you say more, allowing all your suppositions and reasonings? You tell me, indeed, that this disposition of things proceeds from intelligence and design. But whatever it proceeds from, the disposition itself, on which depends our happiness or misery, and consequently our conduct and deportment in life is still the same. It is still open for me, as well as you, to regulate my behaviour, by my experience of past events. And if you affirm, that, while a divine providence is allowed, and a supreme distributive justice in the universe, I ought to expect some more particular reward of the good, and punishment of the bad, beyond the ordinary course of events; I here find the same fallacy, which I have before endeavoured to detect. You persist in imagining, that, if we grant that divine existence, for which you so earnestly contend, you may safely infer consequences from it, and add something to the experienced order of nature, by arguing from the attributes which you ascribe to your gods. You seem not to remember, that all your reasonings on this subject can only be drawn from effects to causes; and that every argument, deduced from causes to effects, must of necessity be a gross sophism; since it is impossible for you to know anything of the cause, but what you have antecedently, not inferred, but discovered to the full, in the effect.

But what must a philosopher think of those vain reasoners, who, instead of regarding the present scene of things as the sole object of their contemplation, so far reverse the whole course of nature, as to render this life merely a passage to something farther; a porch, which leads to a greater, and vastly different building; a prologue, which serves only to introduce the piece, and give it more grace and propriety? Whence, do you think, can such philosophers derive their idea of the gods? From their own conceit and imagination surely. For if they derived it from the present phenomena, it would never point to anything farther, but must be exactly adjusted to them. That the divinity may possibly be endowed with attributes, which we have never seen exerted; may be governed by principles of action, which we cannot discover to be satisfied: all this will freely be allowed. But still this is mere possibility and hypothesis. We never can have

reason to *infer* any attributes, or any principles of action in him, but so far as we know them to have been exerted and satisfied.

Are there any marks of a distributive justice in the world? If you answer in the affirmative, I conclude, that, since justice here exerts itself, it is satisfied. If you reply in the negative, I conclude, that you have then no reason to ascribe justice, in our sense of it, to the gods. If you hold a medium between affirmation and negation, by saying, that the justice of the gods, at present, exerts itself in part, but not in its full extent; I answer, that you have no reason to give it any particular extent, but only so far as you see it, at present, exert itself.

Thus I bring the dispute, O Athenians, to a short issue with my antagonists. The course of nature lies open to my contemplation as well as to theirs. The experienced train of events is the great standard, by which we all regulate our conduct. Nothing else can be appealed to in the field, or in the senate. Nothing else ought ever to be heard of in the school, or in the closet. 115 In vain would our limited understanding break through those boundaries, which are too narrow for our fond imagination. While we argue from the course of nature, and infer a particular intelligent cause, which first bestowed, and still preserves order in the universe, we embrace a principle, which is both uncertain and useless. It is uncertain; because the subject lies entirely beyond the reach of human experience. It is useless; because our knowledge of this cause being derived entirely from the course of nature, we can never, according to the rules of just reasoning. return back from the cause with any new inference, or making additions to the common and experienced course of nature. establish any new principles of conduct and behaviour.

I observe (said I, finding he had finished his harangue) that you neglect not the artifice of the demagogues of old; and as you were pleased to make me stand for the people, you insinuate yourself into my favour by embracing those principles, to which, you know, I have always expressed particular attachment. But allowing you to make experience (as indeed I think you ought) the only standard of our judgement concerning this, and all other questions of fact; I doubt not but, from the very same experience, to which you appeal, it may be possible to refute this reasoning, which you have put into the mouth of Epicurus. If you

^{115 &}quot;Closet" = 'private quarters' in present-day usage.

saw, for instance, a half-finished building, surrounded with heaps of brick and stone and mortar, and all the instruments of masonry; could you not infer from the effect, that it was a work of design and contrivance? And could you not return again, from this inferred cause, to infer new additions to the effect, and conclude, that the building would soon be finished, and receive all the further improvements, which art could bestow upon it? If you saw upon the sea-shore the print of one human foot, you would conclude, that a man had passed that way, and that he had also left the traces of the other foot, though effaced by the rolling of the sands or inundation of the waters. Why then do you refuse to admit the same method of reasoning with regard to the order of nature? Consider the world and the present life only as an imperfect building, from which you can infer a superior intelligence; and arguing from that superior intelligence, which can leave nothing imperfect: why may you not infer a more finished scheme or plan, which will receive its completion in some distant point of space or time? Are not these methods of reasoning exactly similar? And under what pretence can you embrace the one, while you reject the other?

The infinite difference of the subjects, replied he, is a sufficient foundation for this difference in my conclusions. In works of human art and contrivance, it is allowable to advance from the effect to the cause, and returning back from the cause. to form new inferences concerning the effect, and examine the alterations, which it has probably undergone, or may still undergo. But what is the foundation of this method of reasoning? Plainly this; that man is a being, whom we know by experience, whose motives and designs we are acquainted with, and whose projects and inclinations have a certain connexion and coherence, according to the laws which nature has established for the government of such a creature. When, therefore, we find, that any work has proceeded from the skill and industry of man; as we are otherwise acquainted with the nature of the animal, we can draw a hundred inferences concerning what may be expected from him; and these inferences will all be founded in experience and observation. But did we know man only from the single work or production which we examine, it were impossible for us to argue in this manner; because our knowledge of all the qualities, which we ascribe to him, being in that case derived from the production, it is impossible they could point to anything farther, or be the foundation of any new inference. The

print of a foot in the sand can only prove, when considered alone, that there was some figure adapted to it, by which it was produced: but the print of a human foot proves likewise, from our other experience, that there was probably another foot, which also left its impression, though effaced by time or other accidents. Here we mount from the effect to the cause; and descending again from the cause, infer alterations in the effect; but this is not a continuation of the same simple chain of reasoning. We comprehend in this case a hundred other experiences and observations, concerning the *usual* figure and members of that species of animal, without which this method of argument must be considered as fallacious and sophistical.

The case is not the same with our reasonings from the works of nature. The Deity is known to us only by his productions, and is a single being in the universe, not comprehended under any species or genus, from whose experienced attributes or qualities, we can, by analogy, infer any attribute or quality in him. As the universe shews wisdom and goodness, we infer wisdom and goodness. As it shews a particular degree of these perfections. we infer a particular degree of them, precisely adapted to the effect which we examine. But farther attributes or farther degrees of the same attributes, we can never be authorised to infer or suppose, by any rules of just reasoning. Now, without some such licence of supposition, it is impossible for us to argue from the cause, or infer any alteration in the effect, beyond what has immediately fallen under our observation. Greater good produced by this Being must still prove a greater degree of goodness: a more impartial distribution of rewards and punishments must proceed from a greater regard to justice and equity. Every supposed addition to the works of nature makes an addition to the attributes of the Author of nature; and consequently, being entirely unsupported by any reason or argument, can never be admitted but as mere conjecture and hypothesis. 116

In general, it may, I think, be established as a maxim, that where any cause is known only by its particular effects, it must be impossible to infer any new effects from that cause; since the qualities, which are requisite to produce these new effects along with the former, must either be different, or superior, or of more extensive operation, than those which simply produced the

¹¹⁶ The following paragraph is a promoted footnote.

effect, whence alone the cause is supposed to be known to us. We can never, therefore, have any reason to suppose the existence of these qualities. To say, that the new effects proceed only from a continuation of the same energy, which is already known from the first effects, will not remove the difficulty. For even granting this to be the case (which can seldom be supposed), the very continuation and exertion of a like energy (for it is impossible it can be absolutely the same), I say, this exertion of a like energy, in a different period of space and time, is a very arbitrary supposition, and what there cannot possibly be any traces of in the effects, from which all our knowledge of the cause is originally derived. Let the *inferred* cause be exactly proportioned (as it should be) to the known effect; and it is impossible that it can possess any qualities, from which new or different effects can be *inferred*.

The great source of our mistake in this subject, and of the unbounded licence of conjecture, which we indulge, is, that we tacitly consider ourselves, as in the place of the Supreme Being, and conclude, that he will, on every occasion, observe the same conduct, which we ourselves, in his situation, would have embraced as reasonable and eligible. But, besides that the ordinary course of nature may convince us, that almost everything is regulated by principles and maxims very different from ours; besides this, I say, it must evidently appear contrary to all rules of analogy to reason, from the intentions and projects of men, to those of a Being so different, and so much superior. In human nature, there is a certain experienced coherence of designs and inclinations; so that when, from any fact, we have discovered one intention of any man, it may often be reasonable, from experience, to infer another, and draw a long chain of conclusions concerning his past or future conduct. But this method of reasoning can never have place with regard to a Being. so remote and incomprehensible, who bears much less analogy to any other being in the universe than the sun to a waxen taper, and who discovers himself¹¹⁷ only by some faint traces or outlines, beyond which we have no authority to ascribe to him any attribute or perfection. What we imagine to be a superior perfection, may really be a defect. Or were it ever so much a perfection, the ascribing of it to the Supreme Being, where it

¹¹⁷ The old sense of 'discover' was 'uncover', as in the chess term 'discovered check'. Hence "discovers himself" here means 'reveal himself' or 'makes himself evident'.

appears not to have been really exerted, to the full, in his works, savours more of flattery and panegyric, than of just reasoning and sound philosophy. All the philosophy, therefore, in the world, and all the religion, which is nothing but a species of philosophy, will never be able to carry us beyond the usual course of experience, or give us measures of conduct and behaviour different from those which are furnished by reflections on common life. No new fact can ever be inferred from the religious hypothesis; no event foreseen or foretold; no reward or punishment expected or dreaded, beyond what is already known by practice and observation. So that my apology for Epicurus will still appear solid and satisfactory; nor have the political interests of society any connexion with the philosophical disputes concerning metaphysics and religion.

There is still one circumstance, replied I, which you seem to have overlooked. Though I should allow your premises, I must deny your conclusion. You conclude, that religious doctrines and reasonings can have no influence on life, because they ought to have no influence; never considering, that men reason not in the same manner you do, but draw many consequences from the belief of a divine Existence, and suppose that the Deity will inflict punishments on vice, and bestow rewards on virtue. beyond what appear in the ordinary course of nature. Whether this reasoning of theirs be just or not, is no matter. Its influence on their life and conduct must still be the same. And, those, who attempt to disabuse them of such prejudices, may, for aught I know, be good reasoners, but I cannot allow them to be good citizens and politicians; since they free men from one restraint upon their passions, and make the infringement of the laws of society, in one respect, more easy and secure.

After all, I may, perhaps, agree to your general conclusion in favour of liberty, though upon different premises from those, on which you endeavour to found it. I think, that the state ought to tolerate every principle of philosophy; nor is there an instance, that any government has suffered in its political interests by such indulgence. There is no enthusiasm among philosophers; their doctrines are not very alluring to the people; and no restraint can be put upon their reasonings, but what must be of dangerous consequence to the sciences, and even to the state, by paving the way for persecution and oppression in points, where the generality of mankind are more deeply interested and concerned.

But there occurs to me (continued \boldsymbol{I}) with regard to your

main topic, a difficulty, which I shall just propose to you without insisting on it; lest it lead into reasonings of too nice and delicate a nature. In a word, I much doubt whether it be possible for a cause to be known only by its effect (as you have all along supposed) or to be of so singular and particular a nature as to have no parallel and no similarity with any other cause or object, that has ever fallen under our observation. It is only when two species of objects are found to be constantly conjoined, that we can infer the one from the other; and were an effect presented. which was entirely singular, and could not be comprehended under any known species. I do not see, that we could form any conjecture or inference at all concerning its cause. If experience and observation and analogy be, indeed, the only guides which we can reasonably follow in inferences of this nature; both the effect and cause must bear a similarity and resemblance to other effects and causes, which we know, and which we have found, in many instances, to be conjoined with each other. I leave it to your own reflection to pursue the consequences of this principle. 118 I shall just observe, that, as the antagonists of Epicurus always suppose the universe, an effect quite singular and unparalleled. to be the proof of a Deity, a cause no less singular and unparalleled; your reasonings, upon that supposition, seem, at least, to merit our attention. There is, I own, some difficulty, how we can ever return from the cause to the effect, and, reasoning from our ideas of the former, infer any alteration on the latter, or any addition to it.

¹¹⁸ Hume is here questioning whether experience allows the inference to any deity at all, even one with no greater attributes than whatever is required to produce the existing world. He is thus hinting at what—after Strato of Lampsacus, second in succession after Aristotle as Head of the Lyceum—had come to be called Stratonician atheism. This maintains that, since every system of explanation has to end in some fundamentals which are not and cannot be themselves explained, all our explanations should end with the existence of the Universe and the subsistence of whatever science discovers to be its most fundamental laws.

Of the academical or sceptical Philosophy

PARTI

There is not a greater number of philosophical reasonings, displayed upon any subject, than those, which prove the existence of a Deity, and refute the fallacies of *Atheists*; and yet the most religious philosophers still dispute whether any man can be so blinded as to be a speculative atheist. How shall we reconcile these contradictions? The knights-errant, who wandered about to clear the world of dragons and giants, never entertained the least doubt with regard to the existence of these monsters.

The *Sceptic* is another enemy of religion, who naturally provokes the indignation of all divines and graver philosophers; though it is certain, that no man ever met with any such absurd creature, or conversed with a man, who had no opinion or principle concerning any subject, either of action or speculation. This begets a very natural question; What is meant by a sceptic? And how far it is possible to push these philosophical principles of doubt and uncertainty?

There is a species of scepticism, antecedent to all study and philosophy, which is much inculcated by Des Cartes and others. as a sovereign preservative against error and precipitate judgement. It recommends an universal doubt, not only of all our former opinions and principles, but also of our very faculties; of whose veracity, say they, we must assure ourselves, by a chain of reasoning, deduced from some original principle, which cannot possibly be fallacious or deceitful. But neither is there any such original principle, which has a prerogative above others, that are self-evident and convincing: or if there were, could we advance a step beyond it, but by the use of those very faculties, of which we are supposed to be already diffident. The Cartesian doubt, therefore, were it ever possible to be attained by any human creature (as it plainly is not) would be entirely incurable; and no reasoning could ever bring us to a state of assurance and conviction upon any subject.

It must, however, be confessed, that this species of scepticism, when more moderate, may be understood in a very reasonable sense, and is a necessary preparative to the study of philosophy, by preserving a proper impartiality in our judgements, and weaning our mind from all those prejudices, which we may have imbibed from education or rash opinion. To begin with clear and self-evident principles, to advance by timorous and sure steps, to review frequently our conclusions, and examine accurately all their consequences; though by these means we shall make both a slow and a short progress in our systems; are the only methods, by which we can ever hope to reach truth, and attain a proper stability and certainty in our determinations.

There is another species of scepticism, consequent to science and enquiry, when men are supposed to have discovered, either the absolute fallaciousness of their mental faculties, or their unfitness to reach any fixed determination in all those curious subjects of speculation, about which they are commonly employed. Even our very senses are brought into dispute, by a certain species of philosophers; and the maxims of common life are subjected to the same doubt as the most profound principles or conclusions of metaphysics and theology. As these paradoxical tenets (if they may be called tenets) are to be met with in some philosophers, and the refutation of them in several, they naturally excite our curiosity, and make us enquire into the arguments, on which they may be founded.

I need not insist upon the more trite topics, employed by the sceptics in all ages, against the evidence of <code>sense</code>; such as those which are derived from the imperfection and fallaciousness of our organs, on numberless occasions; the crooked appearance of an oar in water; the various aspects of objects, according to their different distances; the double images which arise from the pressing one eye; with many other appearances of a like nature. These sceptical topics, indeed, are only sufficient to prove, that the senses alone are not implicitly to be depended on; but that we must correct their evidence by reason, and by considerations, derived from the nature of the medium, the distance of the object, and the disposition of the organ, in order to render them, within their sphere, the proper <code>criteria</code> of truth and falsehood. There are other more profound arguments against the senses, which admit not of so easy a solution.

It seems evident, that men are carried, by a natural instinct

or prepossession, to repose faith in their senses; and that, without any reasoning, or even almost before the use of reason, we always suppose an external universe, which depends not on our perception, but would exist, though we and every sensible creature were absent or annihilated. Even the animal creation are governed by a like opinion, and preserve this belief of external objects, in all their thoughts, designs, and actions.

It seems also evident, that, when men follow this blind and powerful instinct of nature, they always suppose the very images, presented by the senses, to be the external objects, and never entertain any suspicion, that the one are nothing but representations of the other. This very table, which we see white, and which we feel hard, is believed to exist, independent of our perception, and to be something external to our mind, which perceives it. Our presence bestows not being on it: our absence does not annihilate it. It preserves it existence uniform and entire, independent of the situation of intelligent beings, who perceive or contemplate it.

But this universal and primary opinion of all men is soon destroyed by the slightest philosophy, which teaches us, that nothing can ever be present to the mind but an image or perception, and that the senses are only the inlets, through which these images are conveyed, without being able to produce any immediate intercourse between the mind and the object. The table, which we see, seems to diminish, as we remove farther from it: but the real table, which exists independent of us, suffers no alteration: it was, therefore, nothing but its image, which was present to the mind. These are the obvious dictates of reason; and no man, who reflects, ever doubted, that the existences, which we consider, when we say, this house and that tree, are nothing but perceptions in the mind, and fleeting copies or representations of other existences, which remain uniform and independent.

So far, then, are we necessitated by reasoning to contradict or depart from the primary instincts of nature, and to embrace a new system with regard to the evidence of our senses. But here philosophy finds herself extremely embarrassed, when she should justify this new system, and obviate the cavils and objections of the sceptics. She can no longer plead the infallible and irresistible instinct of nature: for that led us to a quite different system, which is acknowledged fallible and even erroneous. And to justify this pretended philosophical system,

by a chain of clear and convincing argument, or even any appearance of argument, exceeds the power of all human capacity.

By what argument can it be proved, that the perceptions of the mind must be caused by external objects, entirely different from them, though resembling them (if that be possible) and could not arise either from the energy of the mind itself, or from the suggestion of some invisible and unknown spirit, or from some other cause still more unknown to us? It is acknowledged, that, in fact, many of these perceptions arise not from anything external, as in dreams, madness, and other diseases. And nothing can be more inexplicable than the manner, in which body should so operate upon mind as ever to convey an image of itself to a substance, supposed of so different, and even contrary a nature.

It is a question of fact, whether the perceptions of the senses be produced by external objects, resembling them: how shall this question be determined? By experience surely; as all other questions of a like nature. But here experience is, and must be entirely silent. The mind has never anything present to it but the perceptions, and cannot possibly reach any experience of their connexion with objects. The supposition of such a connexion is, therefore, without any foundation in reasoning.

To have recourse to the veracity of the supreme Being,¹¹⁹ in order to prove the veracity of our senses, is surely making a very unexpected circuit. If his veracity were at all concerned in this matter, our senses would be entirely infallible; because it is not possible that he can ever deceive. Not to mention, that, if the external world be once called in question, we shall be at a loss to find arguments, by which we may prove the existence of that Being or any of his attributes.

This is a topic, therefore, in which the profounder and more philosophical sceptics will always triumph, when they endeavour to introduce an universal doubt into all subjects of human knowledge and enquiry. Do you follow the instincts and propensities of nature, may they say, in assenting to the veracity of sense? But these lead you to believe that the very perception or sensible image is the external object. Do you disclaim this principle, in order to embrace a more rational opinion, that the

 $^{^{119}\,\}mathrm{Hume}$ here challenges an argument for the existence of the external world used by Descartes.

perceptions are only representations of something external? You here depart from your natural propensities and more obvious sentiments; and yet are not able to satisfy your reason, which can never find any convincing argument from experience to prove, that the perceptions are connected with any external objects.

There is another sceptical topic of a like nature, derived from the most profound philosophy; which might merit our attention, were it requisite to dive so deep, in order to discover arguments and reasonings, which can so little serve to any serious purpose. 120 It is universally allowed by modern enquirers, that all the sensible qualities of objects, such as hard, soft, hot, cold, white, black, &c. are merely secondary, and exist not in the objects themselves, but are perceptions of the mind, without any external archetype or model, which they represent. If this be allowed, with regard to secondary qualities, it must also follow, with regard to the supposed primary qualities of extension and solidity; nor can the latter be any more entitled to that denomination than the former. The idea of extension is entirely acquired from the senses of sight and feeling; and if all the qualities, perceived by the senses, be in the mind, not in the object, the same conclusion must reach the idea of extension. which is wholly dependent on the sensible ideas or the ideas of secondary qualities. Nothing can save us from this conclusion, but the asserting, that the ideas of those primary qualities are attained by Abstraction, an opinion, which, if we examine it accurately, we shall find to be unintelligible, and even absurd. An extension, that is neither tangible nor visible, cannot

secondary qualities'. According to those who uphold this distinction, some of the perceived qualities of an object (such as its colour or smell) are not really aspects of the object; they are effects produced by the object in the body or mind of the observer. Other perceived qualities—the primary qualities, like size, shape, or motion—really do characterize the object, independently of the observer. Locke advocated the distinction in his *Essay concerning Human Understanding* (1690), Book II, Chapter 8. Berkeley attacked it very persuasively in his *Principles of Human Knowledge* (1710), Sections 9–20. The distinction was first made explicitly by Robert Boyle in his *Origin of Forms and Qualities* (1666), though it is implicit in the writings of Galileo (1564–1642) and Descartes, and has even been traced back to Democritus, who held that taste, temperature, and colour exist by "convention"—in reality there are only "atoms and the void". It is prominent in Newton's *Opticks*. There is still no agreement on this issue among philosophers.

possibly be conceived: and a tangible or visible extension, which is neither hard nor soft, black nor white, is equally beyond the reach of human conception. Let any man try to conceive a triangle in general, which is neither *Isosceles* nor *Scalenum*, nor has any particular length or proportion of sides; and he will soon perceive the absurdity of all the scholastic notions with regard to abstraction and general ideas. 121

This argument is drawn from Dr. Berkeley; and indeed most of the writings of that very ingenious author form the best lessons of scepticism, which are to be found either among the ancient or modern philosophers, Bayle not excepted. He professes, however, in his title-page (and undoubtedly with great truth) to have composed his book against the sceptics as well as against the atheists and free-thinkers. But that all his arguments, though otherwise intended, are, in reality, merely sceptical, appears from this, that they admit of no answer and produce no conviction. Their only effect is to cause that momentary amazement and irresolution and confusion, which is the result of scepticism.

Thus the first philosophical objection to the evidence of sense or to the opinion of external existence consists in this, that such an opinion, if rested on natural instinct, is contrary to reason, and if referred to reason, is contrary to natural instinct, and at the same time carries no rational evidence with it, to convince an impartial enquirer. The second objection goes farther, and represents this opinion as contrary to reason: at least, if it be a principle of reason, that all sensible qualities are in the mind, not in the object. Bereave matter of all its intelligible qualities, both primary and secondary, you in a manner annihilate it, and leave only a certain unknown, inexplicable *something*, as the cause of our perceptions; a notion so imperfect, that no sceptic will think it worth while to contend against it.

¹²¹ The next paragraph, gently and characteristically mischievous, is another promoted footnote. George Berkeley (1685–1753), philosopher and divine, is best known for his idealist doctrine that the existence of sensible objects just is to be perceived. Berkeley argued against 'abstract ideas' in his *Principles of Human Knowledge* and elsewhere. Pierre Bayle (1647–1706) came from a French Protestant family, and so had to spend most of his working life in Dutch exile. His *Dictionnaire historique et critique*, in some version, was in every gentleman's library throughout the eighteenth century. It is often credited with constituting the arsenal of the Enlightenment.

PART II

It may seem a very extravagant attempt of the sceptics to destroy *reason* by argument and ratiocination; yet is this the grand scope of all their enquiries and disputes. They endeavour to find objections, both to our abstract reasonings, and to those which regard matter of fact and existence.

The chief objection against all abstract reasonings is derived from the ideas of space and time; ideas, which, in common life and to a careless view, are very clear and intelligible, but when they pass through the scrutiny of the profound sciences (and they are the chief object of these sciences) afford principles, which seem full of absurdity and contradiction. No priestly dogmas, invented on purpose to tame and subdue the rebellious reason of mankind, ever shocked common sense more than the doctrine of the infinite divisibility of extension, with its consequences; as they are pompously displayed by all geometricians and metaphysicians, with a kind of triumph and exultation. A real quantity, infinitely less than any finite quantity, containing quantities infinitely less than itself, and so on in infinitum; this is an edifice so bold and prodigious, that it is too weighty for any pretended demonstration to support, because it shocks the clearest and most natural principles of human reason. 122

Whatever disputes there may be about mathematical points, we must allow that there are physical points; that is, parts of extension, which cannot be divided or lessened, either by the eye or imagination. These images, then, which are present to the fancy or senses, are absolutely indivisible, and consequently must be allowed by mathematicians to be infinitely less than any real part of extension; and yet nothing appears more certain to reason, than that an infinite number of them composes an infinite extension. How much more an infinite number of those infinitely small parts of extension, which are still supposed infinitely divisible. 123

But what renders the matter more extraordinary, is, that these seemingly absurd opinions are supported by a chain of reasoning, the clearest and most natural; nor is it possible for us

¹²² The next paragraph is a promoted footnote.

¹²³ The opinion that Hume thinks "shocks the clearest and most natural principles of human reason" is that a line of finite length is composed of an infinite number of infinitely divisible points.

to allow the premises without admitting the consequences. Nothing can be more convincing and satisfactory than all the conclusions concerning the properties of circles and triangles; and yet, when these are once received, how can we deny, that the angle of contact between a circle and its tangent is infinitely less than any rectilineal angle, that as you may increase the diameter of the circle in infinitum, this angle of contact becomes still less, even in infinitum, and that the angle of contact between other curves and their tangents may be infinitely less than those between any circle and its tangent, and so on, in infinitum? The demonstration of these principles seems as unexceptionable as that which proves the three angles of a triangle to be equal to two right ones, though the latter opinion be natural and easy, and the former big with contradiction and absurdity. Reason here seems to be thrown into a kind of amazement and suspence, which, without the suggestions of any sceptic, gives her a diffidence of herself, and of the ground on which she treads. She sees a full light, which illuminates certain places; but that light borders upon the most profound darkness. And between these she is so dazzled and confounded, that she scarcely can pronounce with certainty and assurance concerning any one object.

The absurdity of these bold determinations of the abstract sciences seems to become, if possible, still more palpable with regard to time than extension. An infinite number of real parts of time, passing in succession, and exhausted one after another, appears so evident a contradiction, that no man, one should think, whose judgement is not corrupted, instead of being improved, by the sciences, would ever be able to admit of it.

Yet still reason must remain restless, and unquiet, even with regard to that scepticism, to which she is driven by these seeming absurdities and contradictions. How any clear, distinct idea can contain circumstances, contradictory to itself, or to any other clear, distinct idea, is absolutely incomprehensible; and is, perhaps, as absurd as any proposition, which can be formed. So that nothing can be more sceptical, or more full of doubt and hesitation, than this scepticism itself, which arises from some of the paradoxical conclusions of geometry or the science of quantity.¹²⁴

It seems to me not impossible to avoid these absurdities and

¹²⁴ The next paragraph is, again, a promoted footnote.

contradictions, if it be admitted, that there is no such thing as abstract or general ideas, properly speaking; but that all general ideas are, in reality, particular ones, attached to a general term. which recalls, upon occasion, other particular ones, that resemble, in certain circumstances, the idea, present to the mind Thus when the term Horse is pronounced, we immediately figure to ourselves the idea of a black or a white animal, of a particular size or figure: But as that term is also usually applied to animals of other colours, figures and sizes, these ideas, though not actually present to the imagination, are easily recalled; and our reasoning and conclusion proceed in the same way, as if they were actually present. If this be admitted (as seems reasonable) it follows that all the ideas of quantity, upon which mathematicians reason, are nothing but particular, and such as are suggested by the senses and imagination, and consequently, cannot be infinitely divisible. It is sufficient to have dropped this hint at present, without prosecuting it any farther. It certainly concerns all lovers of science not to expose themselves to the ridicule and contempt of the ignorant by their conclusions; and this seems the readiest solution of these difficulties.

The sceptical objections to moral evidence, or to the reasonings concerning matter of fact, are either popular or philosophical. The popular objections are derived from the natural weakness of human understanding; the contradictory opinions. which have been entertained in different ages and nations: the variations of our judgement in sickness and health, youth and old age, prosperity and adversity; the perpetual contradiction of each particular man's opinions and sentiments; with many other topics of that kind. It is needless to insist farther on this head. These objections are but weak. For as, in common life, we reason every moment concerning fact and existence, and cannot possibly subsist, without continually employing this species of argument, any popular objections, derived from thence, must be insufficient to destroy that evidence. The great subverter of $Pyrrhonism^{125}$ or the excessive principles of scepticism is action, and employment, and the occupations of common life. These

^{125 &}quot;Pyrrhonism" is named after Pyrrho (c. 360–c. 270 BCE), the first notable 'skeptic'. There are conflicting traditions about what Pyrrho actually taught, but his name became associated with the view that we should suspend belief in all non-evident matters. See the discussion by Richard H. Popkin, The History of Skepticism from Erasmus to Descartes (New York, 1969).

principles may flourish and triumph in the schools; where it is, indeed, difficult, if not impossible, to refute them. But as soon as they leave the shade, and by the presence of the real objects, which actuate our passions and sentiments, are put in opposition to the more powerful principles of our nature, they vanish like smoke, and leave the most determined sceptic in the same condition as other mortals.

The sceptic, therefore, had better keep within his proper sphere, and display those philosophical objections, which arise from more profound researches. Here he seems to have ample matter of triumph; while he justly insists, that all our evidence for any matter of fact, which lies beyond the testimony of sense or memory, is derived entirely from the relation of cause and effect; that we have no other idea of this relation than that of two objects which have been frequently conjoined together; that we have no argument to convince us, that objects, which have, in our experience, been frequently conjoined, will likewise, in other instances, be conjoined in the same manner; and that nothing leads us to this inference but custom or a certain instinct of our nature: which it is indeed difficult to resist, but which, like other instincts, may be fallacious and deceitful. While the sceptic insists upon these topics, he shows his force, or rather, indeed, his own and our weakness; and seems, for the time at least, to destroy all assurance and conviction. These arguments might be displayed at greater length, if any durable good or benefit to society could ever be expected to result from them.

For here is the chief and most confounding objection to *excessive* scepticism, that no durable good can ever result from it; while it remains in its full force and vigour. We need only ask such a sceptic, *What his meaning is? And what he proposes by all these curious researches?* He is immediately at a loss, and knows not what to answer. A Copernican or Ptolemaic, ¹²⁶ who supports each his different system of astronomy, may hope to produce a conviction, which will remain constant and durable, with his audience. A Stoic or Epicurean displays principles, which may

 $^{^{126}}$ Nicolaus Copernicus (1473–1543) was a Polish astronomer who developed a system of heliocentric (Sun-centred) planetary motion, in opposition to the in his day long-established system developed by Ptolemy (second century CE), a Greek working in Alexandria, Egypt. This Ptolemaic system was related to that of Aristotle, which represented the Earth as the unmoving centre of the Universe.

not only be durable, but which have an effect on conduct and behaviour. But a Pyrrhonian cannot expect, that his philosophy will have any constant influence on the mind: or if it had, that its influence would be beneficial to society. On the contrary, he must acknowledge, if he will acknowledge anything, that all human life must perish, were his principles universally and steadily to prevail. All discourse, all action would immediately cease: and men remain in a total lethargy, till the necessities of nature. unsatisfied, put an end to their miserable existence. It is true; so fatal an event is very little to be dreaded. Nature is always too strong for principle. And though a Pyrrhonian may throw himself or others into a momentary amazement and confusion by his profound reasonings; the first and most trivial event in life will put to flight all his doubts and scruples, and leave him the same, in every point of action and speculation, with the philosophers of every other sect, or with those who never concerned themselves in any philosophical researches. When he awakes from his dream, he will be the first to join in the laugh against himself, and to confess, that all his objections are mere amusement, and can have no other tendency than to show the whimsical condition of mankind, who must act and reason and believe: though they are not able, by their most diligent enquiry. to satisfy themselves concerning the foundation of these operations, or to remove the objections, which may be raised against them.

PART III

There is, indeed, a more *mitigated* scepticism or *academical* philosophy, which may be both durable and useful, and which may, in part, be the result of this Pyrrhonism, or *excessive* scepticism, when its undistinguished doubts are, in some measure, corrected by common sense and reflection. The greater part of mankind are naturally apt to be affirmative and dogmatical in their opinions; and while they see objects only on one side, and have no idea of any counterpoising argument, they throw themselves precipitately into the principles, to which they are inclined; nor have they any indulgence for those who entertain opposite sentiments. To hesitate or balance perplexes their understanding, checks their passion, and suspends their action. They are, therefore, impatient till they escape from a

state, which to them is so uneasy: and they think, that they can never remove themselves far enough from it, by the violence of their affirmations and obstinacy of their belief. But could such dogmatical reasoners become sensible of the strange infirmities of human understanding, even in its most perfect state, and when most accurate and cautious in its determinations; such a reflection would naturally inspire them with more modesty and reserve, and diminish their fond opinion of themselves, and their prejudice against antagonists. The illiterate may reflect on the disposition of the learned, who, amidst all the advantages of study and reflection, are commonly still diffident in their determinations; and if any of the learned be inclined, from their natural temper, to haughtiness and obstinacy, a small tincture of Pyrrhonism might abate their pride, by showing them, that the few advantages, which they may have attained over their fellows, are but inconsiderable, if compared with the universal perplexity and confusion, which is inherent in human nature. In general, there is a degree of doubt, and caution, and modesty, which, in all kinds of scrutiny and decision, ought for ever to accompany a just reasoner.

Another species of *mitigated* scepticism which may be of advantage to mankind, and which may be the natural result of the Pyrrhonian doubts and scruples, is the limitation of our enquiries to such subjects as are best adapted to the narrow capacity of human understanding. The *imagination* of man is naturally sublime, delighted with whatever is remote and extraordinary, and running, without control, into the most distant parts of space and time in order to avoid the objects. which custom has rendered too familiar to it. A correct Judgement observes a contrary method, and avoiding all distant and high enquiries, confines itself to common life, and to such subjects as fall under daily practice and experience; leaving the more sublime topics to the embellishment of poets and orators. or to the arts of priests and politicians. To bring us to so salutary a determination, nothing can be more serviceable, than to be once thoroughly convinced of the force of the Pyrrhonian doubt, and of the impossibility, that anything, but the strong power of natural instinct, could free us from it. Those who have a propensity to philosophy, will still continue their researches: because they reflect, that, besides the immediate pleasure, attending such an occupation, philosophical decisions are nothing but the reflections of common life, methodized and corrected.

But they will never be tempted to go beyond common life, so long as they consider the imperfection of those faculties which they employ, their narrow reach, and their inaccurate operations. While we cannot give a satisfactory reason, why we believe, after a thousand experiments, that a stone will fall, or fire burn; can we ever satisfy ourselves concerning any determination, which we may form, with regard to the origin of worlds, and the situation of nature, from, and to eternity?

This narrow limitation, indeed, of our enquiries, is, in every respect, so reasonable, that it suffices to make the slightest examination into the natural powers of the human mind and to compare them with their objects, in order to recommend it to us. We shall then find what are the proper subjects of science and enquiry.

It seems to me, that the only objects of the abstract sciences or of demonstration are quantity and number, and that all attempts to extend this more perfect species of knowledge beyond these bounds are mere sophistry and illusion. As the component parts of quantity and number are entirely similar. their relations become intricate and involved; and nothing can be more curious, as well as useful, than to trace, by a variety of mediums, their equality or inequality, through their different appearances. But as all other ideas are clearly distinct and different from each other, we can never advance farther, by our utmost scrutiny, than to observe this diversity, and, by an obvious reflection, pronounce one thing not to be another. Or if there be any difficulty in these decisions, it proceeds entirely from the undeterminate meaning of words, which is corrected by juster definitions. That the square of the hypothenuse is equal to the squares of the other two sides, cannot be known, let the terms be ever so exactly defined, without a train of reasoning and enquiry. But to convince us of this proposition, that where there is no property, there can be no injustice, it is only necessary to define the terms, and explain injustice to be a violation of property. This proposition is, indeed, nothing but a more imperfect definition. It is the same case with all those pretended syllogistical reasonings, which may be found in every other branch of learning, except the sciences of quantity and number: and these may safely, I think, be pronounced the only proper objects of knowledge and demonstration.

All other enquiries of men regard only matter of fact and existence; and these are evidently incapable of demonstration.

Whatever *is* may *not be*. No negation of a fact can involve a contradiction. The non-existence of any being, without exception, is as clear and distinct an idea as its existence. The proposition, which affirms it not to be, however false, is no less conceivable and intelligible, than that which affirms it to be. The case is different with the sciences, properly so called.¹²⁷ Every proposition, which is not true, is there confused and unintelligible. That the cube root of 64 is equal to the half of 10, is a false proposition, and can never be distinctly conceived. But that Cæsar, or the angel Gabriel, or any being never existed, may be a false proposition, but still is perfectly conceivable, and implies no contradiction.

The existence, therefore, of any being can only be proved by arguments from its cause or its effect; and these arguments are founded entirely on experience. If we reason *a priori*, anything may appear able to produce anything. The falling of a pebble may, for aught we know, extinguish the sun; or the wish of a man control the planets in their orbits. It is only experience, which teaches us the nature and bounds of cause and effect, and enables us to infer the existence of one object from that of another. Such is the foundation of moral reasoning, which forms the greater part of human knowledge, and is the source of all human action and behaviour.¹²⁸

That impious maxim of the ancient philosophy, *Ex nihilo*, *nihil fit*, by which the creation of matter was excluded, ceases to be a maxim, according to this philosophy. Not only the will of the supreme Being may create matter; but, for aught we know *a priori*, the will of any other being might create it, or any other cause, that the most whimsical imagination can assign.

Moral reasonings are either concerning particular or general facts. All deliberations in life regard the former; as also all disquisitions in life regard the former; as also all disquisitions in history, chronology, geography, and astronomy.

The sciences, which treat of general facts, are politics, natural philosophy, physic, chemistry, &c. where the qualities, causes and effects of a whole species of objects are enquired into.

Divinity or Theology, as it proves the existence of a Deity,

 $^{^{127}}$ The sciences based on strict rational demonstration; in Hume's view these are confined to mathematics.

 $^{^{128}}$ The new two sentences were originally a footnote. "That impious maxim" translates: 'From nothing, nothing comes'.

and the immortality of souls, is composed partly of reasonings concerning particular, partly concerning general facts. It has a foundation in *reason*, so far as it is supported by experience. But its best and most solid foundation is *faith* and divine revelation.

Morals and criticism are not so properly objects of the understanding as of taste and sentiment. Beauty, whether moral or natural, is felt, more properly than perceived. Or if we reason concerning it, and endeavour to fix its standard, we regard a new fact, to wit, the general taste of mankind, or some such fact, which may be the object of reasoning and enquiry.

When we run over libraries, persuaded of these principles, what havoc must we make? If we take in our hand any volume; of divinity or school metaphysics, for instance; let us ask, *Does it contain any abstract reasoning concerning quantity or number?* No. *Does it contain any experimental reasoning concerning matter of fact and existence?* No. Commit it then to the flames: for it can contain nothing but sophistry and illusion.

BIBLIOGRAPHY

A. WORKS BY HUME

A Treatise of Human Nature (1739–1740)

An Abstract of a Treatise of Human Nature (1740)

Essays, Moral and Political (1741–1742)

Letter from a Gentleman to His Friend in Edinburgh (1745)

An Enquiry concerning Human Understanding (1748)

An Enquiry concerning the Principles of Morals (1751)

Political Discourses (1752)

The History of England (1754–1762)

Four Dissertations (1757) (including The Dissertation on the Passions and The Natural History of Religion)

A Concise and Genuine Account of the Dispute Between Mr. Hume and Mr. Rousseau (1766)

My Own Life (1777)

 ${\it Two \, Essays}$ ('Of Suicide' and 'Of the Immortality of the Soul') (1777)

Dialogues concerning Natural Religion (1779)

The Letters of David Hume. Edited by J.Y.T. Greig. 2 volumes. Oxford: Oxford University Press, 1932.

New Letters of David Hume. Edited by R. Klibansky and E.C. Mossner. Oxford: Clarendon, 1954.

For a complete Hume bibliography, see T.E. Jessop's Bibliography of David Hume and of Scottish Philosophy from Francis Hutcheson to Lord Balfour, and Roland Hall's A Hume Bibliography, from 1930. A supplement to the latter was printed in the Philosophical Quarterly, January 1976.

B. IMPORTANT WORKS ON HUME

Anderson, Robert F. *Hume's First Principles*. Lincoln: University of Nebraska Press, 1966.

- Beauchamp, Tom L. and Alexander Rosenberg. *Hume and the Problem of Causation*. Oxford: Oxford University Press, 1981.
- Bennett, Jonathan. Locke, Berkeley, Hume: Central Themes. Oxford: Clarendon, 1973.
- Bricke, John. *Hume's Philosophy of Mind*. Edinburgh: Edinburgh University Press, 1980.
- Capaldi, Nicholas. *David Hume: The Newton Philosopher.* Boston: Twayne, 1975.
- Flew, Antony. *Hume's Philosophy of Belief.* London: Routledge & Kegan Paul, 1961.
- Flew, Antony. David Hume, Philosopher of Moral Science. Oxford: Blackwell, 1986.
- Fogelin, Robert J. Hume's Skepticism in the Treatise of Human Nature. London: Routledge and Kegan Paul, 1985.
- Forbes, Duncan. *Hume's Philosophical Politics*. Cambridge: Cambridge University Press, 1975.
- Gaskin, J. A. C. *Hume's Philosophy of Religion*. London: Macmillan, Second Edition, 1988.
- Hendel, Charles W. Studies in the Philosophy of David Hume. Indianapolis & New York: Bobbs-Merrill, 1963.
- Jones, Peter. *Hume's Sentiments*. Edinburgh: Edinburgh University Press, 1982.
- Kemp Smith, Norman. *The Philosophy of David Hume*. London: Macmillan, 1941.
- Laird, John. *Hume's Philosophy of Human Nature*. London: Methuen, 1932.
- Mackie, J. L. *Hume's Moral Theory*. London: Routledge and Kegan Paul, 1980.
- Macnabb, D. G. C. David Hume: His Theory of Knowledge and Morality. Hambden, Connecticut: Archon, 1966.
- Mossner, E. C. *The Life of David Hume*. Oxford: Clarendon, 1980.
- Norton, David Fate. *David Hume*. Princeton: Princeton University Press, 1982.
- Noxon, James. *Hume's Philosophical Development*. Oxford: Clarendon, 1973.

BIBLIOGRAPHY 199

Passmore, John A. *Hume's Intentions*. New York: Basic Books, 1968.

- Penelhum, Terence. Hume. London: Macmillan, 1975.
- Price, Henry H. *Hume's Theory of the External World*. Oxford: Clarendon Press, 1940.
- Stove, D. C. *Probability and Hume's Inductive Skepticism*. Oxford: Clarendon, 1973.
- Wright, John P. *The Sceptical Realism of David Hume*. Manchester: Manchester University Press, 1982.

C. COLLECTIONS OF ESSAYS ON HUME

- Chappell, V. C. ed. *Hume*. South Bend, Indiana: University of Notre Dame, 1966.
- Livingston, Donald W. & James T. King, eds. *Hume: A Re-Evaluation*. New York: Fordham University Press, 1976.
- Morice, George ed. *David Hume: Bicentenary Papers*. Edinburgh: Edinburgh University Press, 1976.
- Sesonske, A. & N. Fleming, eds. *Human Understanding:* Studies in the Philosophy of David Hume. Belmont, California: Wadsworth, 1965.
- Todd, William B. *Hume and the Enlightenment*. Edinburgh: Edinburgh University Press, 1974.

A journal devoted entirely to research on Hume, *Hume Studies*, is published twice yearly by the University of Western Ontario Department of Philosophy. Subscription enquiries should be addressed to Hume Studies, University of Western Ontario, Department of Philosophy, London, Ontario, N6A 3K7, Canada.

Aberdeen, 17n	argument based on testimony, 144-
abstract ideas, 66, 189	49, see also evidence,
abstraction, 185	testimony
Abstract of A Treatise (Hume), xv	argument from experience,
abstract reasoning, 76, 79, 85, 117,	and Hume's Fork, xi, 194;
187, 195	
	and perceptions of objects, 184–
abstract sciences, 90, 188, 193	85;
abstruse philosophy and thought,	and proofs, 98;
54, 56, 58–59, 62, 82;	and relation of cause and effect,
and Roman Catholicism, 62;	77–81, 176;
effect of, on society, 57–58	as basis of philosophy, 30;
Academica (Cicero), 84n	beyond its premisses (necessarily
Academic or Sceptical philosophy,	fallacious) xii, 77–81, 111
xii, 84–85, 161, 161 <i>n</i> , 191	argument, limits of, 183–84
Academy of Athens, $84n$, $161n$	Argument to Design, see Design,
accuracy, 57	argument to
act of volition, 104, 109	Aristotle, 55 , $55n$, $97n$, 122 , $180n$,
Adam (first man), 33, 34, 73	190n
Addison, Joseph, 55, 55n	arithmetic, 33, 71; see also
Alexander of Abonoteichos, 153,	mathematics
153n, 154	Arnauld, Antoine, 31n, 161
Alexander, or The False Prophet	association of ideas, 43, 69-70, 93;
(Lucian), $153n$	see also causation, connexion
Alexander the Great, 122, 122n, 155,	astronomy, 194
155n	Atheists, 181, 186
Alexandria, 155	Athens, 154, 167, 169
algebra, 71	Augustine, Saint $58n$
Almighty, 164; see also Author,	Austria, 7n
Being, Creator, Deity, God,	Author, 135, 177; see also Almighty,
Maker, Supreme Being	Being, Creator, Deity, God,
America, 15, 16	Maker, Supreme Being
analogy, 73, 74, 91–93, 96, 111, 139,	maker, Supreme Berng
141, 142, 147, 163, 177, 180	
Analogy of Religion, An (Butler), 30n	Bacon, Francis, 30, 30n, 164, 164n
anatomy, 106, 139	Bath, 21
	Bayle, Pierre, 186, 186n
Andromeda Nebula, xvii	Beattie, James, $52n$
animals, the reason of, xiii, 139–141	Bede, Saint, 161, 161n
Annandale, Marquis of, 5	Being, 135, 136, 164, 177, 178, 184;
Antony, Mark, 161n	see also Almighty, Author,
Aquinas, Thomas, 68n	Creator, Deity, God, Maker,
argument against miracles, 144–49,	Supreme Being
150–166	belief, 35, 36, 37, 39, 89–90, 91, 92,
argument against reason (sceptics),	93, 95, 96, 98, 99, 100, 128,
187	00, 00, 00, 00, 100, 120,

132, 141, 144, 147, 163, 168,	cause and effect, xvii–xviii, 31–32,
183, 192;	33, 34, 36, 37, 38, 41, 48, 49, 50,
defined, 92;	69, 70, 72–75, 85–86, 139, 194;
in witnesses, 42, 143, 145-47	and argument for divinity, 170;
Berkeley, George, viii, 185n, 186,	and belief, 93, 96–97;
186n	and custom, 141;
Black, Dr., 24	and differences in human
Boyle, Robert, $185n$	understanding, 142;
Bristol, 4	and necessary connexion, 38, 103,
Brutus, 161n	105, 107–09, 113–16, 128, 132;
Butler, Joseph, 30, 30n, 151n	and necessity, 129;
	and probability, 99, 100, 144;
Colminists 199n	and uniformity, 120, 124, 125;
Calvinists, 138n	as basis of reasoning, 72-75, 77-
Campbell, Reverend George, 17	83, 139, 190, 194;
Canada, 5	in proportion, 170–73, 177
Cantor, Georg, 40–41n	certainty,
Carneades, 161n	and testimony, 154–55;
Carousal, or the Lapiths, The,	bases of, 47, 124;
(Lucian), 167n	degrees of, 128, 144;
Cartesians, 38, 39, 112	sciences of, 71
Cassius, 161n	chance, 98–99, 102, 131–32, 170
Cato the Elder, 95n, 147n	Characteristics of Men, Manners,
Cato the Younger, 147, 147n	Opinions, Times
causal connections, xiv; see	(Shaftesbury), $30n$
causation, cause, cause and	Charles I (of England), 7, 8
effect	Charon, 22-23
causality, xv, see causation,	Chatillon, Duc de, 160
cause, cause and effect	Chaulieu, Abbé, 22
causation, xiv, 43, 93, 95, 110 <i>n</i> ,	chemistry, 194
115n, 121, 129	China, 154
causal powers, 103, 103 <i>n</i>	Christianity ("the Christian
cause, 33, 38, 42, 96, 98, 102, 103,	religion"), xvi, 143, 165, 166
105, 107, 109, 113–14, 127, 129,	Cicero, Marcus Tullius, xii, 4, 55,
159;	55n, 84n, 95n, 151, 151n
and evidence of miracles, 146;	Clarke, Dr. Samuel, 47n, 48, 112,
and human nature, 121;	113n
and necessary connexion, 132;	common sense, 29, 41, 55, 72, 150,
and necessity, 133–34;	187, 191
and probability, 99;	connexion, xiv, 69–70, 93;
and science, 115;	and liberty and necessity, 120-
and uncertainty, 124;	21;
and volition, 135;	and motives, 121–135;
defined, xiv–xv, 132; immediate, 109;	between causes and effect, 74,
	76, 115, 116;
in character, 134; of existence, 47–50, 73–75, 131;	between endeavor and event,
similar, to similar effects, 80–	107;
83, 85, 86, 180;	between fact and fact, 89;
00, 00, 00, 100,	between fact and inference, 72;

ultimate, 109, 135, 170-74

203

between sensible qualities and	Critiques (Kant), vii
secret powers, 78–81;	Cudworth, Ralph, 112, 113n
existence of objects, 32, 37, 104,	Curia Hostilia, 95n
109;	custom (or habit), xii, xiv, 74;
object and image, 182–85;	and animal behaviour, 141;
ultimate, 42;	and argument from experience
see also conjunction, constant	87, 89, 114, 121, 123, 142;
conjunction	relating past to future, 35, 36,
conclusions,	38, 39, 86, 87, 91, 96, 98, 190;
experimental or by experience,	versus faith, 166
29, 34, 77–81, 82, 86, 88, 89,	customary connexion, 117; see also
99;	connexion
mathematical, 101–02;	customary conjunction, 89, 90, 93,
of ideas of objects, 185, 189	96; see also constant
Copernicus, Nicolaus, 190, 190n	conjunction
conjunction,	customary transition, 116, 117, 128
assumptions of, 34, 35, 78–81,	
85, 89–90;	Dominia Charles viii
in belief, 91, 96;	Darwin, Charles, xiii
of events, 113–15, 124;	Deeds of Alexander the Great, The
of motive and action, 125-26,	(Quintus), $122n$ de Finibus (Cicero), $95n$
133;	
of objects, 109–110, 190;	Defoe, Daniel, xvii, 72n
of report and object, 146;	degrees of quality, 47
see also connexion, constant	Deists, xvi
conjunction	Deity, a, 180, 181, 194
consciousness, xiii, $105, 105n, 106,$	Deity, the, xvii, xviii, 38, 110, 111,
107, 110, 134	111 <i>n</i> , 112, 135, 136, 137, 138,
constant conjunction, 33, 36, 38, 42,	149, 177, 179; see also Almighty, Author, Being,
73, 78, 86, 114, 116, 117, 121,	Creator, God, Maker,
128, 129, 130, 133, 144, 145,	Supreme Being
180;	de la Fore, Marquis, 22
and necessity, 133	De la Recherche de la Vérité
contiguity, 33, 38, 43, 69-70, 93, 94,	(Malebranche), 31, 31n, 110n
95, 96; see also association of	Demetrius I of Macedonia, 155, 156n
ideas, connexion, conjunction,	Democritus of Abdera, $167n$, $185n$
customary connexion	demonstration, 31, 34, 47–48, 98; see
contradiction, 35, 36, 71, 79;	also demonstrative proof
of matters of fact, 71	demonstrative proof, 130, 193
contrariety,	demonstrative proof, 150, 155 demonstrative reasoning 79, 81, 98
in events, 144;	Demosthenes, 151 , $151n$
in judgements, 146;	de Natura Deorum (Cicero), 84n
in relation of ideas, 47, 70;	de Rerum Natura (Lucretius), 162n,
in relation of miracles, 161	167n
Conway, General, 9	de Retz, Cardinal 156, 156n
Creator, xvii, 110, 112, 135; see also	Descartes, René, vii, viii, 39, 55, 65n,
Almighty, Author, Being,	106n, 112, 181, 185n
Deity, God, Maker, Supreme	Design, argument to, xvi–xvii, 170–
Being	180

De Carlana arian 150	Ei
De Sylva, xix, 159	Enquiry concerning the Principles of
Dialogues concerning Natural	Morals, An (Hume) vii, 6, 7,
Religion (Hume) 14n.1, 170	52n
Dialogues of the Dead (Lucian), 22	Epictetus, 84
Dick, Sir Alexander, 15	Epicurus, 167, 167 <i>n</i> , 168, 169, 175,
Dio Cassius, 168n	179, 180
Discourse against	equality, 40
Transubstantiation	Erskine, Sir Harry, 5
(Tillotson), 143n	Essay concerning Human
Discourse on the Method	Understanding, An (Locke),
(Descartes), vii, xiii	vii, 30n, 31, 55n, 185n
Dissertation on Miracles	Essays and Treatises on Several
(Campbell), 17	Subjects (Hume), viii
Dissertation on the Passions, A	Essays, Moral and Political (Hume),
(Hume), $52n$	viii, 5, 6
distance and force of ideas, 94	essence, $32, 42$
distributive justice, 174, 175	Eternal and Immutable Morality
Divinity, 194, 195	(Cudworth, compiler), $113n$
doctrine of liberty, 130, 131, 133	Euclid, 71, 71n, 102
doctrine of necessity, 120-21, 126-	Eunach (Lucian), 167n
28, 131, 133, 134	Europe, 29, 160
Doctrine of the Veil of Appearance,	evidence,
ix, xii	and matter of fact, 190;
Dundas, Dr., 22	and miracles, 143-155, 157, 159;
Duns Scotus, John, 68n	and necessary connexion, 115;
	measures of, 31;
T. 1 . 1 . 2 . 2 . 2 . 2 . 2 . 2 . 2 . 2	moral, 42;
Edinburgh, 3, 5, 6, 8, 9, 10, 15, 21,	of witnesses, xviii, 143-46;
23, 24	versus fact, xvi;
Edmondstone, Colonel, 22	versus gossip, 152
Elements of Geometry, The (Euclid),	existence (and real existence), 79, 89,
71n	96, 171, 183, 187, 189, 193, 195;
Elizabeth I, 8, 163	of necessary connexion, 114;
effect, 35, 38, 42, 49, 72–76, 78–79,	see also matter of fact
80, 81, 82, 83, 85 – 87, 88, 93 –	expectation, see belief
95, 100, 103, 104, 106, 108, 109,	experience,
112–14, 120, 129, 139, 177–78,	and conjunction of objects, 109;
180;	and custom and belief, 89, 96,
measure of power, 106, 116;	144, 146, 147, 192;
of gravity, 112	and human action, 119, 126, 168;
Elliot of Minto, Gilbert, 14	and human nature, 121–23, 145,
energy, 102, 103, 104, 105, 107, 108,	174;
109, 110, 111, 112, 113, 116,	and Hume's fork, x;
$120, 171, 178, 184; see\ also$	and improvement, 82;
force, power, will	
England, 5, 6, 7, 7n, 8, 21, 29, 164	and learning (animals) 139
Enquiry concerning Human	and learning (animals), 139–
Understanding, An (Hume),	141;
vi, viii, x, xi, xiv, xvi, xx, 5,	and miracles, 144, 146, 148, 162,
14n.2,52n	163;

and necessary connexion, cause force, 38, 102, 104, 106, 107, 108, and effect, 114-16; 111, 116, 120, 129, 170; see also energy, power, will and power, 103-04; and volition, 105-07; France, 4, 5, 7, 7n, 72as basis of argument, 30; Franklin, Benjamin, 15 as basis of inference, 33-34, 37-Free Inquiry into the Miraculous Power, A (Middleton), 6, 6n 39, 86, 87, 88, 176-77, 180, free will, 41-42 194: as basis of knowledge, 36, 73, 74, 122, 139-140, 164, 184, 190; Galileo, 185n as basis of knowledge of fact, general appearance, 41 112; geography, 194 as basis of necessity of cause, 50; geometry, 33, 40, 71, 76, 101, 102, as basis of reasoning, matter of 187-88 fact, 77-81, 144; God, xvi, 65, 110, 158, 160, 165, see as basis of testimony, 163; also Almighty, Author, Being, limits of, 108, 111, 164, 175; Creator, Deity, Maker, see also argument from Supreme Being experience gods, nature of the, 169-174 experiment (and experimental), 78, Gospel, 18; see also Christianity 81, 100, 102, 114, 121-23, 142, Grant, Captain, then General, 5 145, 145n, 195extension, idea of, 185-86, 187 external bodies, 60, 97, 117 habit, see custom (or habit) Halkerton, Lord (maternal uncle), 3 external existence, 39, 186 harmony, pre-established, between external objects, 103, 104, 108, 110, 124, 126, 129, 139, 182-84 nature and ideas, 96 external universe, 183 Hartley, David, 43n Helen (of Troy), 57, 57nextraordinary event, 197, 164 Heraut, Mons. (lieutenant de Police), 159 Fable of the Bees, The (Mandeville), Herodotus, 161, 161n 30nHerring, Dr. (Primate of England), 7 fact, xvi, 32, 189, 194; see also matter Hertford, Earl of (ambassador to of fact Paris, then Lord Lieutenant Faculty of Advocates, 7 of Ireland), 9, 10 Falconer, Sir David (later Lord Hippocrates, 122, 122nHalkerton) (maternal history, 121, 126, 152, 162, 163, grandfather), 3 165, 194 feelings History of England (Hume), xixn; (sentiments), 91, 92, 93, 114, 115, History of the First Two Stuarts 127-28; (vol. 1), 7; (senses), 117, 185 History of the House of Tudor fictions of the imagination, xiii, 91, (vol. 2), 892,93 History of Skepticism from Erasmus Fifteen Sermons (Butler) 30n to Descartes (Popkin) 189n final causes, xiii, 96; see also Hobbes, Thomas, 47n, 48 ultimate causes Home (or Hume), Earl of (family), 3 First Vatican Council, xvi Home, John, 21 Flew, Antony, viiin

Home, Henry, xv , xvn	and connexions, 114, 115, 117;
human actions, 133–36, 194	and ideas, 189;
human knowledge, xvi, 50, 184, 193	and miracles, 151, 161-62;
human law, 133	and qualities of gods, 172, 174
human nature, 121-23, 145-46, 150,	immortality, xvi
152, 166, 178, 192;	impressions, ix, 40, 65-67, 93, 94-
the science of, 30, 85	95, 99, 102, 103, 104, 107, 111 <i>n</i> ;
human reason, 59, 71, 111, 115, 165,	and necessary connexion, 114;
187; see also reason/reasoning,	defined, 31, 64
human understanding	induction, the problem of, xi
human understanding, 56, 60, 82,	inference,
85, 119, 130, 141–42, 189, 192	across time, 125;
Hume's Fork, x	and constant conjunction, 121,
Hume's Law, xi	129, 130, 145, 190;
Hume's Philosophy of Belief (Flew),	and motive and human action,
viii	
Hurd, Dr., 8	126–27, 131;
	and necessary connexion, 115,
Hutcheson, Francis, 30, 30n, 60n	117, 132;
hypotheses, Hume's contempt for, 30	and necessity, 133;
	and ultimate causes, 110;
ideas,	based on experience, 33–34, 72–
and belief, 35–37, 92–93;	73, 87, 89, 99, 120, 140, 150,
and nature, 96;	176;
and sensible objects, 94, 185;	from cause to effect, 33, 38, 42,
and terms, 119;	85 - 86, 139, 172, 173, 174 -
as effect of soul, 108;	180, 194;
as effect of Creator, 110;	from effect to cause, 170–77,
comparison of, 47, 188;	180;
defined (by Berkeley), ix, (by	in geometry and mathematics,
Descartes), viii, (by Hume), ix,	101–02;
xiii, 31, 39–40, 64, (by Locke),	sensible quality and secret
vii, ix, 67;	powers, 78–82
derived from impressions, 31–	infinite divisibility, 40, 41
32, 64–67, 102–04, 107;	innate ideas, 67–68; see also ideas
distinct, 48, 101, 188, 193, 194;	Inquiry into the Nature and Causes
of mind's nerven 119, 19,	$of\ the\ We alth\ of\ Nations, An$
of mind's power, 112–13; of necessary connexion, 114,	(Smith), $8n$
	Inquiry into the Original of Our
116–17;	Ideas of Beauty and Virtue
relations of, 71, 76, 79;	(Hutcheson), $30n$
use by imagination, 90–92;	instinct, 97, 141, 183, 184, 190; see
versus instinct, 141	also natural instincts
image,	Italy, 6
of mind, 184, 187;	
of senses, 183;	
of will, 130–31	Jansen, Cornelius, $157n$
imagination, xiii, 43, 60, 63, 64, 66,	Jericho, 160
69, 92, 96, 99, 187, 192;	Julius Caesar (Shakespeare), 161n
and act of volition, 104;	${\rm Jupiter(thegod),171,171}n,173$
and belief, 90–92, 93, 141;	

Kant, Immanuel, vii mathematics, 76, 76n, 101, 102. Kirkcaldy, Fifeshire, 21, 24 194n; see also arithmetic knowledge. matter, 38, 42, 104, 105, 107, 108, animal, 139-141; 112, 120, 121, 129, 133, 171, of cause from effect, 171: 172, 186, 194 see also human knowledge matter of fact, 32, 34, 35, 36, 71-73, 77–79, 81, 89, 91, 96, 115, 131, 139, 144, 187, 189, 190, 193, La Bruyère, 55, 55n 195; Laelis, 95n and witnesses, 146, 164 La Flèche, Anjou, 4, 18; memory, 72, 89, 91, 93, 96, 114, 120, Jesuits' College of, 18 127, 142, 145, 190 L'Art de Penser (Arnauld and metaphysics, 67, 76, 102, 131, 133, Nicole), 31, 31n 179, 182, 195 laws of nature, 74, 76, 99, 120, 125; Michotte, Albert, 104n and miracles, 148-49, 162, 163, Middleton, Dr. Conyers, 6, 6n 164 Millar, Andrew (Hume's Leibniz, (Leibnitz in Hume), publisher/bookseller), 6, 6n.2, Gottfried Wilhelm, 30, 30n le Franc, Mademoiselle, 159 mind, 59-60, 61, 91-94, 96-97, 98liberty, 99, 101-111, 113, 116, 119, 121, and morality, 134; 129, 184, 185, 193; and philosophy, 167, 179; and morality, 133, 134, 137 and necessity, 120, 132, 135; miracles, xvi, xviii, 143, 147-49, defined, 131; 150, 152, 154, 157, 163, 166; or indifference, 130 Catholic, 18; Life of Cato (Plutarch), 147 of Abbé Paris, xix, 157-161 Life of Vespasian (Suetonius), 155n Molina, Luis de, 158n Livy (Titus Livius), 154, 154n, 165, Montgeron, 158 165nmoral evidence, 144, 144, 189 Locke, John, vii, viii, ix, 30, 30n, 32, moralists 61; see also moral 47n, 49, 55, 55n, 67, 68, 98philosophy 104, 112, 185nmorality, logic, and reasoning, 30-31 and liberty, 133-35, 137, 168; London, 4, 6, 7, 21 and necessity, 133; Lucian, 153, 153n, 154, 167n, 168n and reasoning, 132 Lucretius (Titus Lucretius Carus), moral philosophy, 53, 53n, 76, 102, 162n, 167n121; see also moral reasoning moral reasoning, 79, 102, 194; see Mahomet (Muhammed), 154, 154n also moral philosophy Maker, 108, 110; see also Almighty, morals, 30, 195; Author, Being, Creator, Deity, and society, 168, 173 God, Supreme Being moral sciences, 101, 127 Malebranche, Father Nicholas, 31n, Morpeth, 21 32, 55, 55n, 110n, 112Moscovy, 148 Mandeville, Bernard, 30, 30n motives and actions, 121-28, 130-31, Marcus Aurelius, 136n, 153, 153n, 133 168n

natural and moral evidence, 127

Mariana, Juan, 161, 161n

Natural History of Religion (Hume),	observation, 88, 124, 140, 142, 145;
6n.2, 7, 52n	see also experience
natural instincts, 90, 140, 182-83,	Observations on Man, His Frame,
186, 192; see also instinct	His Duty and His
natural philosophy, 102, 133, 194	Expectations (Hartley), 43n
natural theology, xvi, 170	obvious philosophy, 54, 55–56
Natural Theology, Or Evidence of the	occasions, 109
Existence and Attributes of	Octavian, 161n
the Deity Collected from the	opinion, see belief
Appearances of Nature	Opticks (Newton), xiv, 185n
(Paley), $72n$	Origins of Forms and Qualities
nature,	(Boyle), $185n$
and belief, 91, 99, 141;	
and custom, 140-41;	D. I
and probability, 99;	Paley, Archdeacon William, 72n
and succession of ideas, 96–97;	Paphlagonia, 153, 153n, 154
as argument for divinity, 170–	Paris, 9
75, 178;	Paris, Abbé (François de Paris), xix,
as moral system, 136;	157, 157 <i>n</i> , 161 <i>n</i>
common operations of,	Pascal, Blaise, 31n, 157n, 160, 161
explained, 109, 113;	passions, 54, 60, 85, 92, 93, 101,
man's role in, xiii;	108, 121, 134, 150, 152, 162,
result of Maker's volition, 108-	168, 179, 191
110	Paul, Saint, 160
necessary causes, 135	perception, 39, 63, 182–86;
necessary connexion, xiv, xv, 38,	defined, 31
101-04, 113-14, 128, 132; see	Perception of Causality, The,
also necessity	(Michotte), 104n
necessary force, 120	Pharsalia, battle of, 161, 161n
necessity,	Philip of Macedon, 151n
and causation, 42, 47–50, 114,	Philippi, battle of, 161, 161n
121, 133–35;	philosophers, 54–55, 56, 57, 58, 77,
and cause and effect, 129, 130;	80, 84, 99, 100, 108, 110, 116,
and human body, 125;	120, 124, 136, 172, 191;
and liberty, 120, 130–34;	of antiquity, 29, 167–69, 172;
defined, 133;	of England, 29
of action in thought, 130	Philosophiae Naturalis Principia
Nero, 88, 88n	Mathematica (Newton), $61n$,
New Essays on the Human	75n
Understanding (Leibniz), 30n	philosophy, 60–61, 76, 84, 112, 167,
Newton, Sir Isaac, x, xiv, 61n, 75n,	168, 179;
103n, 112, 112n, 113n, 185n	versus common sense, 41, 54,
Nicole, Pierre, 31n, 161	92, 116, 184
nisus, 107, 107n, 117	physical necessity, 127
Noailles, Cardinal, 158	physics, 102, 194
Novum Organum (Bacon), 164n	Piso, 94n
	Plato, 55n, 71n, 84n, 95n, 161n, 167n
	Plutarch, 147, 154, 154n, 161
object of power in voluntary motion,	Polemo, 95n Political Discourses (Hume), 6
106	Political Discourses (nume), o

politics, 30, 126, 168, 179, 194	xii, 39, 82, 85, 87, 90, 140,
Polybius, 122, 122n	176–77;
Popper, Sir Karl Raimund, 130n	and Cartesian doubt, 181;
Port-Royal Logic (La logique, ou L'Art	and design, 174–180;
de Penser), see L'Art de Penser	and external objects, 126;
power, 38, 75, 77–78, 80–81, 85, 96,	and mathematics, 187-88;
102–110, 112, 114, 116, 132,	and miracles, 143-49, 150-165;
141, 171; see also energy, force,	based on cause and effect, 72-
will	73, 76, 171, 176;
primary and secondary qualities,	defined, 119–120;
185, 185n, 186	demonstrative (relation of
Principles of Human Knowledge	ideas), 79;
(Berkeley), ix, $185n$, $186n$	experimental, 139–141;
priority (in time), 33, 38	moral (matter of fact and
probable argument (Locke), 98	existence), 77–80, 97, 99, 101,
probability, 98, 99, 100, 145, 146;	102, 103, 104, 108, 114, 117,
and miracles, 163;	132, 139, 189;
and testimony, 148–49	versus instinct, 183, 186
Problem of Induction, the, xi	Reasonings concerning Miracles
proofs, 34–35, 48, 98, 106, 114, 130,	(Hume), xv
134, 144, 146, 148, 150, 157-	Recueil des Miracles de l'Abbé Paris,
58, 163, 166, 170	158
proportion (of ideas), 47	reflection, 93, 101, 105, 112, 123,
Protagoras, 167, 167n	128, 130, 179, 191, 192;
Prussia, 7n	and miracles, 151;
Ptolemy, 190, 190n	and morality, 137;
Pyrrho of Elis, xx, 39n, 189n	see also thought
Pythagoras of Samos, 71n	regular connexion, 124; see also
	connexion, constant
qualities,	conjunction, regular
ascribed to God, 177;	conjunction
ascribed to gods, 172–76;	regular conjunction, 80-82, 121, 130,
of causes and effects, 170–73,	132; see also constant
177–78;	conjunction
of morality and society, 137;	Reid, Thomas, $52n$
of objects in nature, 77–78, 80–	Reims, 4
	relations (infallible relations), 47, 95
82, 90, 103, 104, 185	religion,
quantity of effect (degree of power),	and ancient freedom, 167-68;
116	and experience, 179;
Quintus Curtius Rufus, 122, 122n	and fears and prejudice, 58;
	and miracles, xviii, 143, 151–52,
Racine, Jean, 160, 160n, 161	154, 162–65;
reality (realities), 91, 93, 95	and reasoning, 132–34;
reason, 35, 73–74, 119–120, 151,	Roman Catholic, 94;
168, 169, 172, 185, 195; see also	see also Christianity
reasoning	resemblance, 43, 47, 66, 67, 69, 70,
reasoning,	78–83, 93–95, 120, 130, 139,
and argument from experience,	184
and anguintent in our experience,	101

Richmond, Duke of, 9	Socrates, 167
Robinson Crusoe, (Defoe), xvii, 72	Solomon, 15
Rodin, xiii	soul, 39, 105, 108, 110, 129
Roman empire, 154	Spain, 156
Rome, 147	Speusippus, $95n$
Russell, Mr., 15	Stone, Dr. (primate of Ireland), 7
	Stoics, 84, 136, 190
0. 01 : 0 1 5	Strabo, 14, 14n.4
St. Clair, General, 5	Strafford, Earl of, 7
Saragossa, Arragon, 156	Strahan, William, 21
Saviour (i.e. Jesus Christ), 143, 158	Strato of Lampsacus, 180n
sceptics, 181, 184, 187, 190;	Stuart, House of, 7, 8
of the Academy, $161n$;	substance, 32, 39–40
Pyrrhonian, xx, 39, 189, 191,	Suetonius, $155n$
192;	Sumatra, 148
see also Cartesians	superstition, 58, 59, 155, 162, 168;
scepticism, 82, 115, 181–82, 186,	and Catholicism, 62, 94, 144
188;	Supreme Being, 38, 107, 110, 111,
especially Descartes's, viii-ix;	112, 178, 184, 194; see also
see also, Descartes, sceptics,	Almighty, Author, Being,
sceptical philosophy, xii, 39, 60, 181;	
see also scepticism	Creator, Deity, God, Maker
Scholastic philosopher-theologians,	Swan River (Western Australia), xi
68,68n,186	
Scipio, 95n	Tacitus, 122, 122n, 154, 155
Scotland, 9, 21	Tasman, Abel, xi
secondary and primary qualities,	testimony, xviii,
185, 185n, 186	and degrees of human
secret operation of contrary causes,	understanding, 142;
124	and necessary connexion, 115;
secret wish, 105	of God, 165;
secret causes, 99, 101n	of the senses (evidence), 72, 143
secret mechanism, 108	190;
	of witnesses 89, 143, 145–151,
secret nature, 81	154–57, 159, 161, 162, 163, 164
secret power, 77, 78, 80, 81, 85, 86,	166
101n, 124; see also power	
secret springs, 131;	Theaetetus (Plato), 167n
and human mind, 61	Theodicy (Leibniz), 30n
secondary qualities, 185, 185n, 186	theology, 194
Seneca, 136n	Thibault, Mademoiselle, xix, 159
senses, 103, 110, 114, 116, 120, 127,	Thinker, The, xiii
140, 143, 182–83, 184, 185,	thought, 64, 103, 105, 108;
187, 190	and necessary connexion, 115,
Serapis, $155, 155n$	117;
Sextus Empiricus, 39n	see also reasoning, reflection
Shroud of Turin, viii, $5n$	Tiberius, $85,88n$
Shaftesbury, third Earl of, 30, 30n	Tillotson, John, $143, 143n$
Shakespeare, William, $161n$	time, 48, 188
Siam, 154	Timon of Phlius, $39n$
Smith, Adam, 8n, 21, 25	Tories, $7, 8, 8n$

transcendent, knowledge of the, xvi Treatise of Human Nature, A (Hume), vii, x, xi, xiii, xiv, xix, 4-6, 18, 47-50, 52, 52n,54n, 105nTrue Intellectual System of the Universe, The (Cudworth, compiler), 113nTudor, House of, 8 Turin, viii, 5 Turkey, 154 ultimate cause, 109, 171, 175, 180 ultimate principle, 110 uncertainty and error, in abstruse philosophy, 54-55, of causes, 124, 175; of events, 124, 144 understanding, 53, 57, 97, 101, 115, 121, 127, 129, 132, 151, 175, 195, see also human understanding uniformity, and necessity and causation, 121, 125; in human nature, 121-23, 126; in nature, 34, 147-48; lack of, in experience, 37, 145; supposition of, future to past, 77-81, 99, 142; see also constant conjunction, custom Venus (goddess of love), 57, 57n

velleity, 131
Venus (goddess of love), 57, 57n
Vespasian, Emperor, xix, 155, 155n, 156; and sons Titus and Domitian, 156n
Vienna, 5
Vinnius, 4
vice and virtue, 53, 54, 57, 61, 84, 101, 137, 172, 173–74, 179
Virgil, 4
vis inertiae, 112, 112n
Voet, 4

voluntary actions, 126, 127, 128, 129, 131, 135 volition, 108, 110–113, 125, 127, 135, 149; see also will voluntary motion, 106

Warburton, Dr., 6, 6n.2
Wealth of Nations (Smith), 8n
Wesley, John, 157n
Whigs, 7, 8, 8n
will, 37, 38, 42, 60, 91, 104, 105,
106, 107, 108, 110, 113, 129,
130, 133; see also volition
William of Ockham, 68n
Wittgenstein, Ludwig, xx

Xenocrates, 95n

Zeus, 171*n* Zeuxis, 171, 171*n*